W9-BRJ-258

COLORADO 24/7 · CONNECTICUT 24/7 · DELAWARE 24/7 · FLORIDA 24/7 · GEORGIA 24/7

KANSAS 24/7 · KENTUCKY 24/7 · LOUISIANA 24/7 · MAINE 24/7 · MARYLAND 24/7

MONTANA 24/7 · NEBRASKA 24/7 · NEVADA 24/7 · NEW JERSEY 24/7 · NEW HAMPSHIRE 24/7

OKLAHOMA 24/7 · OREGON 24/7 · PENNSYLVANIA 24/7 · RHODE ISLAND 24/7 · SOUTH CAROLINA 24/7

VIRGINIA 24/7 · WASHINGTON 24/7 · WEST VIRGINIA 24/7 · WISCONSIN 24/7 · WYOMING 24/7

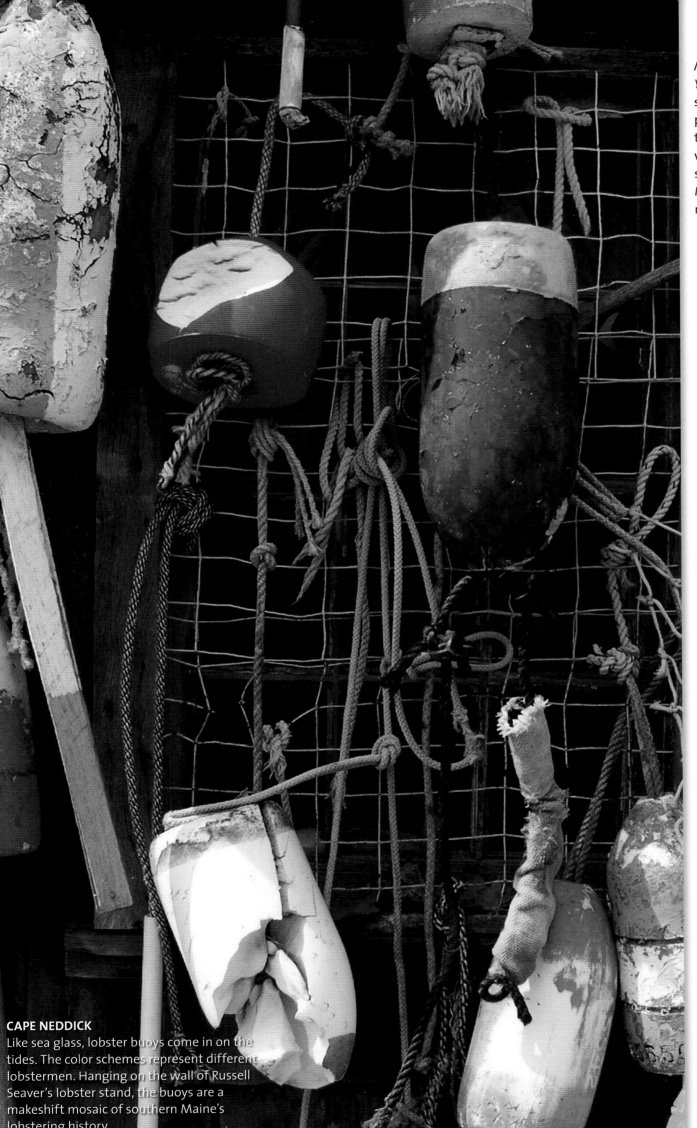

CAPE NEDDICK
Like sea glass, lobster buoys come in on the tides. The color schemes represent different lobstermen. Hanging on the wall of Russell Seaver's lobster stand, the buoys are a makeshift mosaic of southern Maine's lobstering history.
Photo by Alexandra C. Daley-Clark

Maine 24/7 is the sequel to *The New York Times* bestseller *America 24/7* shot by tens of thousands of digital photographers across America over the course of a single week. We would like to thank the following sponsors, the wonderful people of Maine, and the talented photojournalists who made this book possible.

OLYMPUS®

LEXAR
Media™

snapfish

jetBlue
AIRWAYS®

WEBWARE™

Google™

DIGITAL
POND™

ebaY

LONDON, NEW YORK, MUNICH, MELBOURNE, and DELHI

Created by Rick Smolan and David Elliot Cohen

24/7 Media, LLC
PO Box 1189
Sausalito, CA 94966-1189
www.america24-7.com

First Edition, 2004
04 05 06 07 08 10 9 8 7 6 5 4 3 2 1

Published in the United States by
DK Publishing, Inc.
375 Hudson Street
New York, NY 10014

DK Publishing, Inc. offers special discounts for bulk purchases for sales promo-
tions or premiums. Specific, large-quantity needs can be met with special
editions, personalized covers, excerpts of existing guides, and corporate
imprints. For more information, contact:

Special Markets Department
DK Publishing, Inc.
375 Hudson Street
New York, NY 10014
Fax: 212-689-5254

Cataloging-in-Publication data is available
from the Library of Congress
ISBN 0-7566-0059-6

Printed in the UK by Butler & Tanner Limited

First printing, October 2004

MATINICUS ISLAND
With a low tide, soft breeze, and fading
light, Matinicus Harbor tucks in its modest
fishing fleet. Located offshore of Rockland,
Matinicus ("place of wild turkeys" in the
Penobscot language) supports a year-round
population of 50.
Photo by Alison Langley

MAINE 24/7

24 Hours. 7 Days.
Extraordinary Images of
One Week in Maine.

Created by Rick Smolan and David Elliot Cohen

DK Publishing

About the America 24/7 Project

A hundred years hence, historians may pose questions such as: What was America like at the beginning of the third millennium? How did life change after 9/11 and the ensuing war on terrorism? How was America affected by its corporate scandals and the high-tech boom and bust? Could Americans still express themselves freely?

To address these questions, we created *America 24/7*, the largest collaborative photography event in history. We invited Americans to tell their stories with digital pictures. We asked them to shoot a visual memoir of their lives, families, and communities.

During one week in May 2003, more than 25,000 professionals and amateurs shot more than a million pictures. These images, sent to us via the Internet, compose a panoramic yet highly intimate view of Americans in celebration and sadness; in action and contemplation; at work, home, and school. The best of these photographs, more than 6,000, are collected in 51 volumes that make up the *America 24/7* series: the landmark national volume *America 24/7*, published to critical acclaim in 2003, and the 50 state books published in 2004.

Our decision to make *America 24/7* an all-digital project was prompted by the fact that in 2003 digital camera sales overtook film camera sales. This techno-logical evolution allowed us to extend the project to a huge pool of photographers. We were thrilled by the response to our challenge and moved by the insight offered into American life. Sometimes, the amateurs outshot the pros—even the Pulitzer Prize winners.

The exuberant democracy of images visible throughout these books is a revela-tion. The message that emerges is that now, more than ever, America is a supersized idea. A dreamspace, where individuals and families from around the world are free to govern themselves, worship, read, and speak as they wish. Within its wide margins, the polyglot American nation manages to encompass an inexplicably complex yet workable whole. The pictures in this book are dedicated to that idea.

—*Rick Smolan and David Elliot Cohen*

American nightlight: More than a quarter of a billion people trace a nation with incandescence in this composite satellite photograph.
Photo by Craig Mayhew & Robert Simmon, NASA Goddard Flight Center/Visions of Tomorrow

Staying Power

By Bill Nemitz

We call them people "from away." They often ask why we choose to live here in Maine, where the winters are too long, the summers too short, and the shopping centers so scarce that we actually named our largest one "The Maine Mall." They wonder how we can get by on so little, yet still hang signs at our borders that boast, "Welcome to Maine. The Way Life Should Be."

Pretentious? We don't mean it that way.

It's simply the truth.

Life in this corner of the country is, now more than ever, not easy. The mills that once churned out shoes and textiles are long gone. Our proud fishing fleet struggles to stay afloat in a steadily rising tide of federal regulation. The brightest of our children leave for college and, much to our dismay, often never return.

Yet we stay. And we adjust. And we persevere.

We are small enough—only 1.2 million at last count—to know one another by name. We called our prior governor "Angus" and we call the new one "John." His family owns Mama Baldacci's restaurant in Bangor—you'd be surprised how many of us have slurped spaghetti there.

We also have our disagreements. We recently voted down a proposal by two Maine Indian tribes to bring casino gambling here—but only after a bitter debate between the "Two Maines": One is south and along the coast, where many people have good jobs, new cars, and health insurance. The other is north and inland, where many people have none of the above.

THOMASTON
The St. George River at Thomaston, just before it loses itself to the incessant tides of Muscongus Bay.
Photo by John Paul Caponigro

Still, for all our differences, in our hearts we are one. Stories still echo from the ice storm that encrusted Maine six winters ago, leaving thousands stranded for weeks without heat, water, or electricity. Day after day, our newspapers published lists detailing not just what many folks needed, but also what many more folks had to offer. In the end, for all its devastation, the Ice Storm became a thing of unexpected beauty.

Which brings us to the true essence of Maine—and the reason we choose to stay.

Maine, in a word, is beautiful. From the granite outcroppings at West Quoddy Head, where the sun first touches the nation each morning, to the majesty of Mount Katahdin, Maine is a place where people the world over come to look, to smell, to feel the simplicity of nature as it goes about its business. And from the lobsterman to the logger to the musician to the many other faces captured on these pages, it is a place whose people cherish nature's business as they go about their own.

No, it isn't easy. And as long as we stay, with our ghost mills and wicked winters and our mall named after the whole gosh darn state, it likely won't get easier anytime soon. But if there is hardship in Maine, so is there pride. And if living here is a challenge, so is it a blessing.

Welcome to a week in Maine.

The way life should be.

BILL NEMITZ *is a columnist for the* Portland Press Herald *and* Maine Sunday Telegram. *He has worked as a journalist in Maine since 1977 and lives with his wife Andrea in Bar Mills.*

CAPE ELIZABETH
"The rocky ledge runs far into the sea,
and on its outer point, some miles away,
the lighthouse lifts its massive masonry,
A pillar of fire by night, of cloud by day."
These lines from "The Lighthouse"(1849) by
Henry Wadsworth Longfellow were inspired
by the Portland Head Lighthouse.
Photo by James Marshall, Corbis

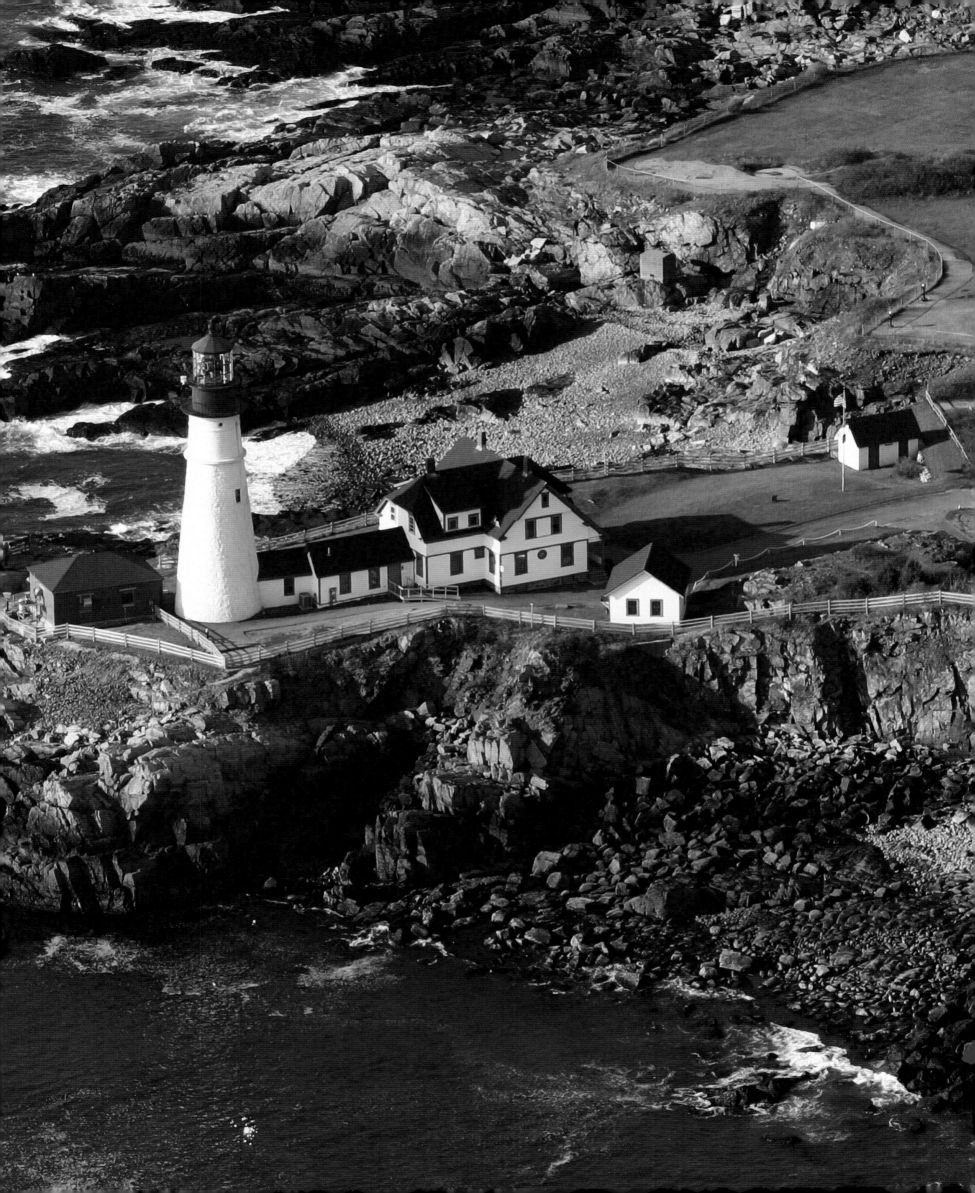

FREEPORT
There was an old lady who lived in a shoe—
but this isn't it. Outdoor wear manufacturer
L.L. Bean commissioned the 14-foot replica
of its Maine Hunting Shoe, aka "the Bean
boot," for its 90th anniversary celebration
in 2002.
Photo by Robert F. Bukaty

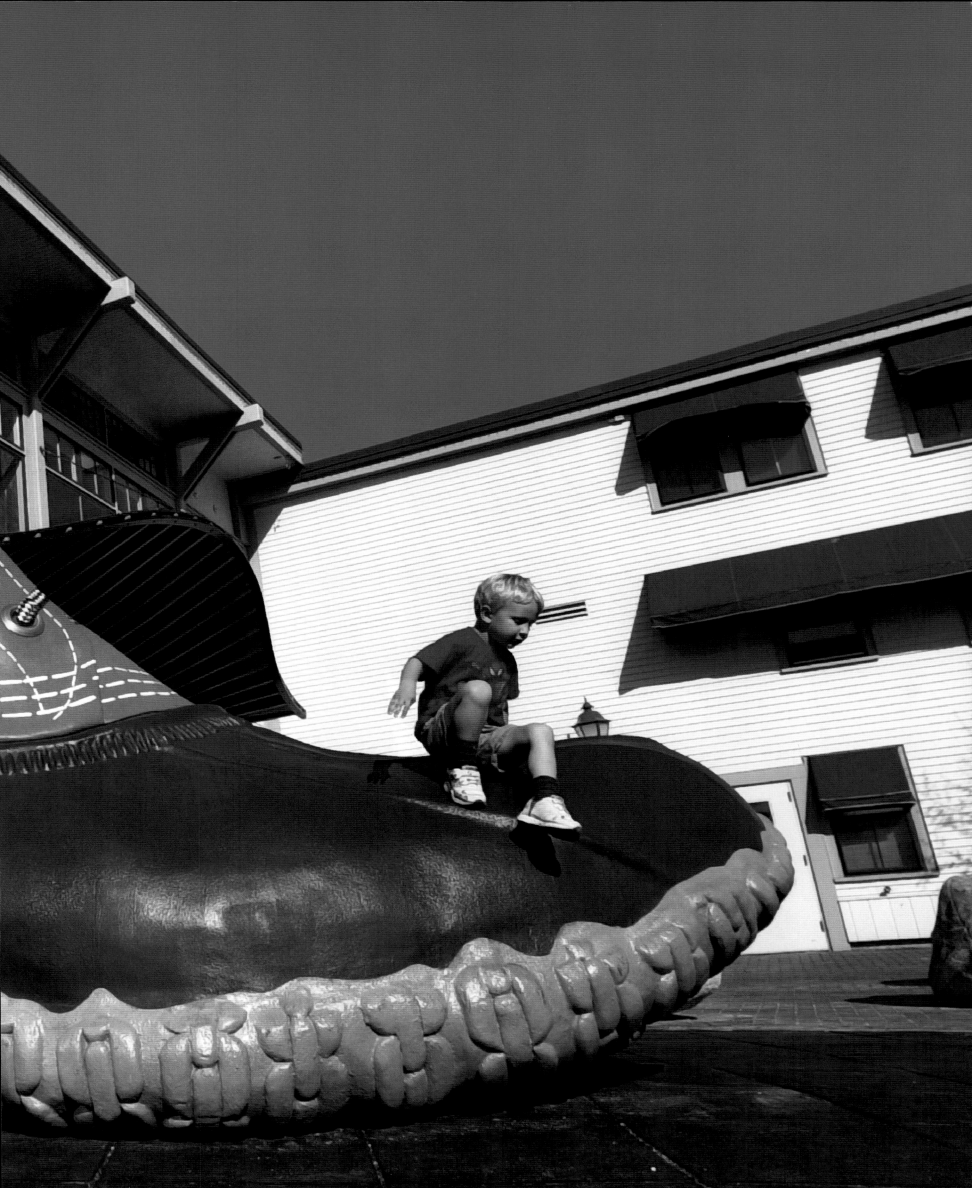

MATINICUS ISLAND
Egg-bearing lobsters such as this oversized one are tossed back. Maine's lobster catch, which increases 2 percent each year due to conservation measures, totaled 62 million pounds in 2002.
Photo by Alison Langley

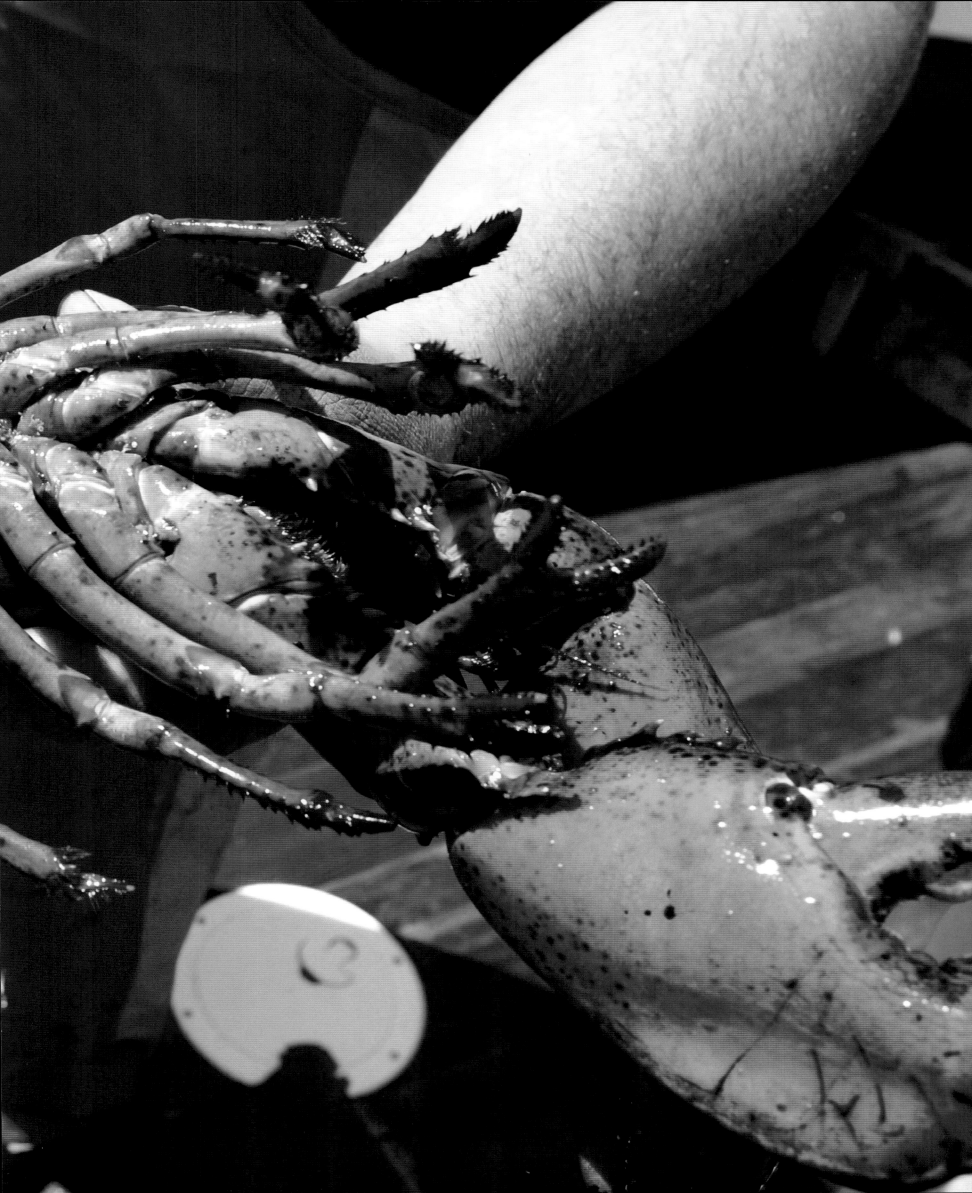

MATINICUS ISLAND

Of Maine's 15 year-round islands, Matinicus, first settled in 1757, is farthest from the mainland (23 miles from Rockland). Just 2 miles long and 1 mile wide, the island's population is 50 in the winter, 200 in the summer. Some of the old fish houses, originally fisherman's workshops and storage sheds, have been remodeled into apartments.
Photo by Alison Langley

BIDDEFORD
Ralph Vadnais, 65, co-owner of Ralph and Roger's Barbershop, speaks French at home; he learned the language from his French-Canadian father. "Thirty-five years ago," says Vadnais, "most of the people here spoke French. They came from Canada to work in the textile mills."
Photo by Shawn Patrick Ouellette

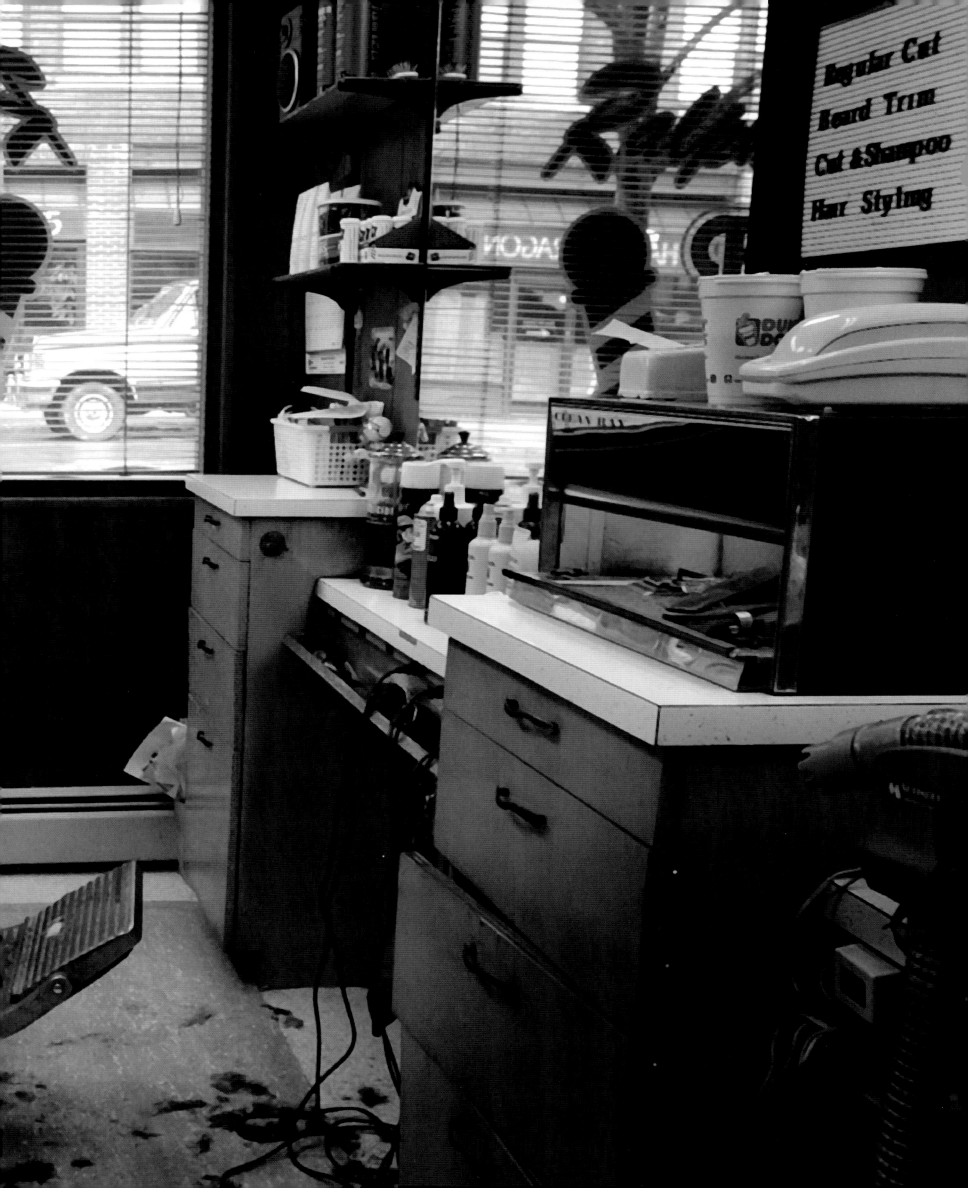

LOVELL
Some kids sit around campfires and tell scary stories, but sisters Sasha and Yazi Azel spin dreams. The 8- and 11-year-old girls, who were born in Maine, say exotic places capture their imaginations. Sasha's latest fantasy, fueled by classes at school, is to become an astronaut and visit Mars.
Photo by José Azel, Aurora

ANDOVER

Egghead: When Finn McLain's dad gave him an Easter bunny inside a large, clear-plastic egg, the three-year-old ignored the toy and turned the egg into a space helmet—which he wears as he downs his favorite evening meal: cottage cheese.
Photo by David McLain, Aurora

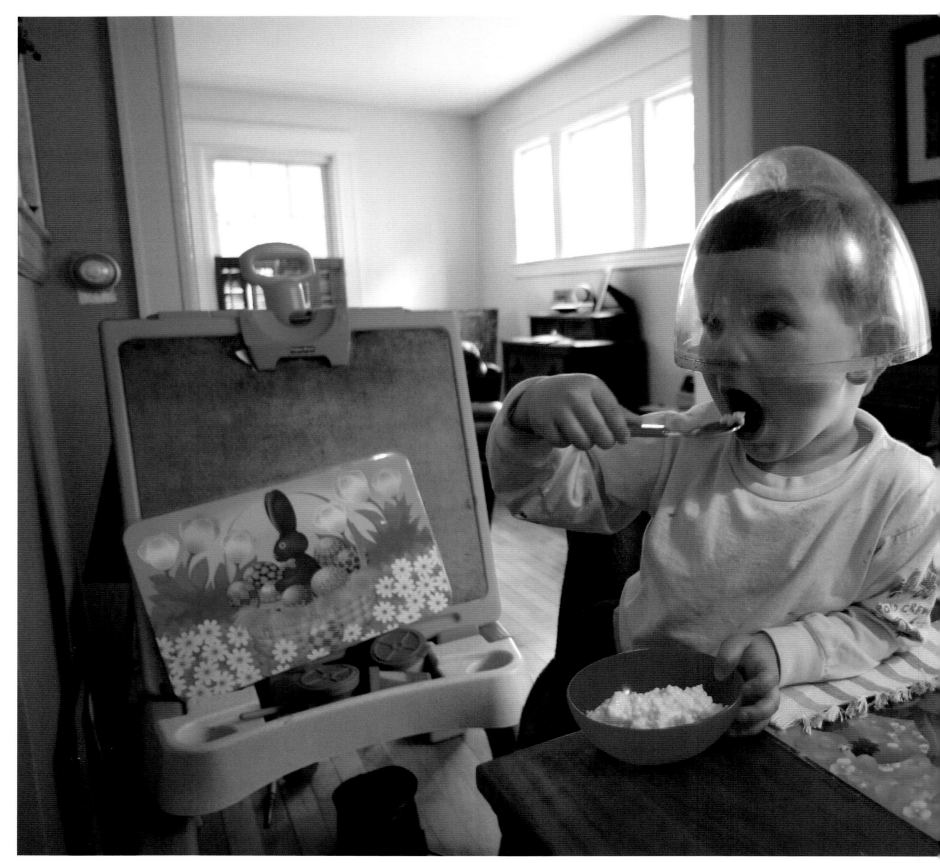

ANDOVER
Finn McLain, 1, admires the unicorn spike he made on his sister's head, but Myla, 3, is indifferent.
Photo by David McLain, Aurora

ORONO
Samantha Nadeau, 7, is used to a busy schedule—school, violin, swimming lessons, and Brownies—but a neighbor's potluck party did her in.
Photo by Michele Stapleton

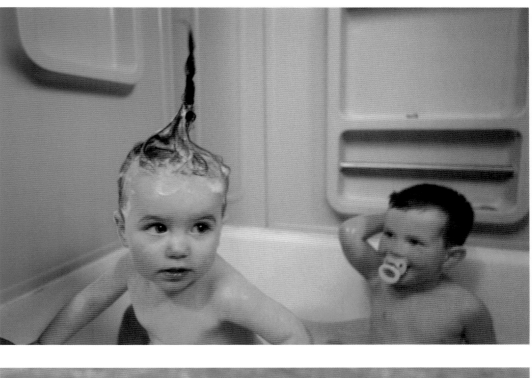

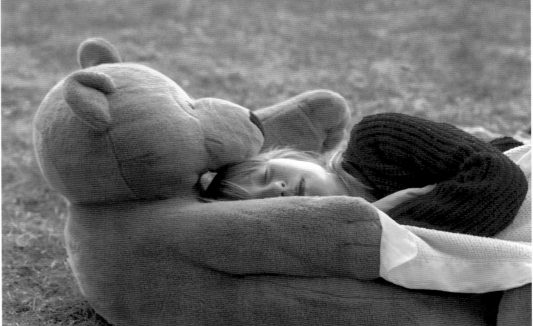

WHITEFIELD

Nerf Sabatine, 68, runs his farm with animal power. The former university professor turned farmer says, "I'm more comfortable with mules than a tractor." He bought the 90-acre farm in 1976 and ran a small Italian cheese and butter business until he retired in 1998. He still ploughs his hay fields with his team of mules.

Photo by Bridget Besaw Gorman, Aurora

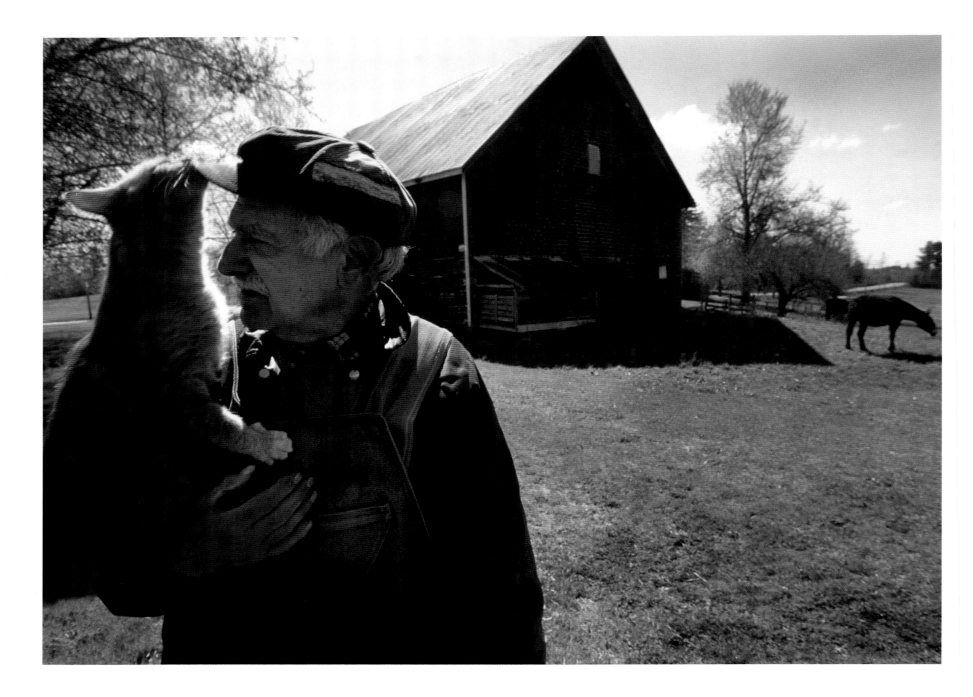

PISCATAQUIS COUNTY

Carol Stirling loves her 30-year-old retired racehorse Jubi so much that she had a window cut into her kitchen door at West Branch Pond Camp so Jubi can visit while she cooks.
Photo by Stephen M. Katz

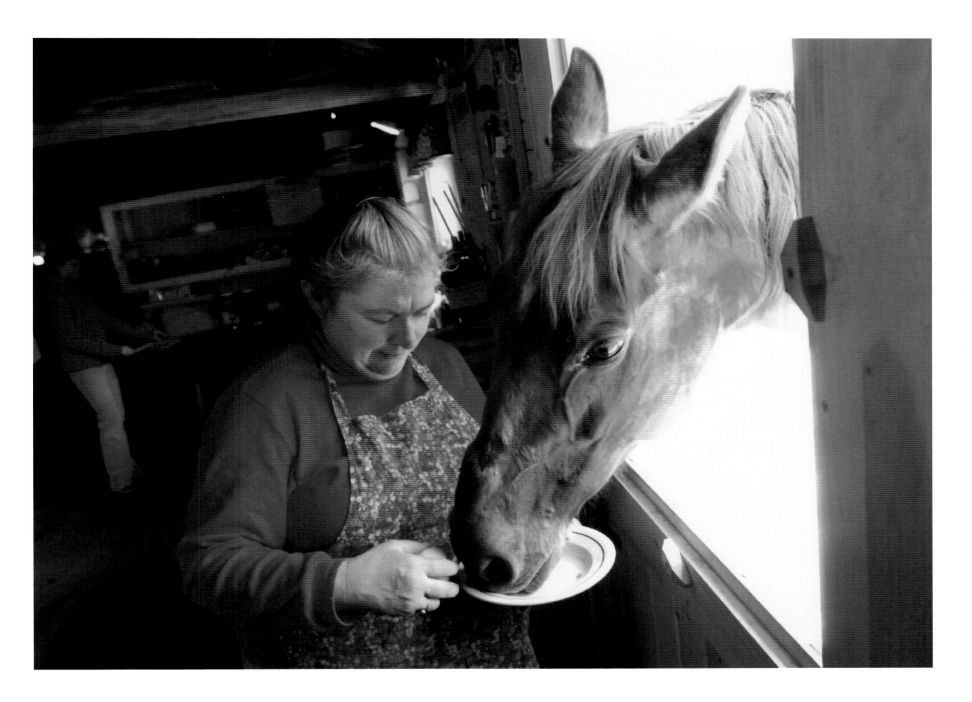

Dairy farmer Tim Leary leaves his work clothes in the cellar, which keeps the cow smell out of the house. "Mrs. Leary insists on it," says Leary, catching up after work with three of his eight children. In the 60s, Saco had 50 dairy farms, Leary says; now, only his 540-acre farm remains. Maine has lost half of its dairy farms since 1978.

Photos by Shawn Patrick Ouellette

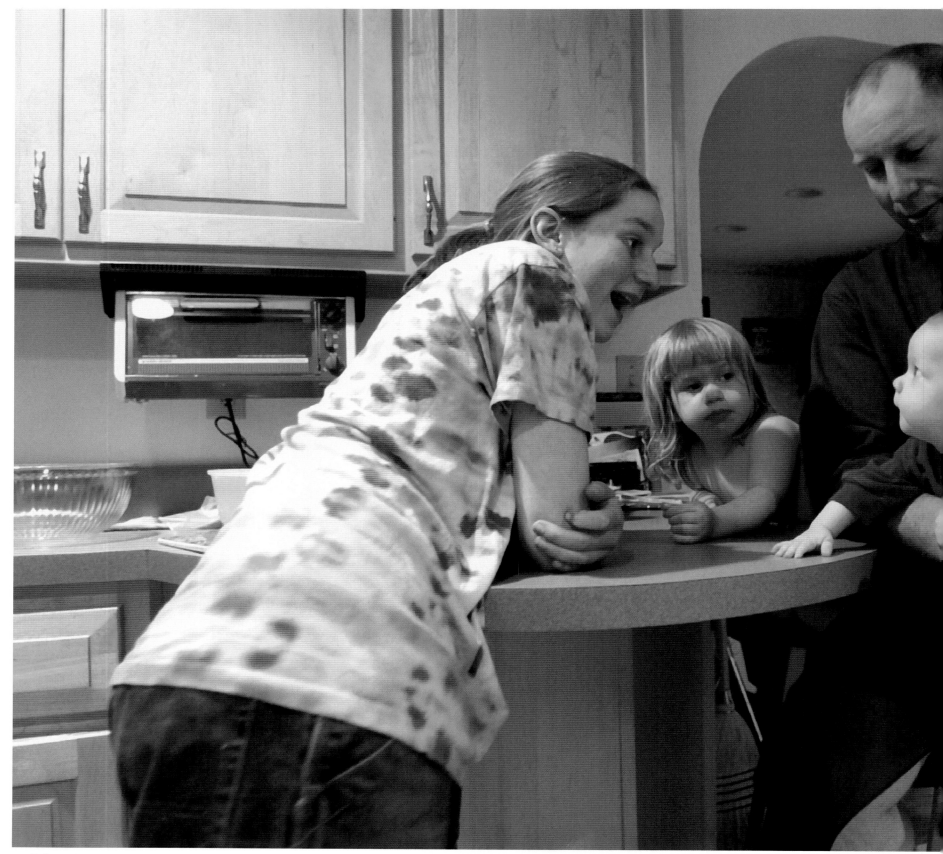

SACO

Tim Leary shows a digital image to three of the kids before school starts. It's 9 a.m., and Leary did the first milking at 6 a.m. "I'm not hard-core," says Tim, "like some farmers who milk at 2:30 in the morning." A third-generation dairyman, Leary milks his 100 Holsteins twice a day.

SACO

Alison Leary, 14, gives her four-year-old brother Benjamin a piggyback ride in the main cow barn. The Leary Dairy Farm is in an area where suburban subdivisions have started to sprout—the quiet town of Saco is just 10 miles south of Portland and 5 miles from the coast.

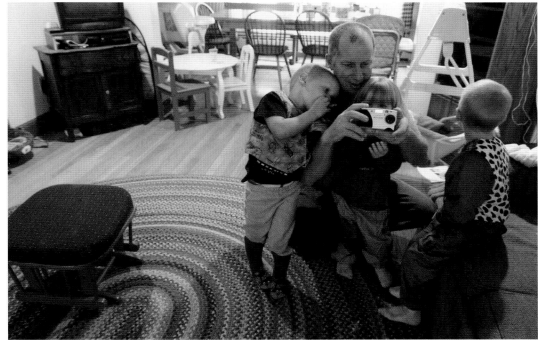

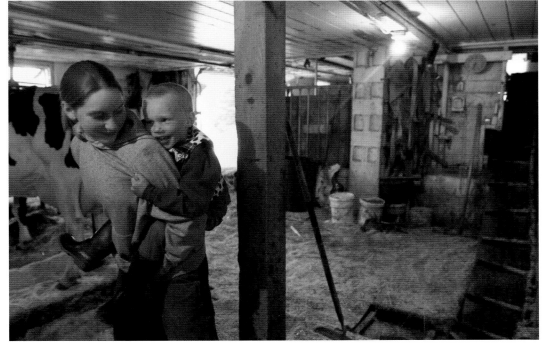

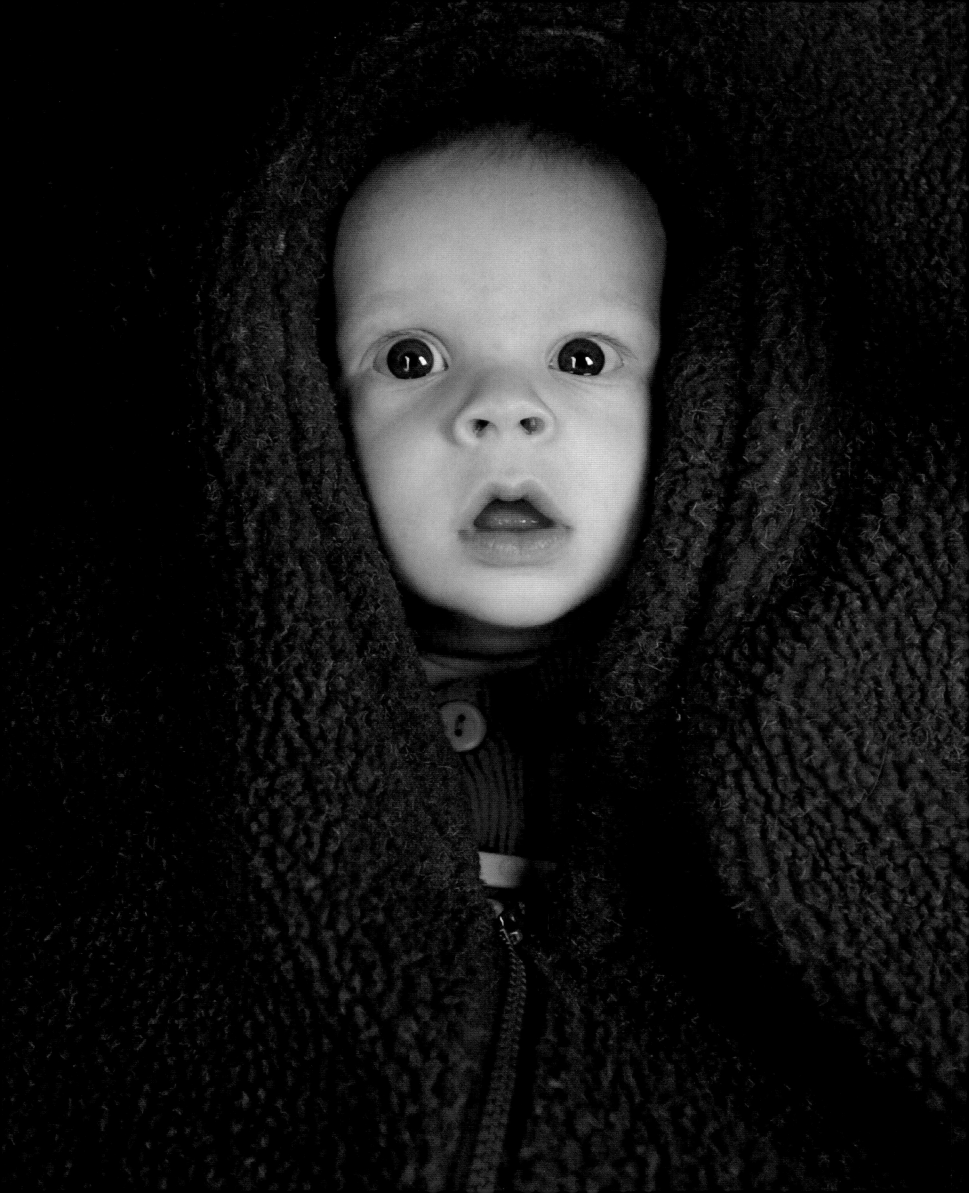

SACO

Six-month-old Aaron Leary waits in his fleece-covered car seat for the ride to day care. Will he be a fourth generation dairy farmer? "The farm has survived because the family stayed out of debt," says Tim Leary. "My grandfather started with one cow in 1943 and paid off everything as he went."

Photos by Shawn Patrick Ouellette

SACO

Four-year-old Benjamin Leary and dad Tim squat on a one-legged stool as they hook up the milking machine to a Holstein. Tim says there is one immutable truth in dairy farming: The cows have to be milked twice a day, every day.

SACO

Patrick Leary, 10, spreads grass seed on the yard, using a 1920s seeder passed down from generation to generation—like the Leary Dairy Farm itself.

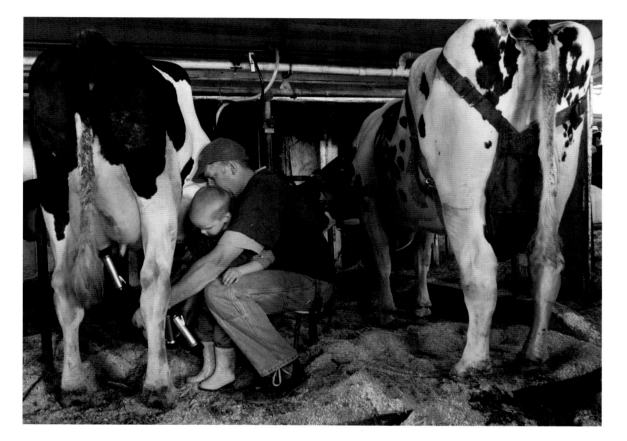

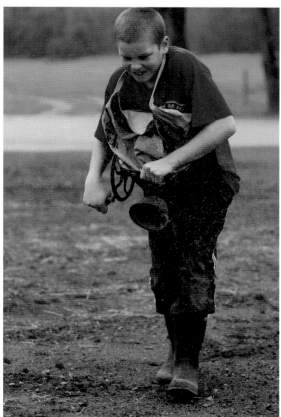

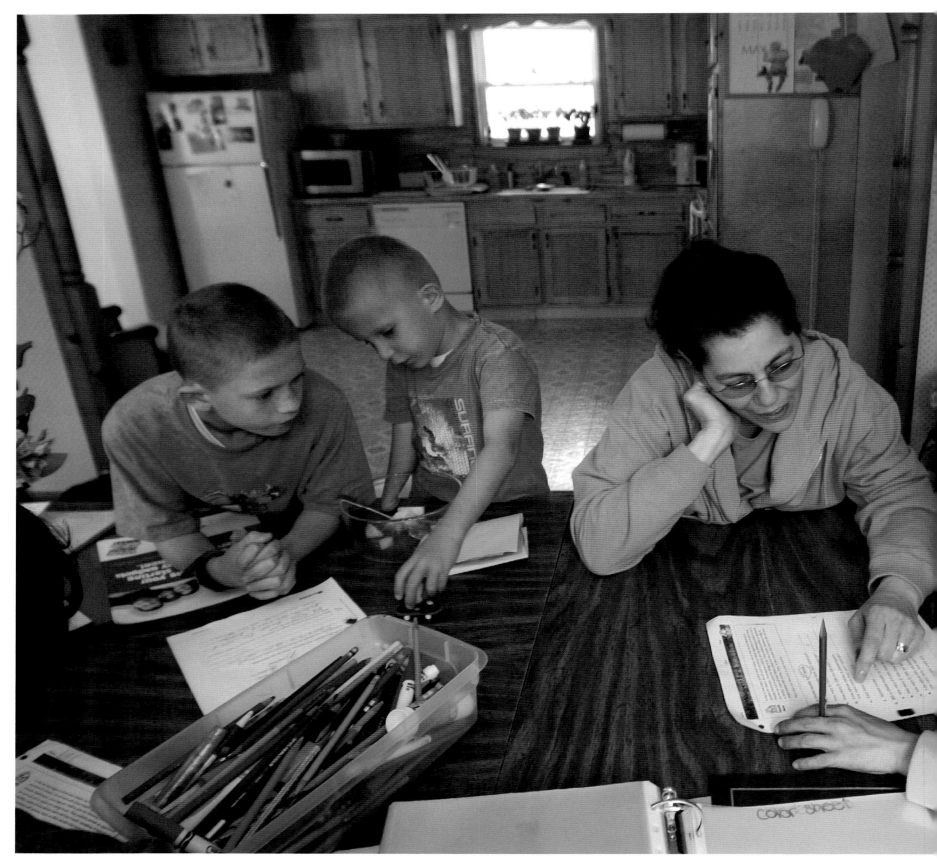

WELLS

In 1986, after she dialed a wrong number and connected with the organization Heal the Children, Christine Tomaszewski and husband John embarked on a lifelong odyssey, resulting in the adoption of 10 children with disabilities. Russians Vanya, Nikolai, and Igor knew little English when adopted, but Igor's first words to his new parents were, "I'm a good boy. Take me."
Photo by Gregory Rec

CAPE PORPOISE

Center stage: Ken Schneider feeds his 4-month-old son Zachary on the stage of Atlantic Hall. Home to the one-room Cape Porpoise Library, the 89-year-old hall is rented out for events like plays and wedding receptions. The Schneider boys are taking a break from the latter.

Photo by Serge J-F. Levy

RANGELEY

Carolyn Smith and her husband first visited Rangeley 22 years ago and considered retiring here. Unhappy with the anonymity of Boston, they decided not to wait for retirement; they relocated two years later. She loves the area's natural beauty and outdoor activities and says the town's 1,200 residents feel like an extended family. "It's kinda like living in Mayberry."

Photo by José Azel, Aurora

NORTH BERWICK
Buster the Energizer dog and Maddie
Hadwen play with Maddie's favorite toy,
the bubble wand. The three generations of
Hadwens who live in this house are trying
to return their 50-acre property to its 1877
farming origins.
Photo by Thatcher Hullerman Cook,
Thatcher Cook Photography

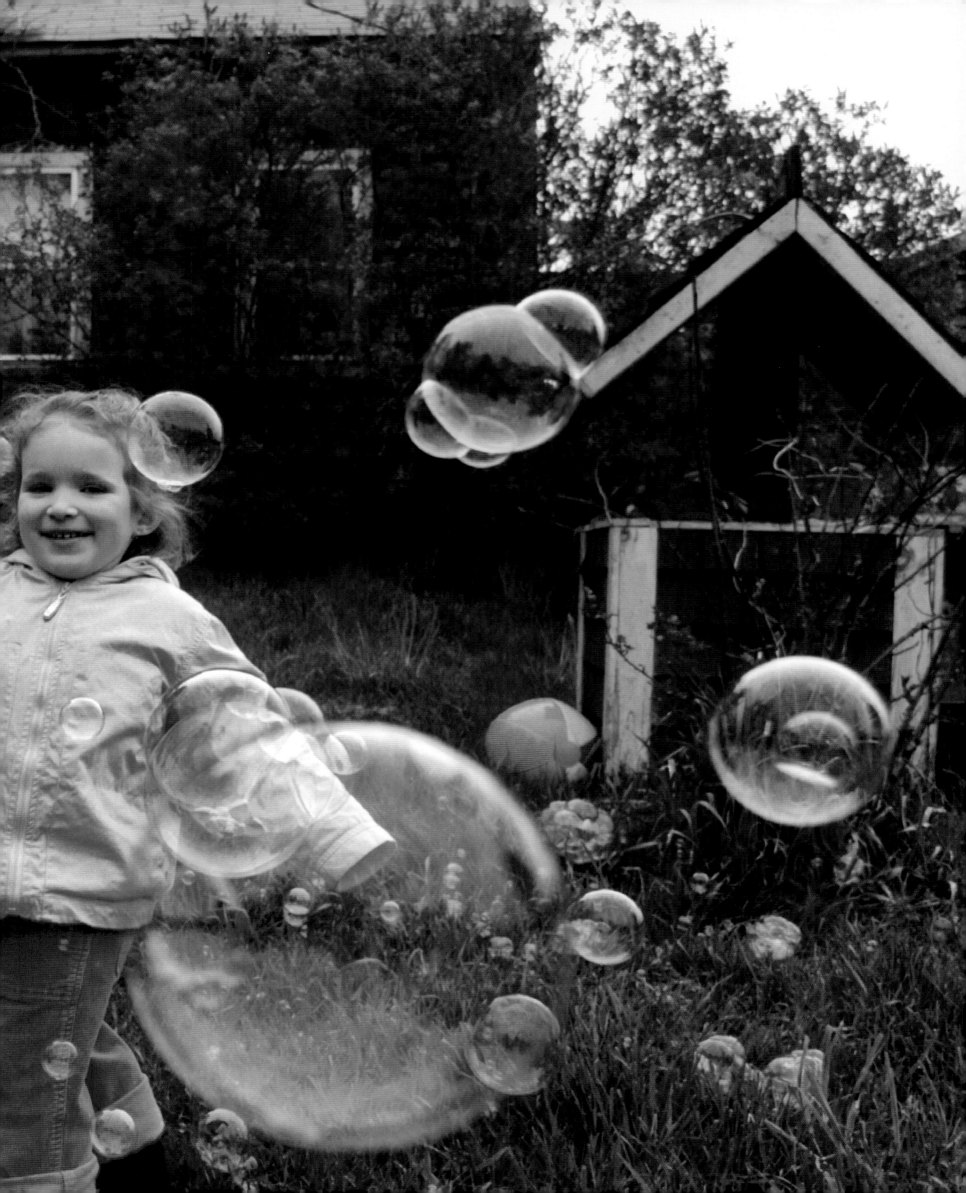

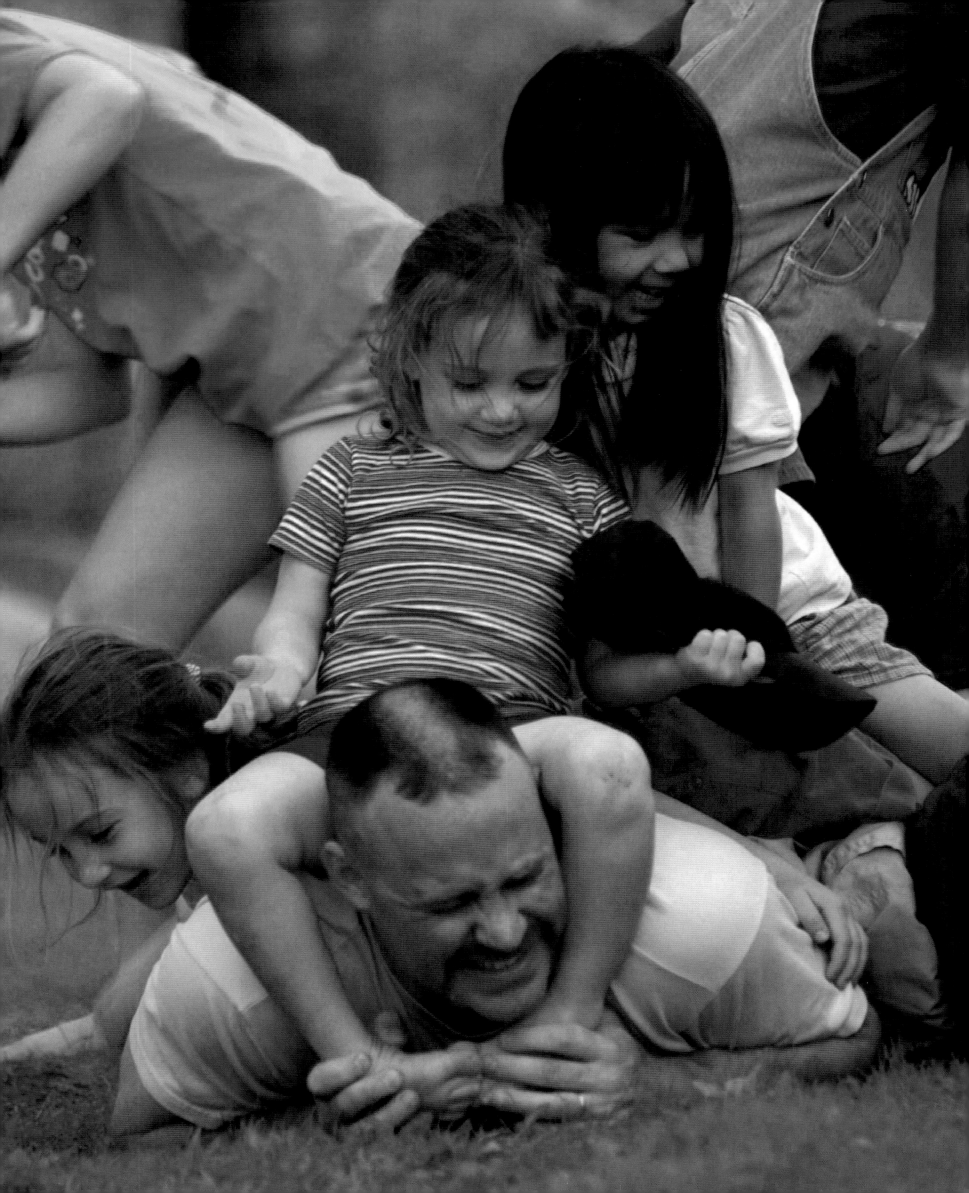

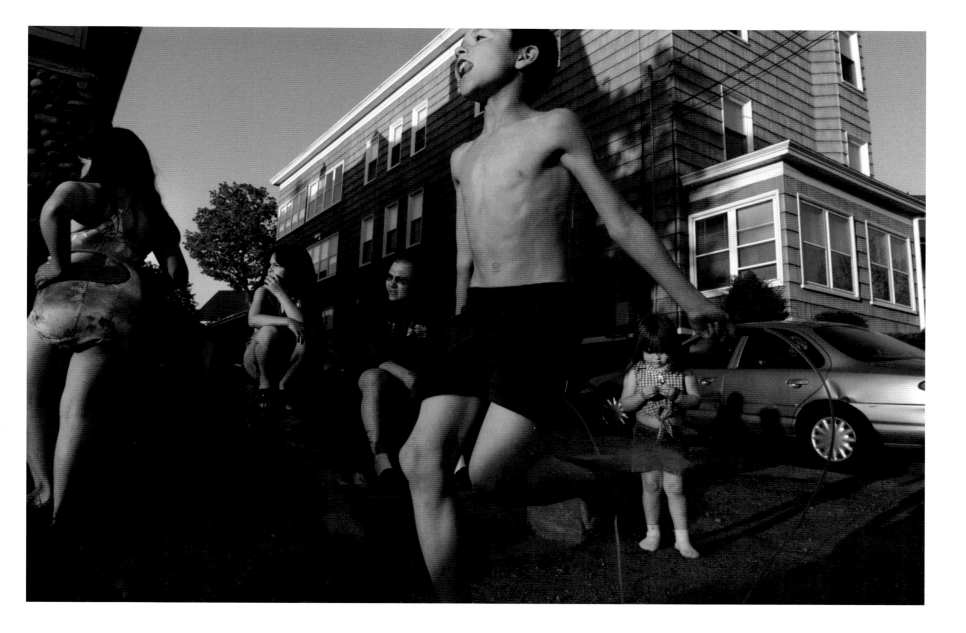

ORONO

Wanting to spend more time with his wife and kids, Stig Callahan, 30, left the U.S. Navy and its long deployments, and relocated his family from Virginia to Orono. He enrolled in the electrical engineering program at the University of Maine. He says he appreciates central Maine's peaceful atmosphere, beauty, and friendly people.
Photo by Michele Stapleton

LEWISTON

On one of the first warm afternoons of the year, neighbors (including Eric Tipodeau, jumping rope) gather around a Webster Street stoop on the edge of downtown Lewiston. Once a center for manufacturing, Lewiston is hoping for some kind of renaissance. Nearly 15,000 worked in the area's shoe and textile mills in the 1950s; the two industries employ just 1,000 today.
Photo by Amy Toensing

ARUNDEL
Although two-year-old Clayton Simoncic was awestruck when he witnessed his first chick hatching, it took him a few days to muster the courage to pet the fuzzy creatures.
Photo by Gregory Rec

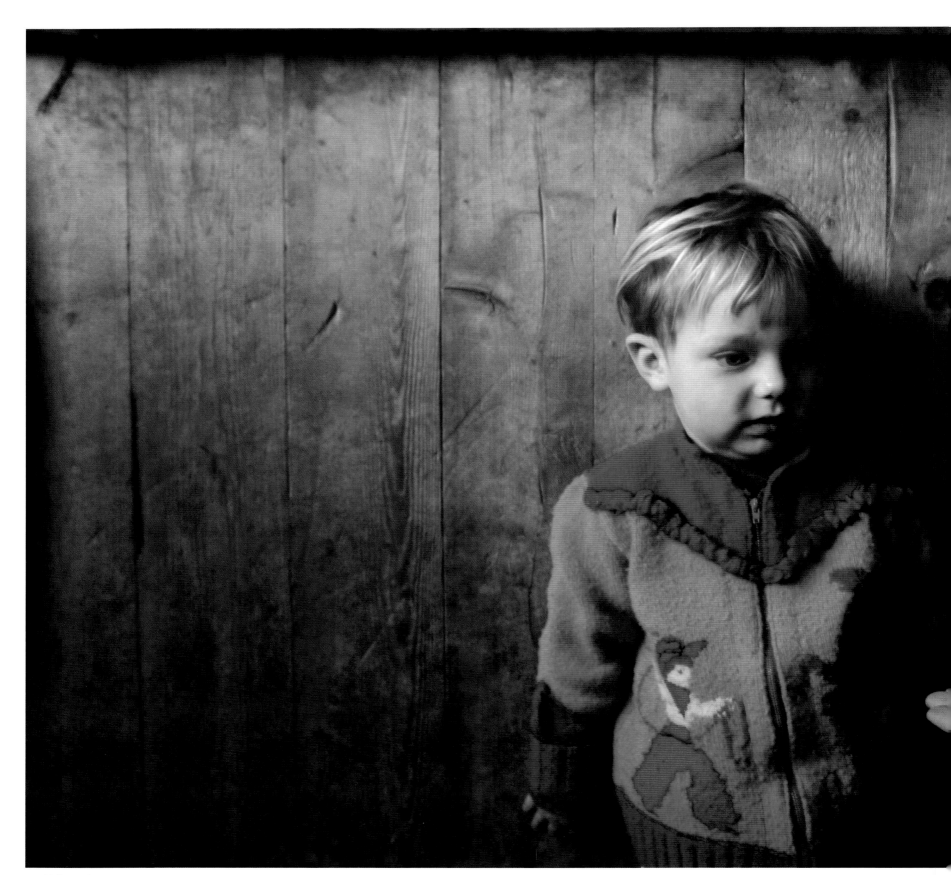

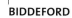

BIDDEFORD

When Jocelyn Lydon, 25, got Amy, a Morgan horse, for Christmas, she was a teenager and rode the horse every afternoon. But a full-time office job, a part-time job at her parents' restaurant, and a husband now leaves little room for Amy. To make up for it, Lydon brings her pizza from the restaurant.

Photo by Gregory Rec

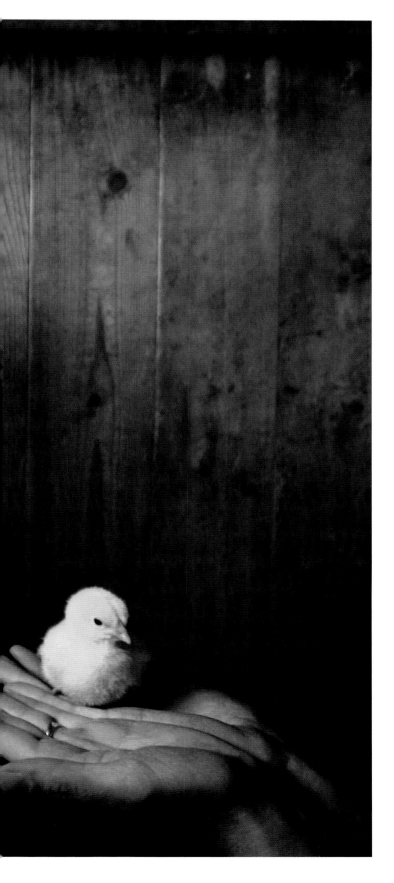

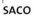

SACO

After her daughter painted the outside of the house purple in 1986, Joyce Petit said, "I felt like I was living in an Easter basket." So the lifelong Red Sox fan repainted the house red and covered it with team memorabilia. The interior belongs to her hero Ted Williams—his photo and number decorate most surfaces, even the dryer.
Photo by Shawn Patrick Ouellette

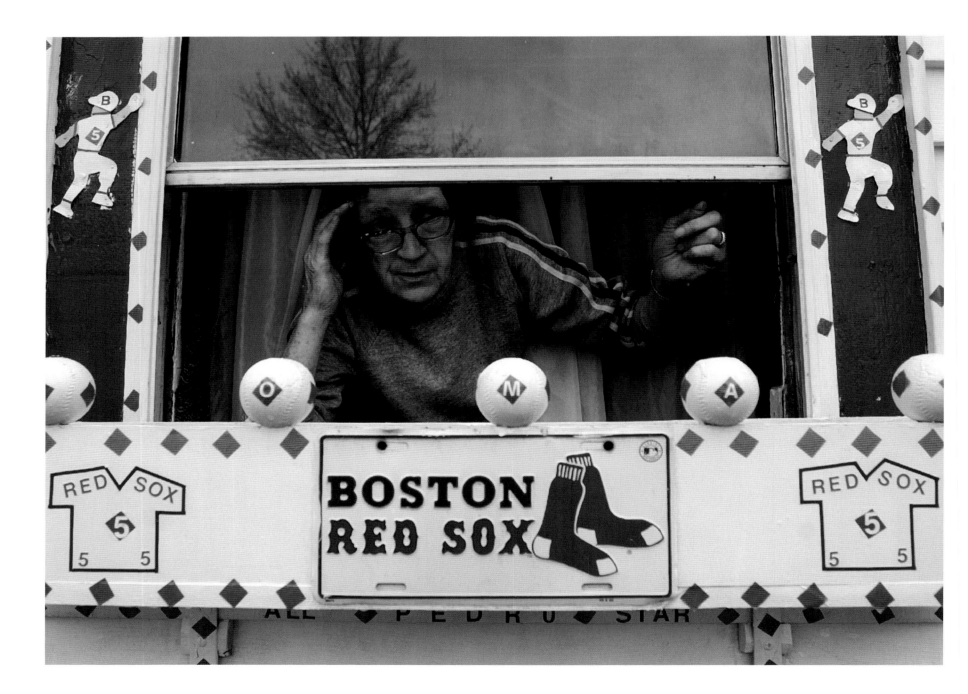

STANDISH

"What are you gonna do...paint it boring white?" That was a neighbor's challenge after the Rogers had their house power washed. Wally Rogers, a Vietnam vet and his wife Helen asked for suggestions and got one. Now the patriotic abode is a photo-op for tourists visiting nearby Sebago Lake, southern Maine's largest lake.
Photo by Carl D. Walsh, Aurora

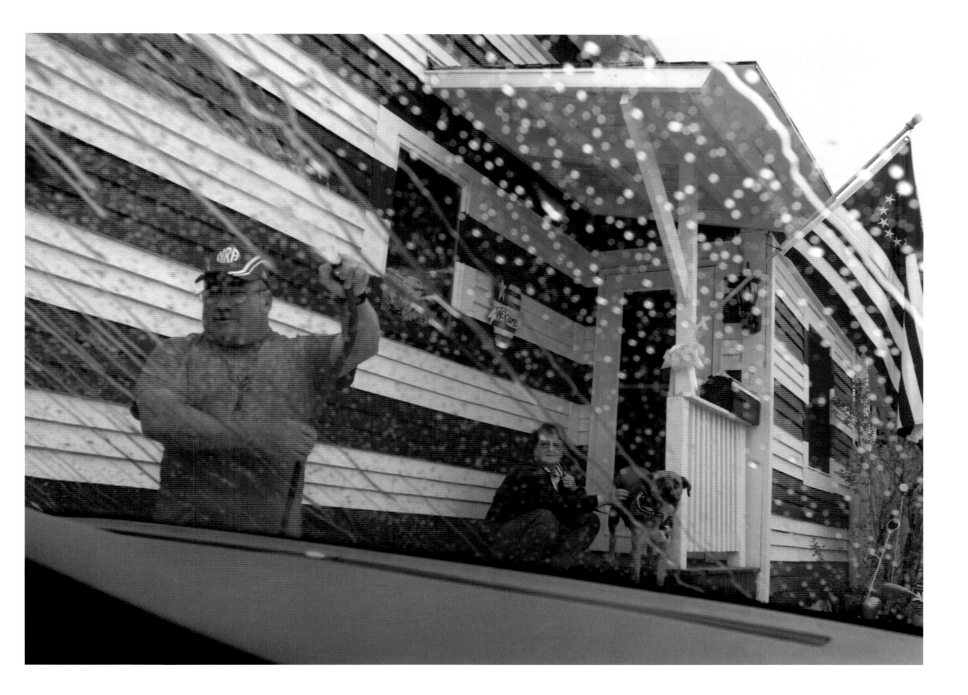

NORTH WATERBORO
Taylor Ouellette gazes out at her summer playground: the family's wooded, 2.5-acre front yard. It's been a long winter; the days are beginning to warm, and the ground has that squishy, spring-is-just-around-the-corner feel.
Photos by Shawn Patrick Ouellette

SOUTH PORTLAND
On her birthday, Taylor Ouellette beams with pure, 3-year-old joy as she rides her favorite carousel animal. The French-Canadian Ouellette family counts six generations in Maine back to the early 1800s when they were potato farmers in Aroostook County.

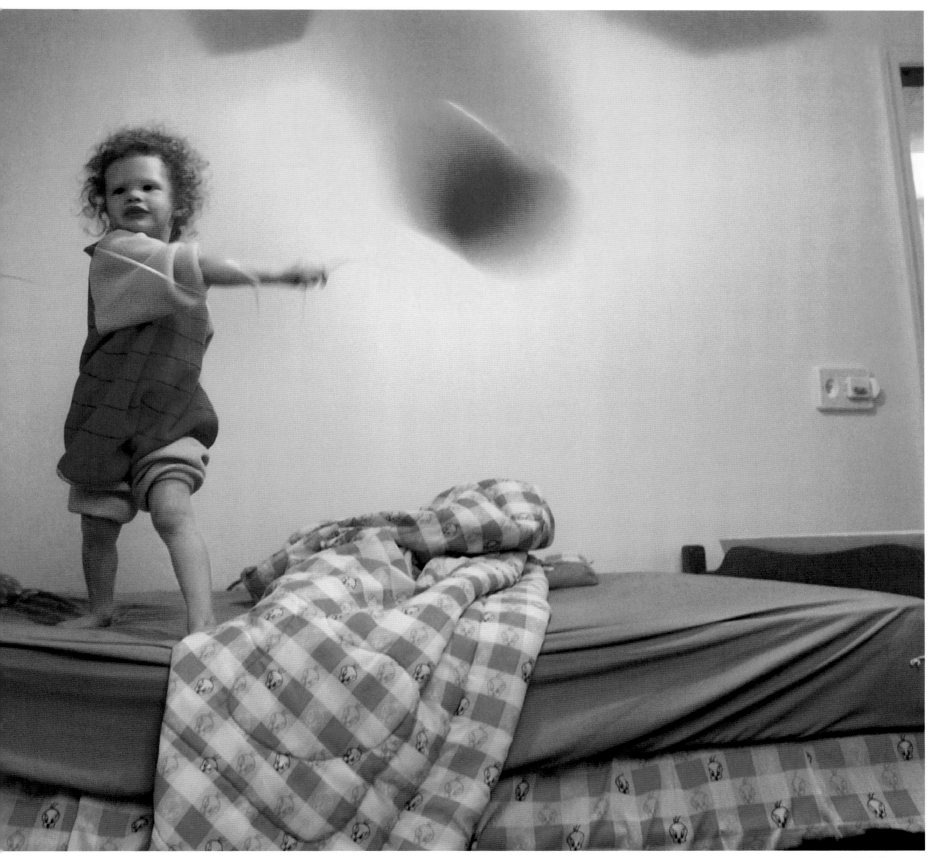

NORTH WATERBORO
Evasive maneuver no. 4: Bounce on your sister's bed and play with a balloon. Like most kids, Taylor Ouellette does not like going to bed. According to dad Shawn, her bag of tricks includes (but is not limited to) the following: "I have to go to the bathroom" and "I can't find my teddy bear."

CUSHING

In his family's wet, 1-acre garden,
18-month-old Sol Caponigro makes like
he's Eeyore, his favorite *Winnie the Pooh*
character. The garden is notable for painter
Andrew Wyeth's use of it in his early work.
The artist lives just 2 miles away.
Photo by John Paul Caponigro

The year 2003 marked a turning point in the history of photography: It was the first year that digital cameras outsold film cameras. To celebrate this unprecedented sea change, the *America 24/7* project invited amateur photographers—along with students and professionals—to shoot and, via the Internet, submit digital images. Think of it as audience participation. Their visions of community are interspersed with the professional frames throughout this book. On the following four pages, however, we present a gallery produced exclusively by amateur photographers.

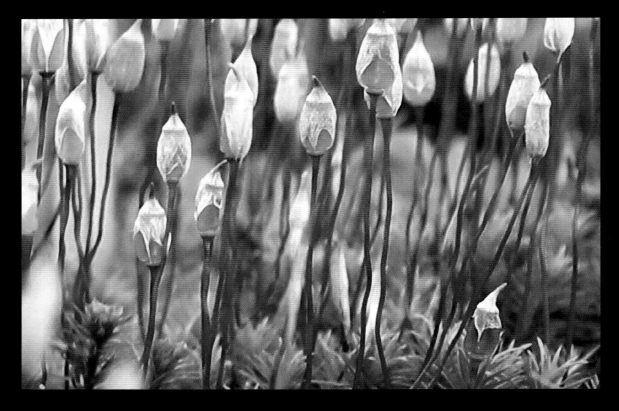

LIMINGTON Sporophyte moss thrives between violets and lilies, blooming fire red in spring and turning into a lush green ground cover in fall. *Photo by Dianna Townsend*

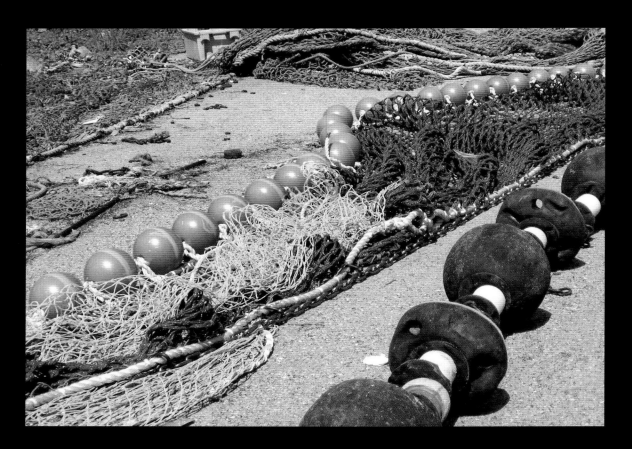

PORTLAND Fishermen's nets dry out in the repair yard of Portland's Fish Pier. *Photo by Judith Harris*

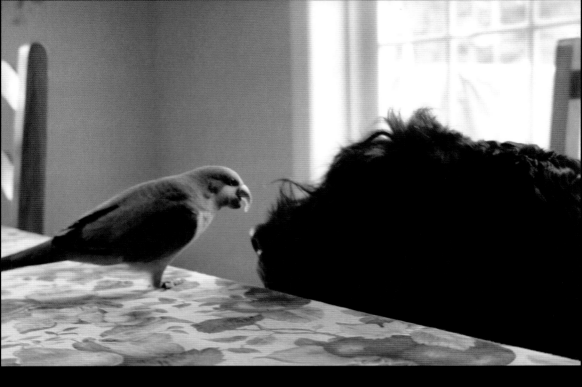

PORTLAND Putchy, the free-flying Quaker parrot, taunts Mack, the grounded Belgian Bouvier des Flandres, with a breakfast of peanut butter toast. *Photo by Nycole Tremblay*

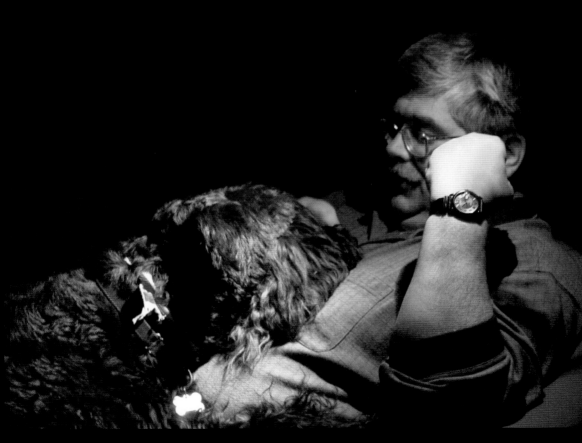

PORTLAND Even though he weighs 96 pounds, Yvan Tremblay's dog Mack thinks he's a lap dog.
Photo by Nycole Tremblay

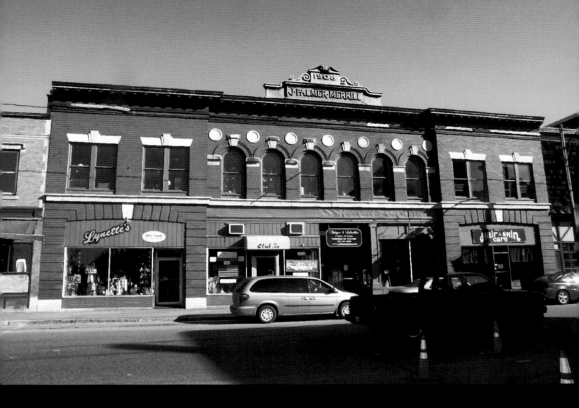

SKOWHEGAN Named after a prominent local attorney, the J. Palmer Merrill building now houses a 24-room antique shop on its top floor in downtown Skowhegan. *Photo by Nancy Jervey*

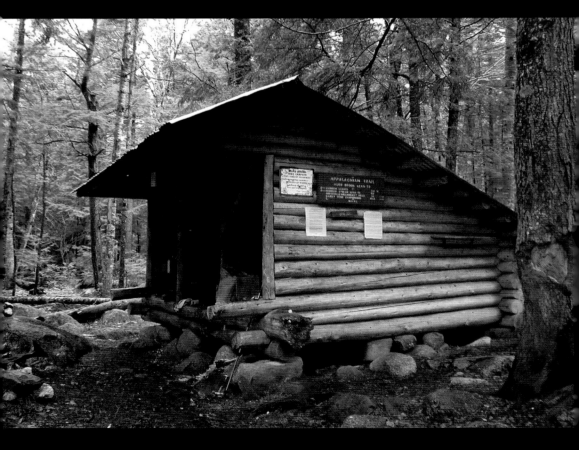

PISCATAQUIS COUNTY Hurd Brook Shelter lies along a stretch of the Appalachian Trail called the 100-Mile Wilderness, named for its remoteness from any population center. *Photo by Denis Clark*

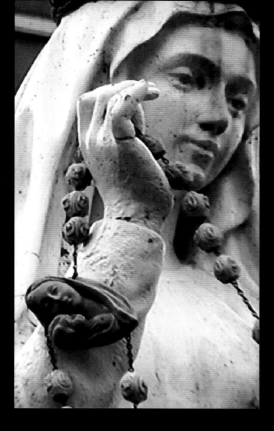

CARIBOU This seven-foot Madonna was installed outside the Holy Rosary Catholic Church in 1960. She has weathered well, but her rosary has been replaced three times. *Photo by Blake Lagasse*

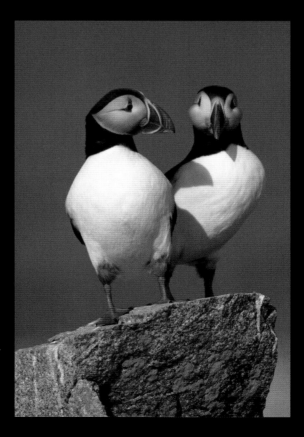

MACHIAS SEAL ISLAND Three thousand Atlantic puffins make their home and raise their young among the rocky burrows of this island off northern Maine. *Photo by Rob Bernstein*

ALNA

Harold Dawson disassembles a 1790s barn made from hand-hewn lumber and hand-forged nails. He'll move it across town and reconstruct it exactly as it was. There is an art to the process: "You have to go slow," Dawson says, "number every piece, and know the old building techniques."

Photo by Bridget Besaw Gorman, Aurora

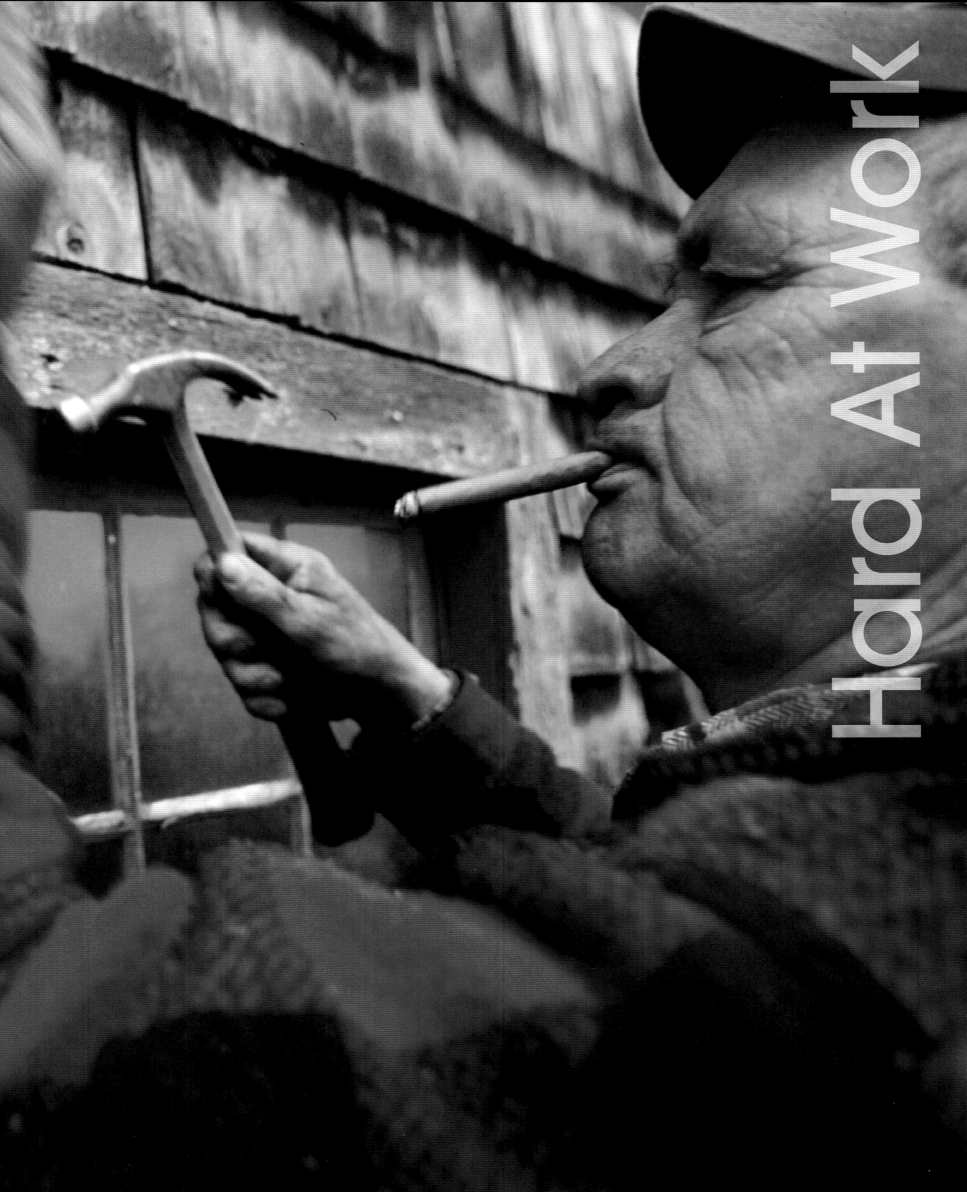

Hard At Work

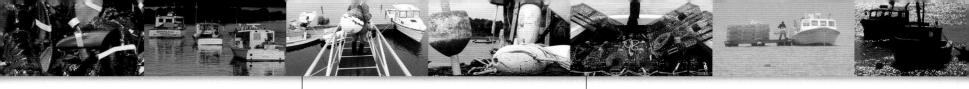

Lobsterman Rick Alley carries a mooring buoy to his wife Stefanie's boat on the tiny lobstering island of Islesford (pop. 60), 3 miles off Mount Desert Island. Stefanie is Islesford's only female lobster fisher with her own boat. "She's doing well and some days catches more than I do," says Alley, who admits to some friendly competition.

Photos by Stephen M. Katz

While Cole surveys the horizon, his owner Rick Alley empties the previous day's lobster catch into a running water tank and replaces the traps' old bait with fresh herring. On a good spring day, Alley lands 100 pounds of lobsters, which he sells to a handler for $3.60 a pound. Maine lobstermen catch 90 percent of the U.S. lobster supply.

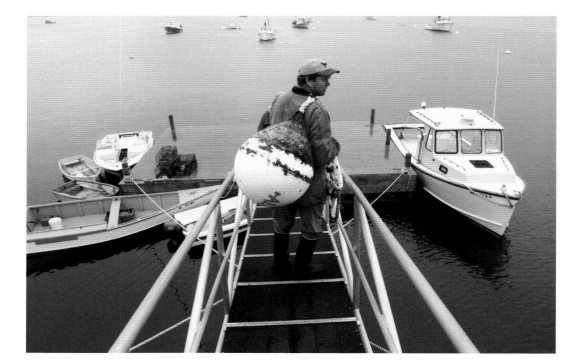

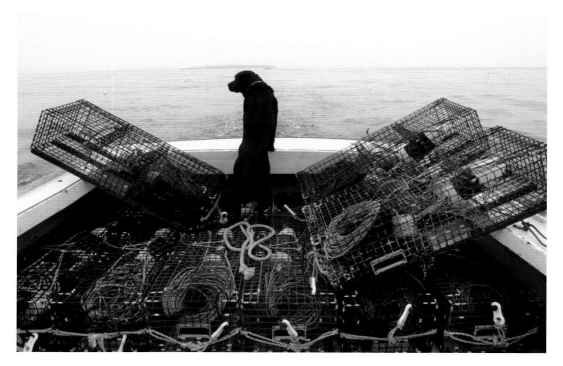

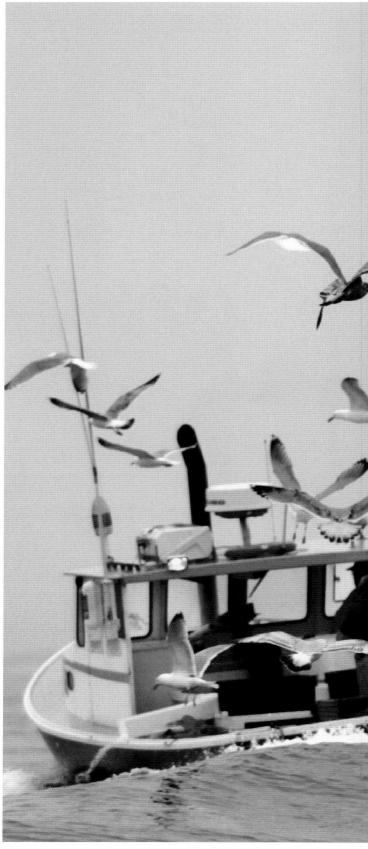

ISLESFORD

Followed by a flock of seagulls swarming for discarded bait, Rick's son Jeremy, 24, and nephew Cory, 30, haul in traps. The cousins got their lobster licenses just in time. To prevent overfishing, aspiring Islesford lobstermen must now wait for license holders to retire before purchasing permission to fish a lobster zone.

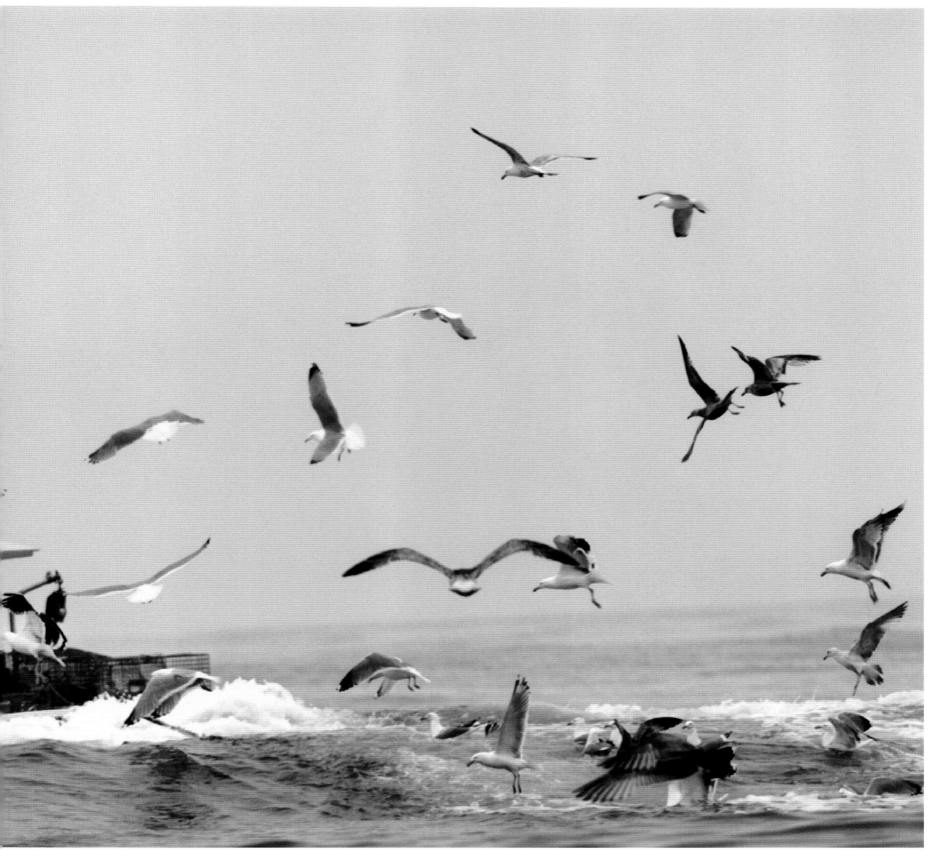

BOOTHBAY HARBOR

Longtime lobsterman Dave Norton measures his catch. According to state regulations, legally caught lobsters must measure no more than 5 inches from eye socket to beginning of tail and no less than 3.25 inches. Norton used to set 1,400 traps, but since 1998 there's been a 600-trap limit. "Makes it rough for guys starting out," he says.

Photos by Bridget Besaw Gorman, Aurora

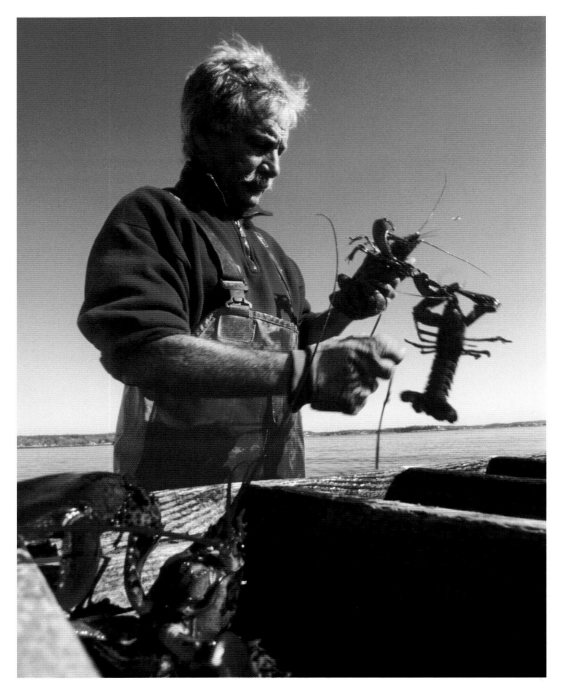

OAK ISLAND

Dave Blake, reflected in the windshield of his boat, and Thomas Harrington, behind the wheel, wait for the tide to go out so they can dig bloodworms on the Sheepscot River Estuary. When the mud shows and the boat beaches, they go to work until the tide comes in. "Using a boat beats walking the mud flats," says Blake.

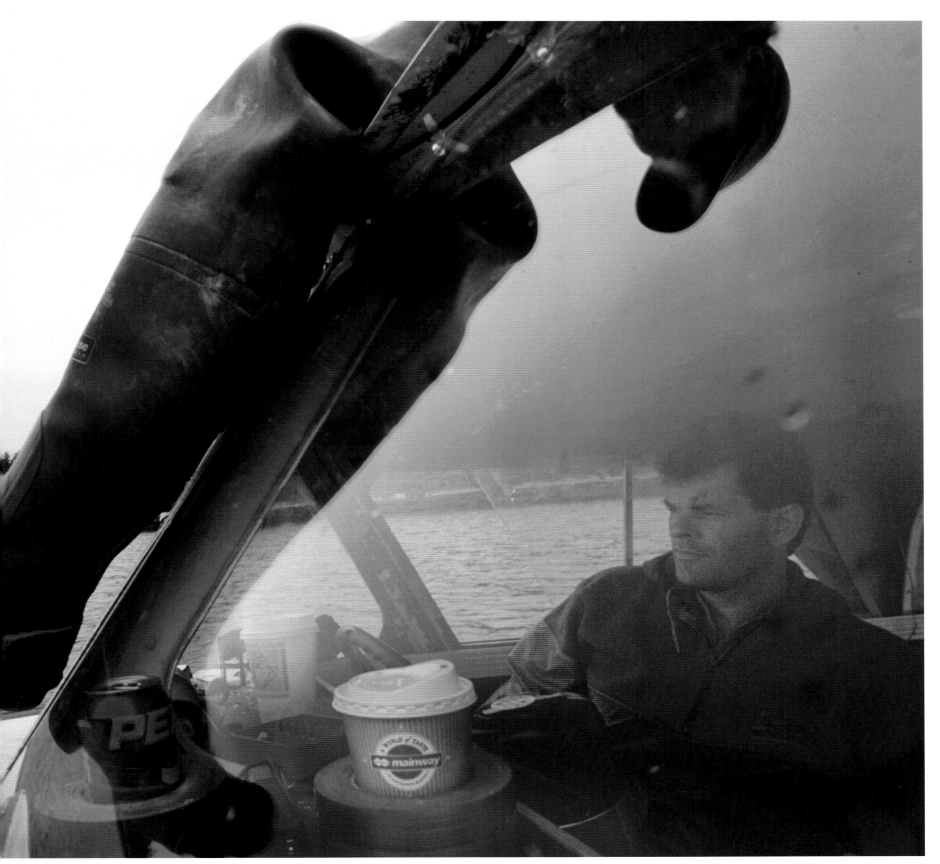

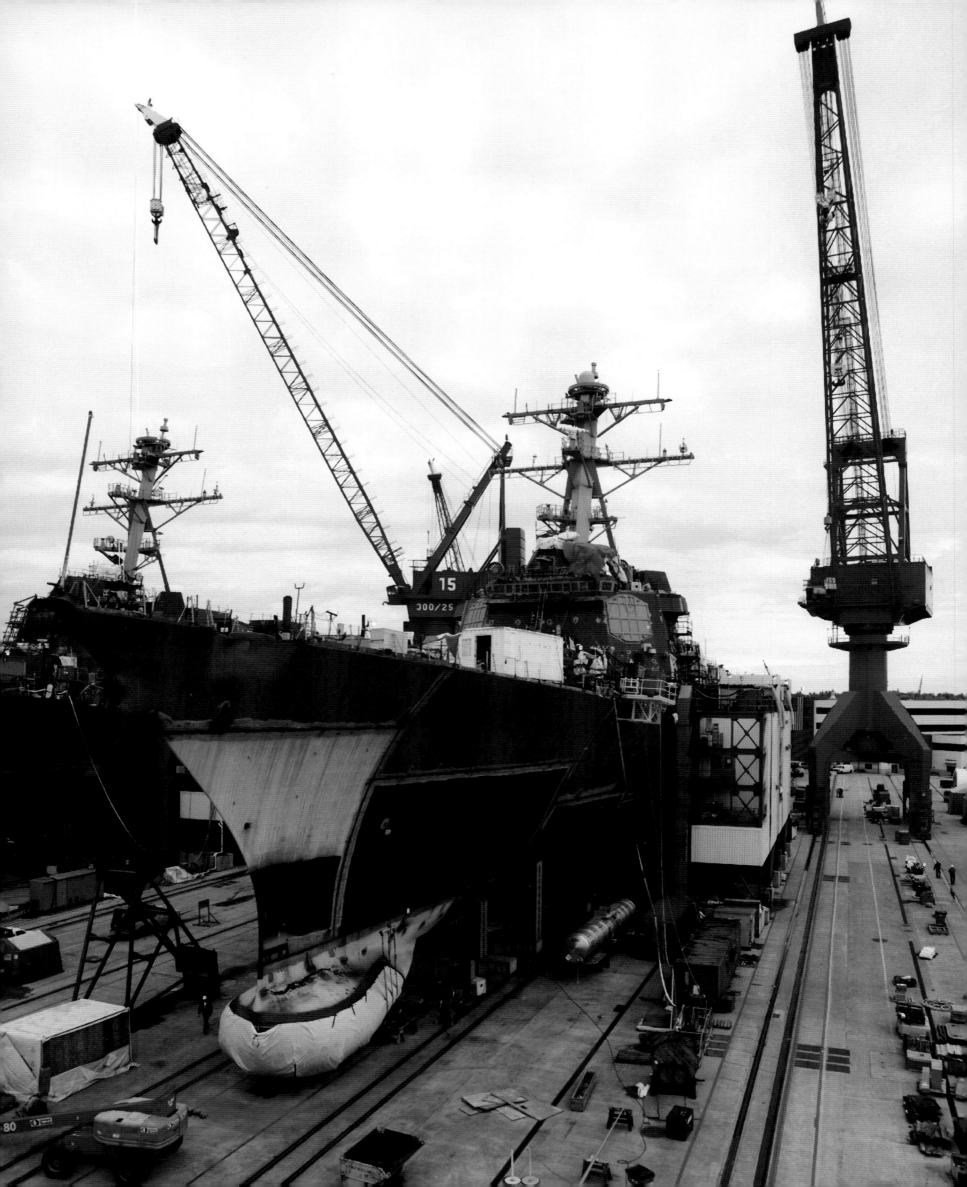

BATH

For nearly 120 years, Bath Iron Works has produced warships for the U.S. Navy. Under construction are two DDG 51 (Arleigh Burke) Class guided-missile destroyers. Equipped with AEGIS Weapon Systems, they're the world's most effective naval surface combatants. It takes more than four years to complete the $1 billion ships.
Photos by Jeffrey Stevensen

BATH

Shipbuilders unload a dish antenna, a key component of the AEGIS Weapon System's targeting radar. Manufactured by Lockheed Martin, the sophisticated weapon system is installed and tested at the shipyard.

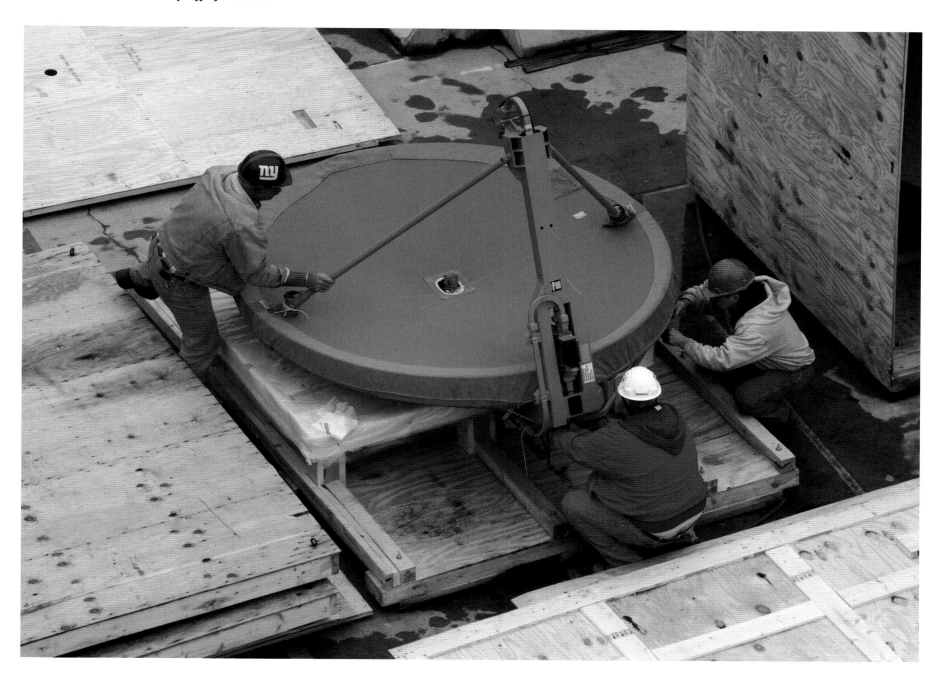

ROCKLAND

Jon Finger applies water-sealing caulk to the *J. & E. Riggin* built in 1927 as an oyster dredger, the 120-foot schooner had been reconfigured as a passenger vessel by the time Finger purchased it in 1997. He uses the boat to take customers on three- to six-day "gunkholing" trips, slipping into small inlets and coves along Maine's coast every summer.
Photo by Alison Langley

ROCKLAND

Mitchell Gagne, 12, puts the finishing touches on a 7.5-foot sailboat at Rockland's Apprenticeshop. Based on the same "experiential education" concept as Outward Bound, the school offers boat-building courses and sailing lessons. Mitchell convinced his parents to buy the boat so he could continue to practice sailing.
Photo by Alison Langley

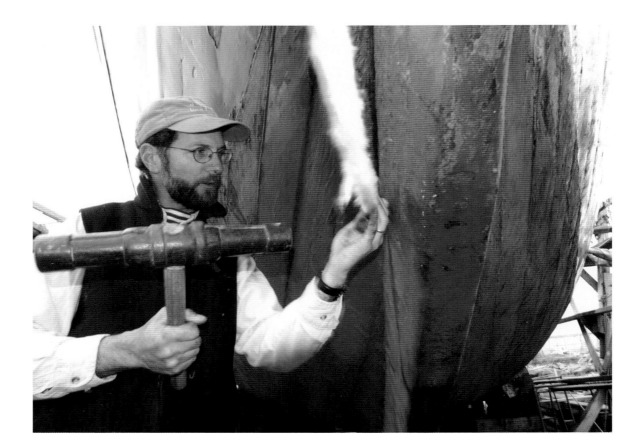

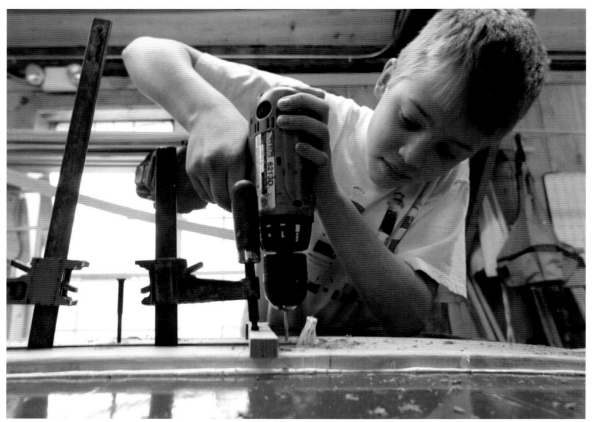

ROCKLAND

Travis Fuller and Jessup Coffin restore a 22-foot-long Prudence Sloop, a cruising sailboat, in the Apprenticeshop workroom. The school's two-year apprenticeship teaches all stages of traditional wooden boatbuilding—from materials and technical skills to project management. Fuller, from Arizona, is in the first year of the program. Coffin, from Oregon, graduates soon and hopes to crew on a tall ship.

Photo by Alison Langley

OLD TOWN

Inspired by the birchbark canoes of the Penobscot Indians, A.E. Wickett and George Gray started Old Town Canoe Company in 1903. The firm has crafted more than a million boats, making it the largest canoe maker in the world. In the workroom, John Sibley applies varnish to a Western Red Cedar inner shell, the sturdy core for many of the firm's boats.

Photo by José Azel, Aurora

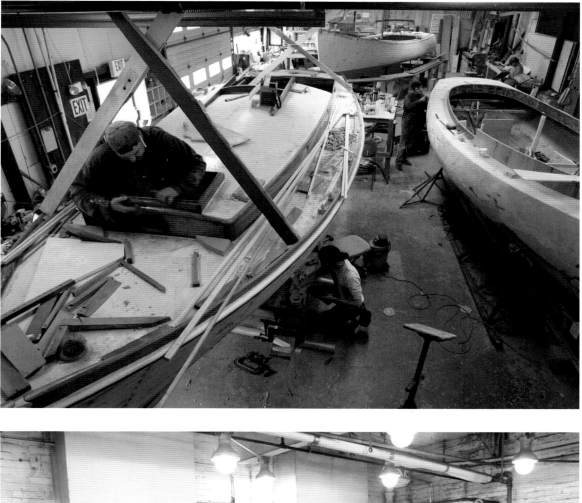

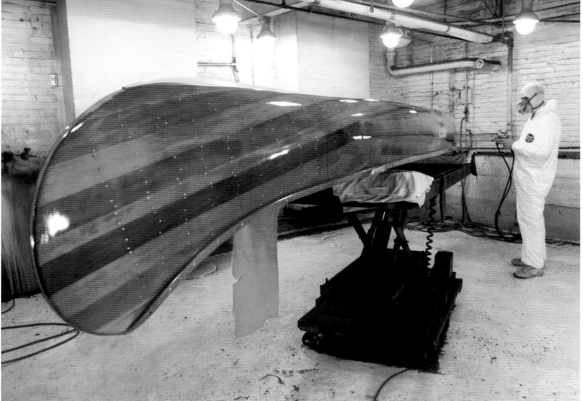

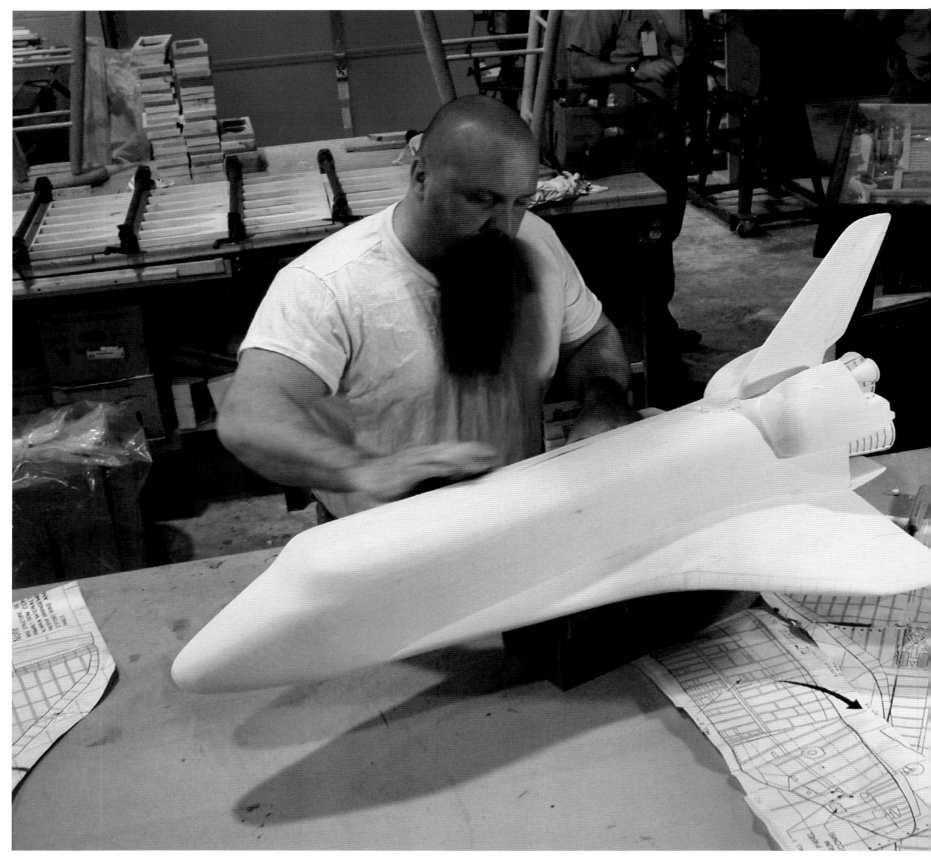

WARREN
Maine State Prison's 50-year-old Industries Program trains inmates in its woodworking, upholstery, and finishing shops. Woodworkers, like Rod Whitten, take safety training and must pass a written test. Whitten's Challenger Space Shuttle replica was commissioned by Framingham State College in Massachusetts for a memorial honoring alumna Christa McAuliffe, the first civilian aboard a space flight.
Photos by Jim Daniels

WARREN

Like all inmates in the Industries Program, Richard Kimball makes between $1.00 and $2.50 an hour, and his yearly salary cannot exceed $5,000. It's a privilege to be accepted into the program and the waiting list is long. Not surprising since the majority of the nearly 160 participants are serving long sentences, many of them for murder.

WARREN

The items produced in this woodworking shop, including these small fishermen carved by inmate Richard Steeves, are sold at the Maine State Prison Showroom in nearby Thomaston. More than 500 items are in stock, everything from hand toys to hutches.

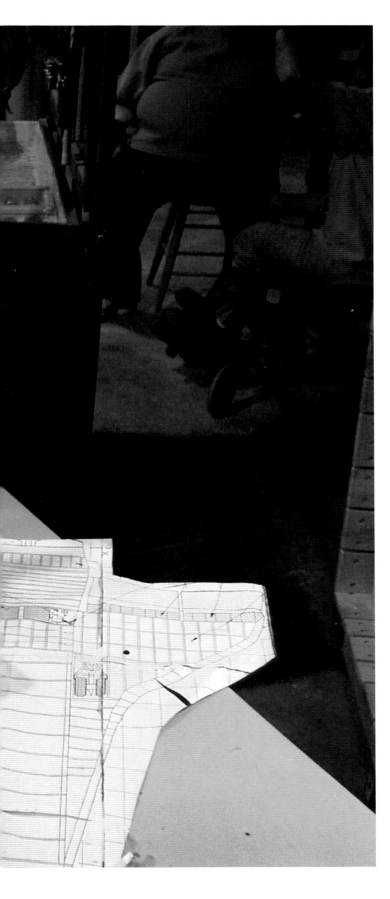

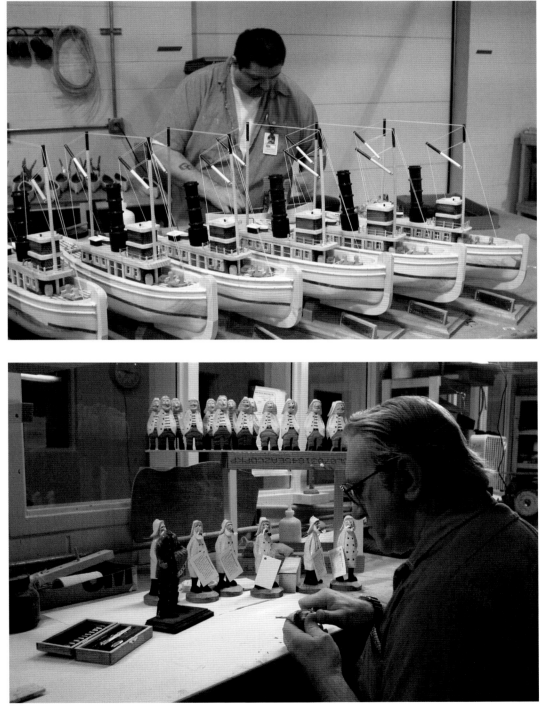

SOMERVILLE
In the logging business, time is money. When equipment goes down, a contractor is immediately brought on-site to repair it. In this case, it's the bum leg of a tractor trailer used to haul wood chips to the mill.
Photo by Chris Pinchbeck,
Pinchbeck Photography

FREEPORT

Digging bloodworms is the main livelihood for some Down Easters like Sonny Newton, who dumps a handful of 6-inch worms into a bucket of salt water. At 20 cents per worm, a good digger can make $200 on a tide. In 2002, the bloodworm harvest totaled $5.5 million.
Photos by Robert F. Bukaty

FREEPORT

Sonny Newton, 62, has been worming since he was 15 years old. After digging the morning tide for two and a half hours, he and his nephew Dale, 31, head home with about 350 worms each. "Not a good count," says Sonny. "Used to be better. They're overharvesting." Bloodworms are prized bait for sports fishermen.
Photo by Robert F. Bukaty

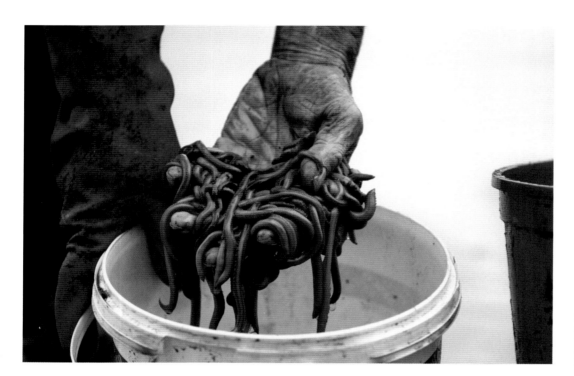

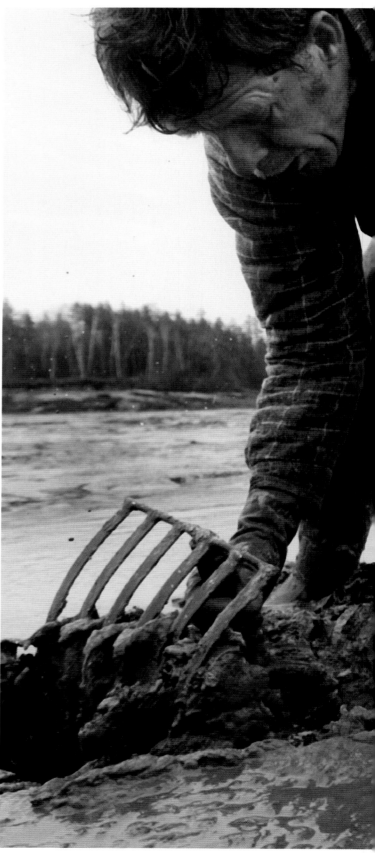

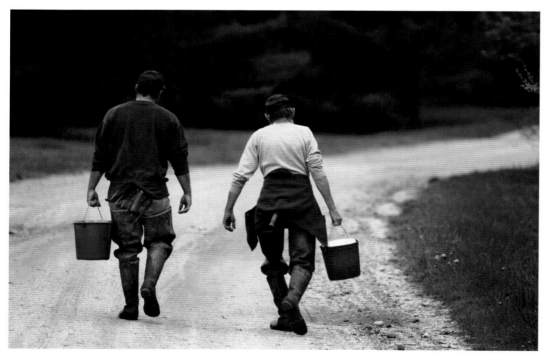

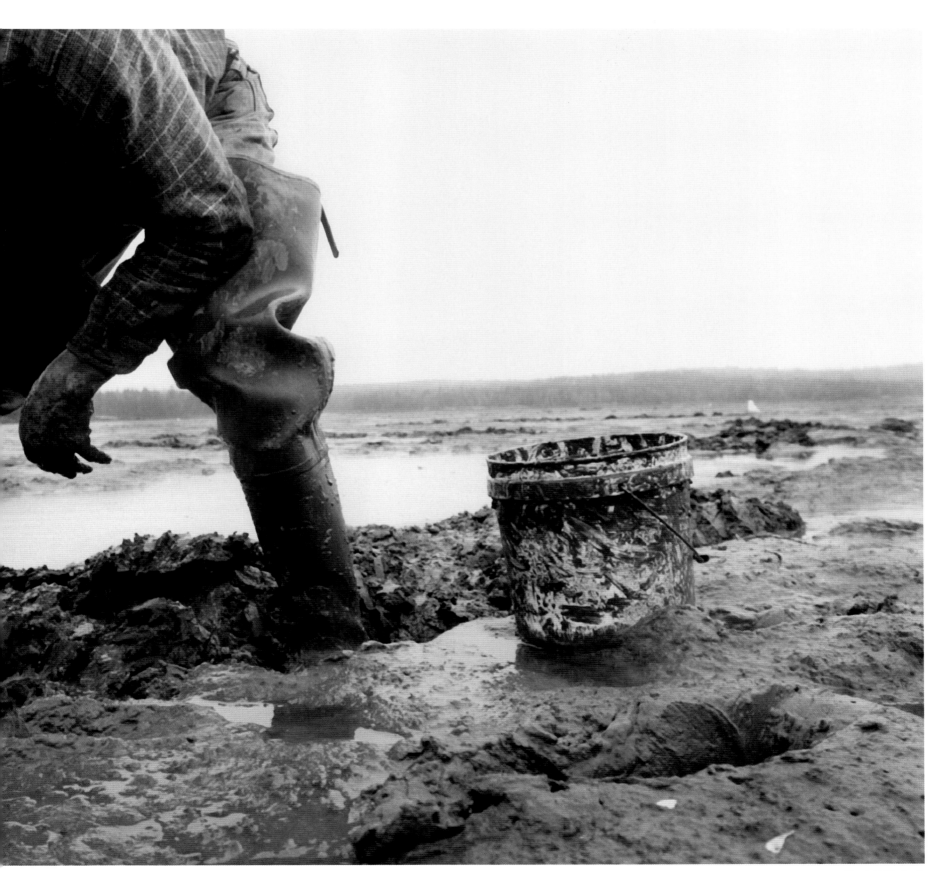

ADDISON

On the tidal flats of Addison, Obed Beal, 47, pulls mud with his special 9-inch hoe. It takes 8 to 12 scoops to find one bloodworm, which has four poisonous barbs at one end "that sting like a bee," Beal says. He's done the job full-time for 16 years.

Photo by Stephen M. Katz

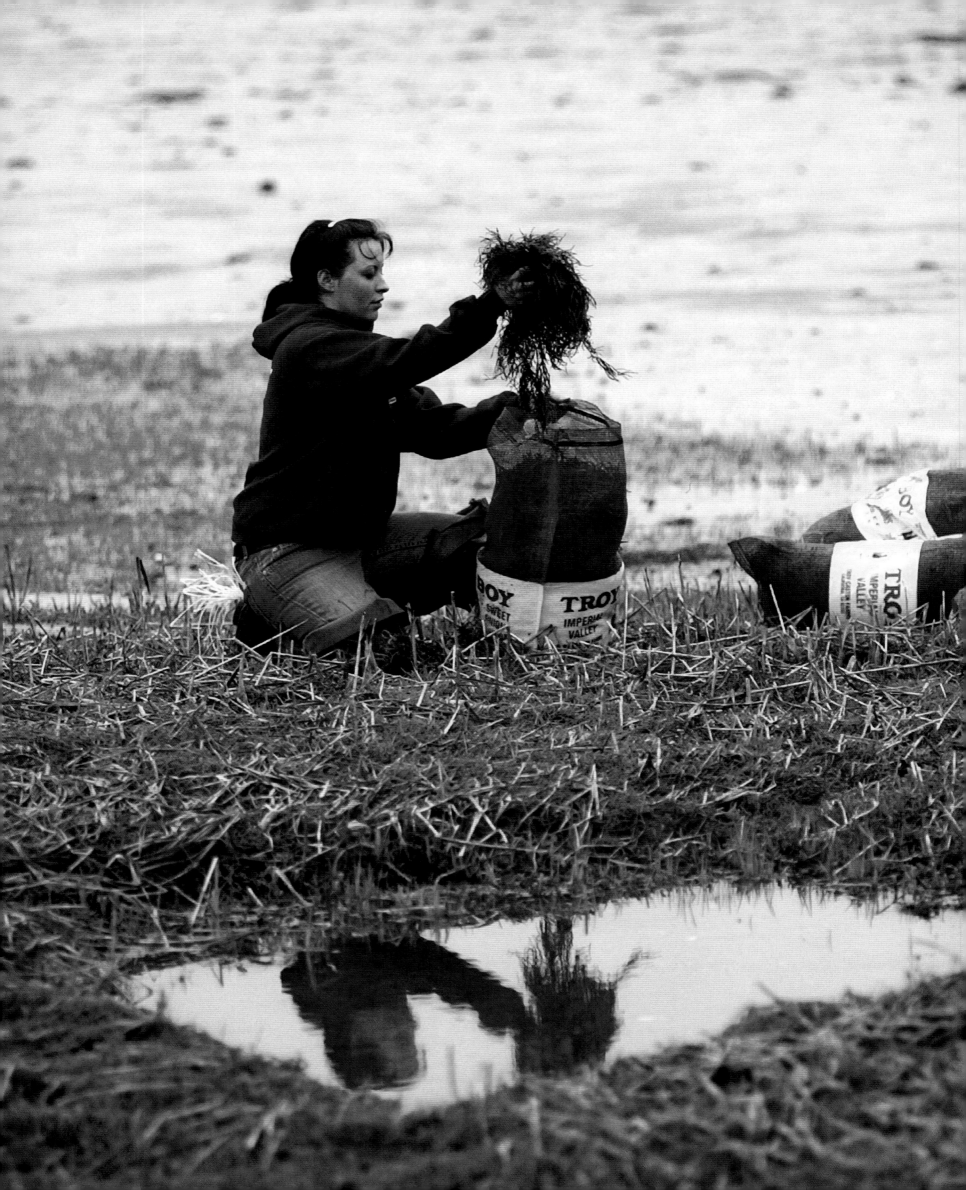

BIDDEFORD POOL

Nina Kellette tops off a 40-pound bag of seaweed. At low tide, she can fill 30 bags in about two hours—which she sells for $6 each to worm dealers, who use the seaweed to pack bloodworms for shipment to distributors worldwide. In the winter, when not harvesting the tidal flats, Kellette takes any part-time work she can find.
Photo by Shawn Patrick Ouellette

CUMBERLAND

Mussel beach: Just off Bangs Island, Aqua Farms owner Tollef Olson and his crew spend the day seeding a million mussels. Tiny mussels, called seeds, are fed by machine into 35-foot-long sleeves, then hung by ropes from floating rafts in Casco Bay. Rope-grown mussels, which yield the most meat, were unheard of in Maine five years ago.
Photo by Jim Daniels

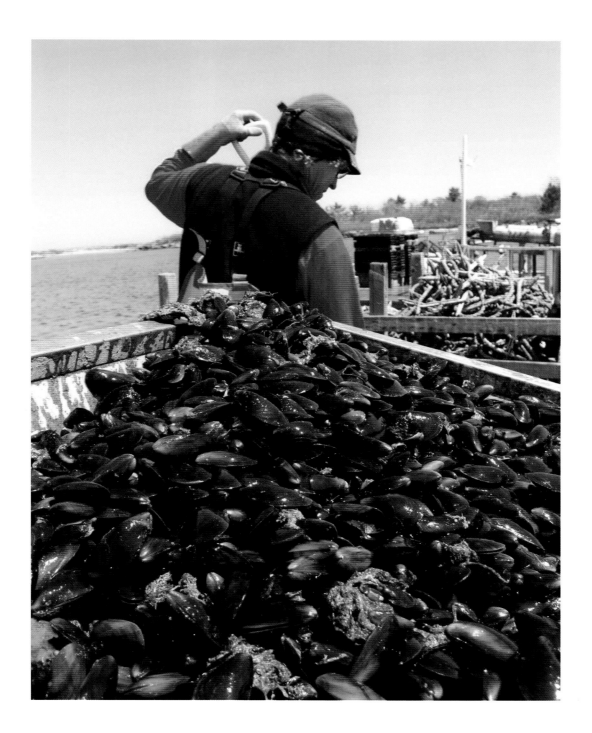

PISCATAQUIS COUNTY

In Township 10 Range 9, a 120-pound, four-year-old male black bear is tagged as part of Maine's long-term tracking program—established to monitor the health of its bear population in response to increased bear hunting. In addition to an ear tag, the animal receives a tattooed number on its upper lip

Photos by Kevin Bennett, Bangor Daily News

PISCATAQUIS COUNTY

Wildlife assistant Shannon Crowley records the statistics of a 73-pound male black bear, the smallest of the three types of North American bears. After being tranquilized and tagged, each bear is weighed and measured, and its vital statistics are taken. Wildlife biologists also fit the females with radio collars so they can track and count cubs and yearlings.

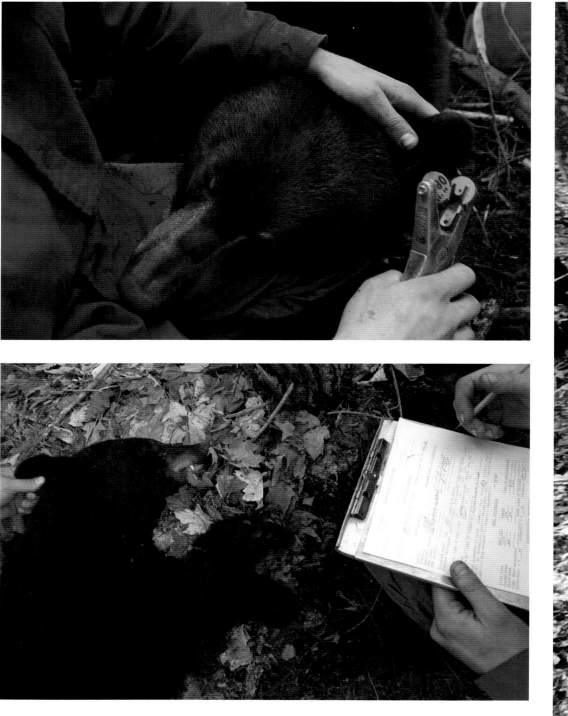

PISCATAQUIS COUNTY
Wildlife biologist Randy Cross carries a sedated male black bear to a recovery area, downhill from the snare. Tranquilizers wear off in about 45 minutes. "There are more bears on the ground in Maine now than there have been in the past 30 years," says Cross.

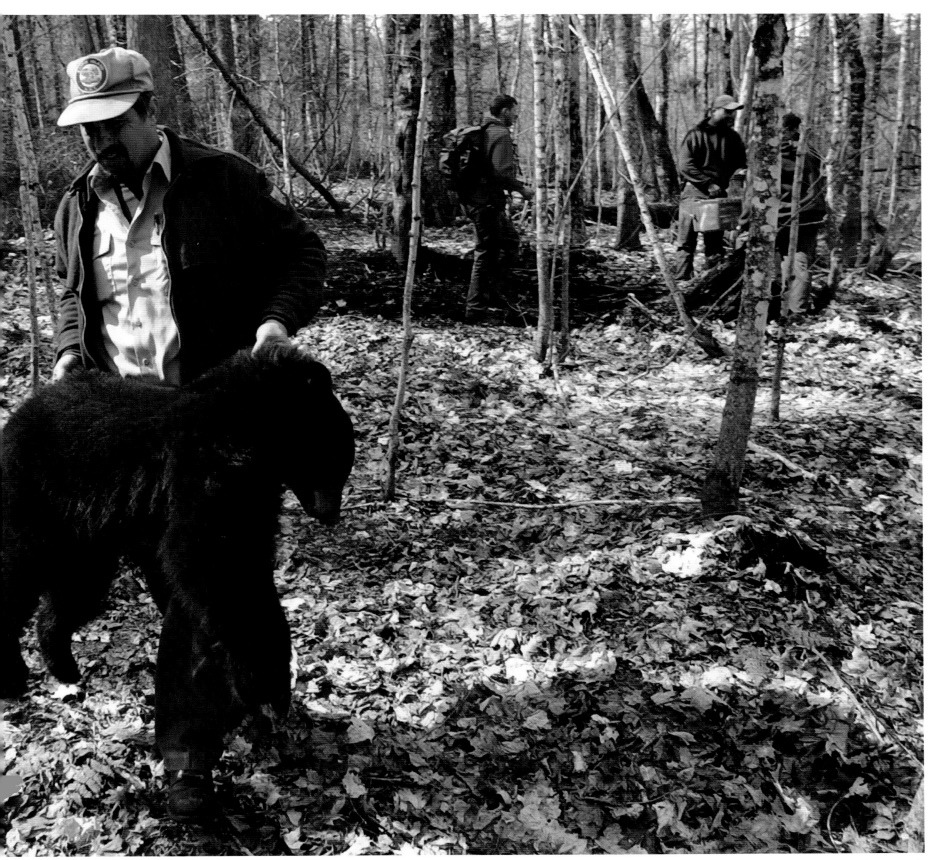

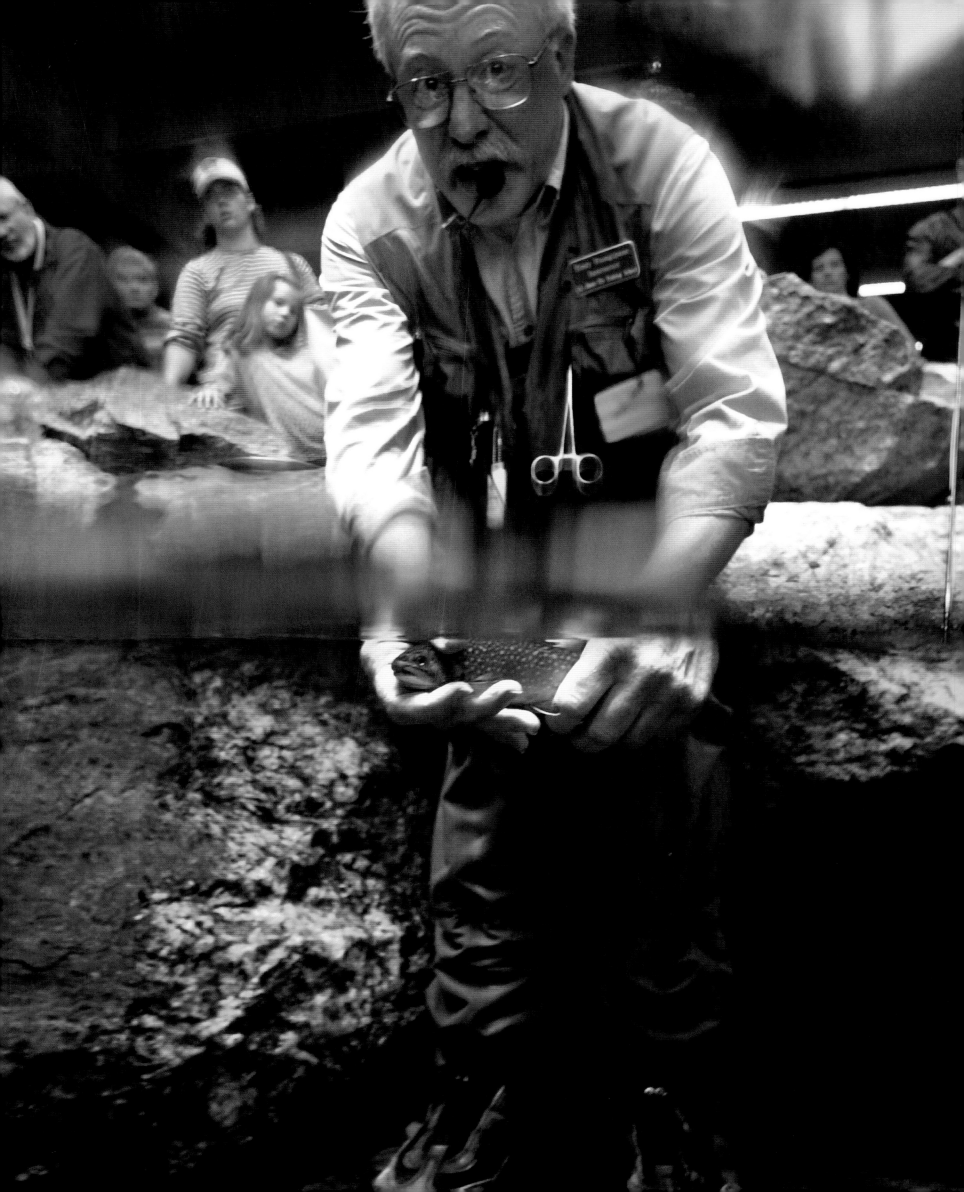

FREEPORT

Caught in the act: L.L. Bean employee Tony Frangipane demonstrates catching and releasing a brook trout in the fish pond at the Main Street store. The best method is to hold the trout gently underwater. "But the key is using a barbless hook," says Frangipane.

Photos by Robert F. Bukaty

CAPE ELIZABETH

Back in the 'hood: When Marine Animal Lifeline rescued this year-old hooded seal, she was a malnourished 70 pounds. After a month of care and regular meals of herring and smelt, she weighed in at 114 pounds. She also has an attitude problem. "No other seal wants to be in the exercise pool with her," says animal care technician Lynda Doughty.

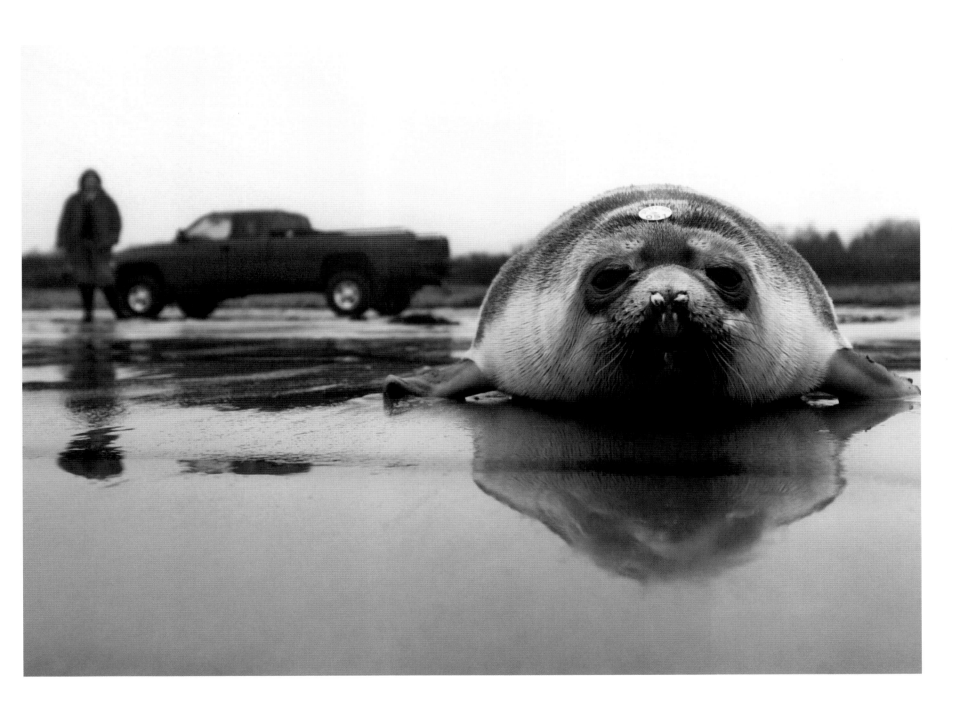

SOUTH PORTLAND

Wearing a "bunny suit," Jean Spaulding removes a rack of silicon wafers from a sputtering machine, which lays a thin metallic coating on the etched circuits, at Fairchild Semiconductor. The work is done in a clean room where the air is filtered and workers must wear body suits to reduce contamination. The yellow lighting is too complicated to explain.

Photos by Jeffrey Stevensen

SOUTH PORTLAND

Fairchild Semiconductor is often credited as launching the second industrial revolution with the invention of the integrated circuit in Silicon Valley in the 1950s. In 1962, the firm opened a plant in South Portland, in large part because Maine was a favorite spot of Fairchild cofounder Robert Noyce. With about 1,200 employees, Fairchild is one of the five largest employers in the area.

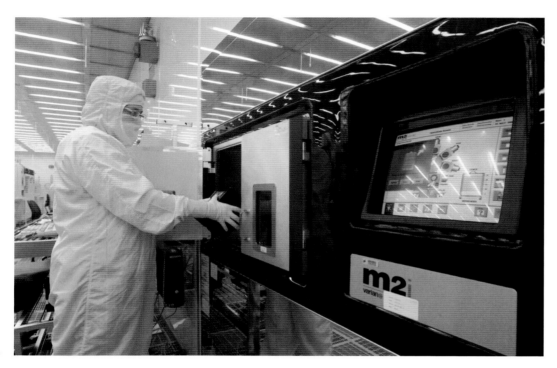

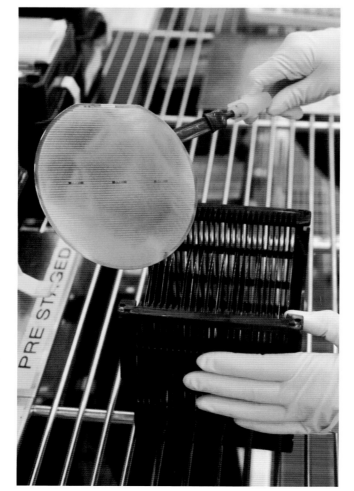

BOOTHBAY HARBOR
The Provasoli-Guillard National Center for Culture of Marine Phytoplankton is the equivalent of a national library for marine algae. Located at the Bigelow Laboratory for Ocean Sciences, the center's huge collection of culture samples is available to scientific, government, and business interests for the study of related subjects such as red tides and omega-3 fatty acids.
Photo by Bridget Besaw Gorman, Aurora

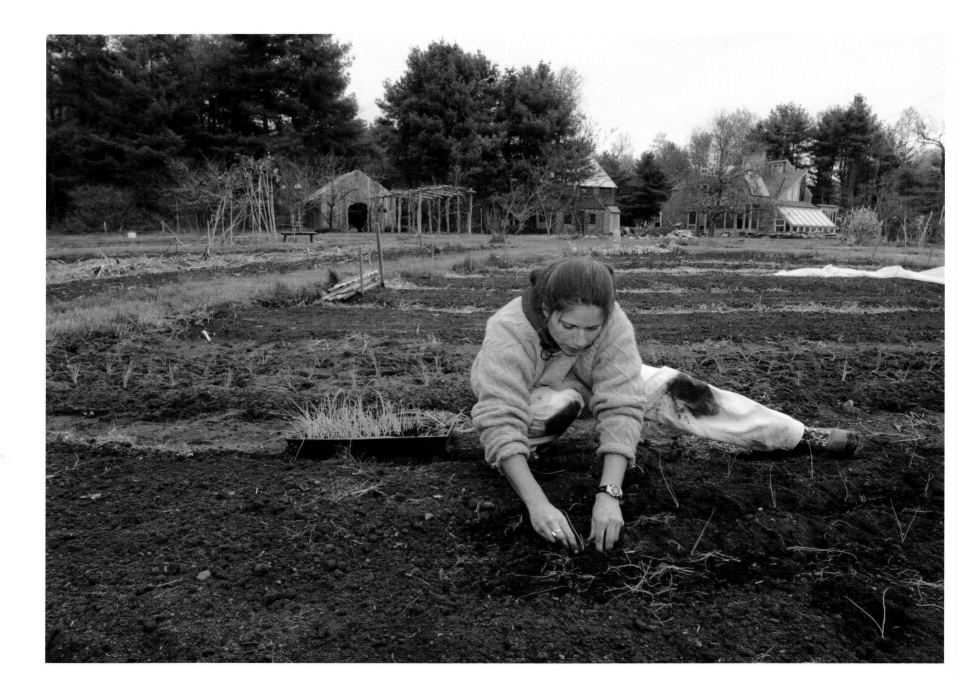

ARUNDEL

In 2001, Jacqueline Devillegas cofounded the Neverdun Farm Community Supported Agriculture project, which sells organic produce to local residents at an equal or lower cost than they would pay at supermarkets. For $320 the cooperative's 25 members can come to the farm during the five-month growing season and pick their own fruits, vegetables, and herbs.

Photos by Gregory Rec

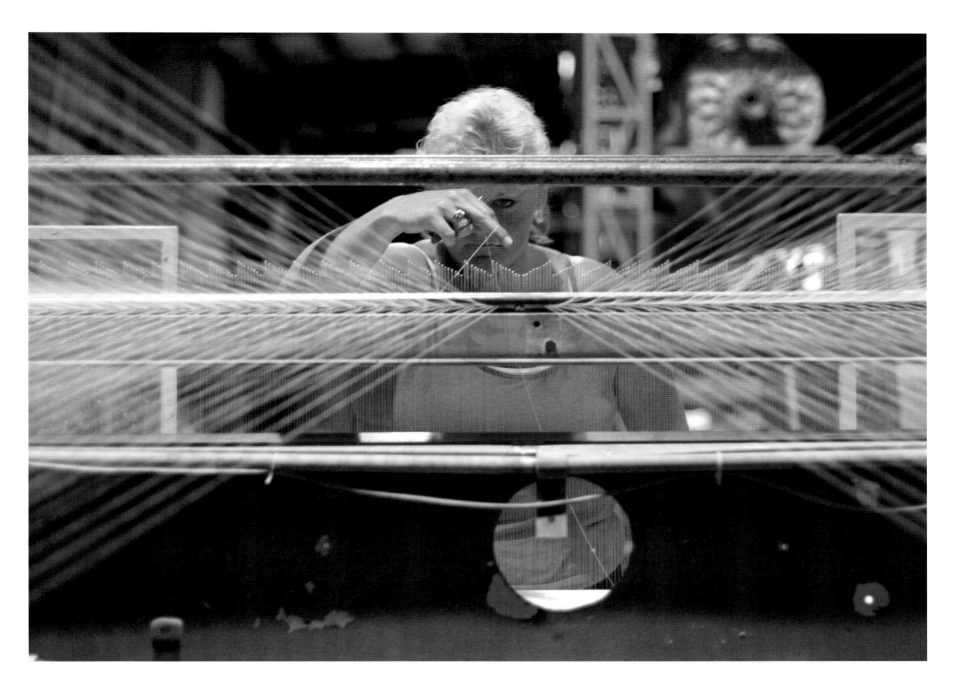

BIDDEFORD

At the Biddeford Blankets factory, Maud Lund threads a warper machine, an early step in the production of electric blankets. Fifty years ago, textile mills supplied 90 percent of the jobs in Biddeford. By May of 2003, it was down to less than 25 percent of the workforce, after many mills moved overseas seeking cheaper labor. Biddeford Blankets, owned by a Taiwanese company, finally shut down in November, 2003.

BOWDOIN

Mitch Mitchell is a jack of all trades—carpenter, maple syrup distiller, and organic farmer. A ninth-generation Mainer, Mitchell may also be the last. One of his children runs a recording studio in San Francisco, another teaches English in Japan, and the third is an architect moving to Ireland. "It's okay," Mitchell says, "as long as they're doing what they love."

Photo by James Marshall, Corbis

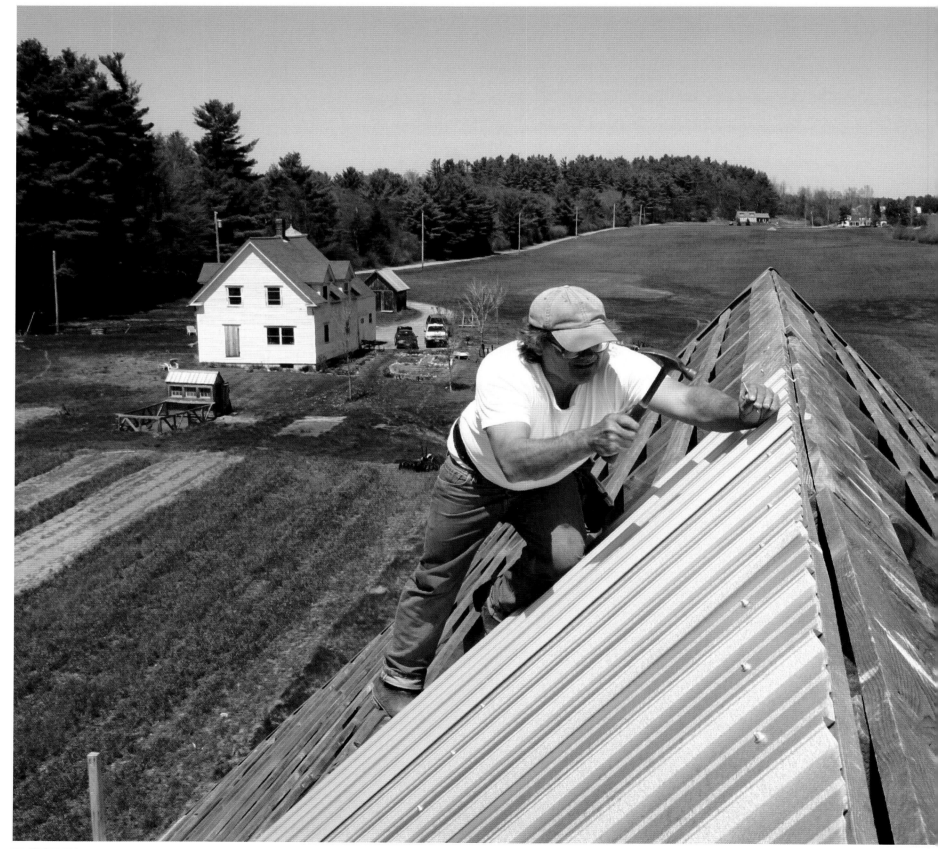

UNION

Commercial beekeeper Ellen Kiley unloads hives so her bees can do their pollinating dance in the blueberry barrens around Union. Kiley gets to work at dawn, when the subdued light and cooler temperatures make the bees less cranky.

Photo by Michele Stapleton

SACO

The crew at Funtown Splashtown U.S.A. installs a 600-pound steel and fiberglass head onto the new Pirate's Paradise water slide. The crew includes (left to right) Peter Hodgdon, Tommy Hart, Cory Hutchinson, (foreground), and Ray LaRose.

Photo by Cy Jariz Cyr

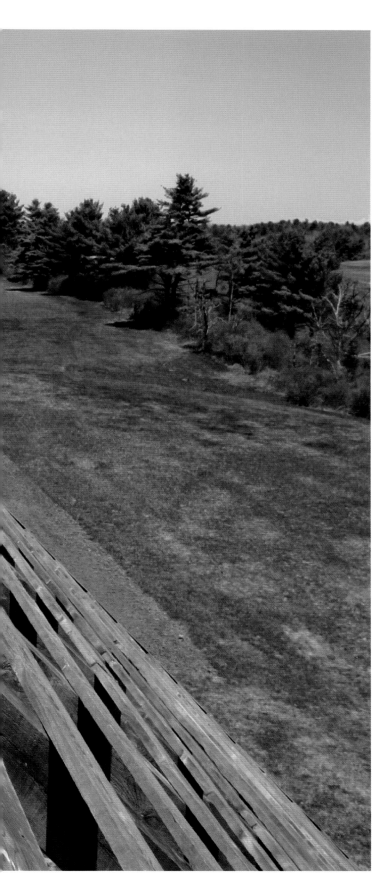

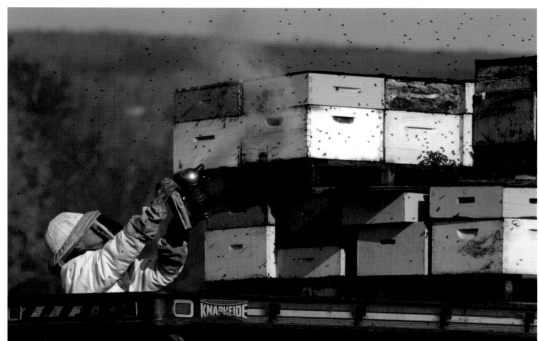

SOMERVILLE

Onsite with Freedom Timber Products, Tim Manning cuts up logs destined for the lumber mill. Behind him, Randy Bennett operates the full tree chipper. A hydraulic clamshell picks up the relatively slender stalks of felled whole trees and guides them directly into the chipper.

Photos by Chris Pinchbeck,
Pinchbeck Photography

SOMERVILLE

Logging began in Maine in the early 1600s. Two hundred years later, the state was home to the world's largest lumber shipping port, Bangor. Continuing the tradition is Rick Martin, owner of Freedom Timber Products. Operating a harvester, Martin is able to cut down a tree and put it in a pile without getting so much as a splinter.

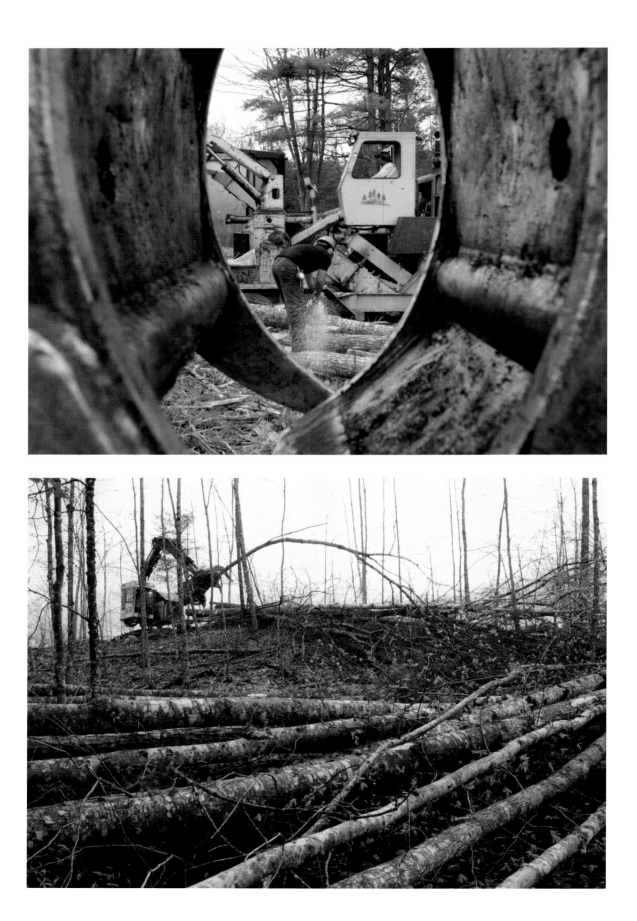

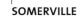

SOMERVILLE
Logger Donald York's steel-tipped boots weather untold chainsaw dings and ensure a full set of toes.

SOMERVILLE
The logging business is not for the tender. Chainsaw operator Tim Manning's left hand is a veritable battlefield of missing fingertips, cuts, calluses, and scars.

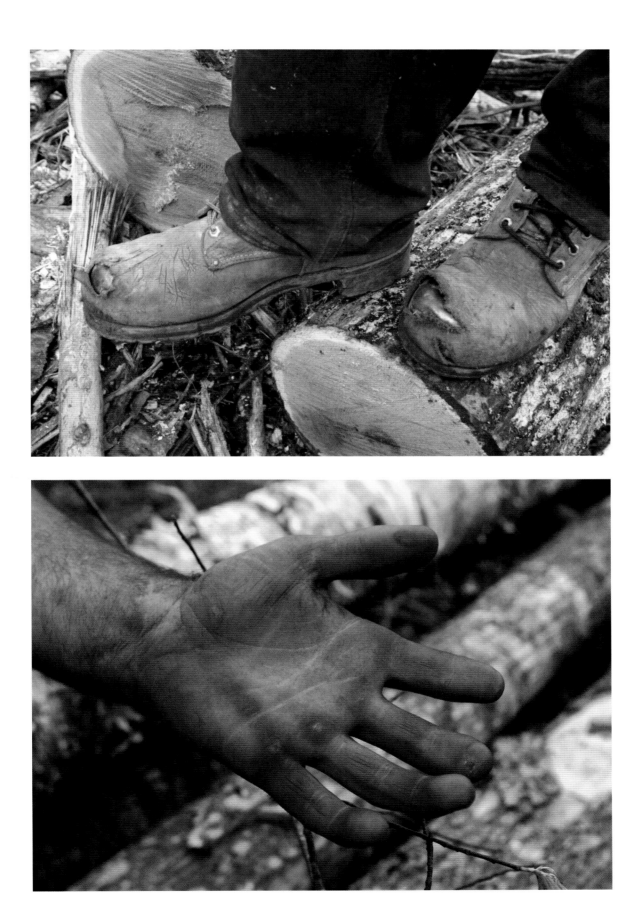

COLUMBIA
Before blueberry fields flower, Franklyn Kopp, a pilot with Maine Helicopter, dusts them to prevent blight, a fungus disease. Antifungal spraying is common, but the introduction of better management practices in the 1980s has reduced insecticide use by about 70 percent. Maine produces a quarter of North America's blueberries.
Photo by Michele Stapleton

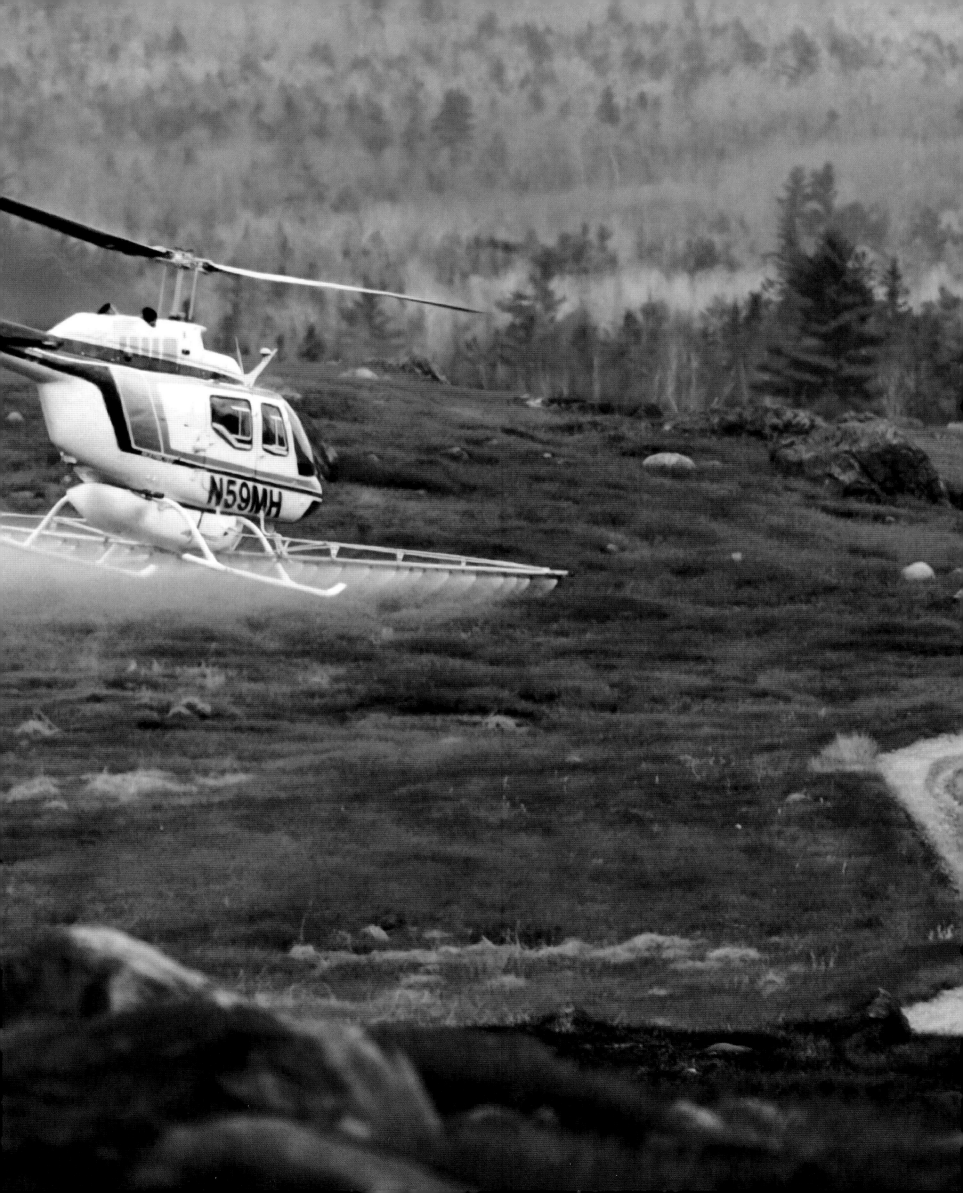

COLUMBIA

A flame thrower sprays fuel oil to burn off
old blueberry brambles and clear the fields for
new growth. Fire lines and a water wagon insure
that the fires stay under control. Many growers,
however, are beginning to switch to mowing the
fields. Burning costs between $150 and $200 an
acre; mowing is one-third the price.
Photo by Michele Stapleton

DOVER

At G & S Tree Farms, one of a half-dozen
Christmas tree farms around Dover, a worker
sprays insecticide on a stand of balsam fir
trees. Each November, G & S cuts and sells
35,000 trees.
Photo by Stephen M. Katz

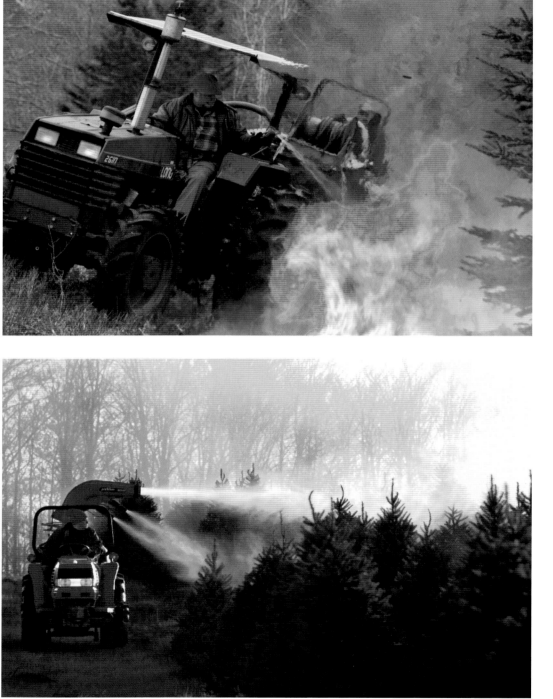

COLUMBIA
Maine has 60,000 acres of wild blueberries.
About one-quarter is burned each year to rid
the barrens of fungus pathogens and fruit
worms. The practice was used by native
Americans prior to European colonization.
Photo by Stephen M. Katz

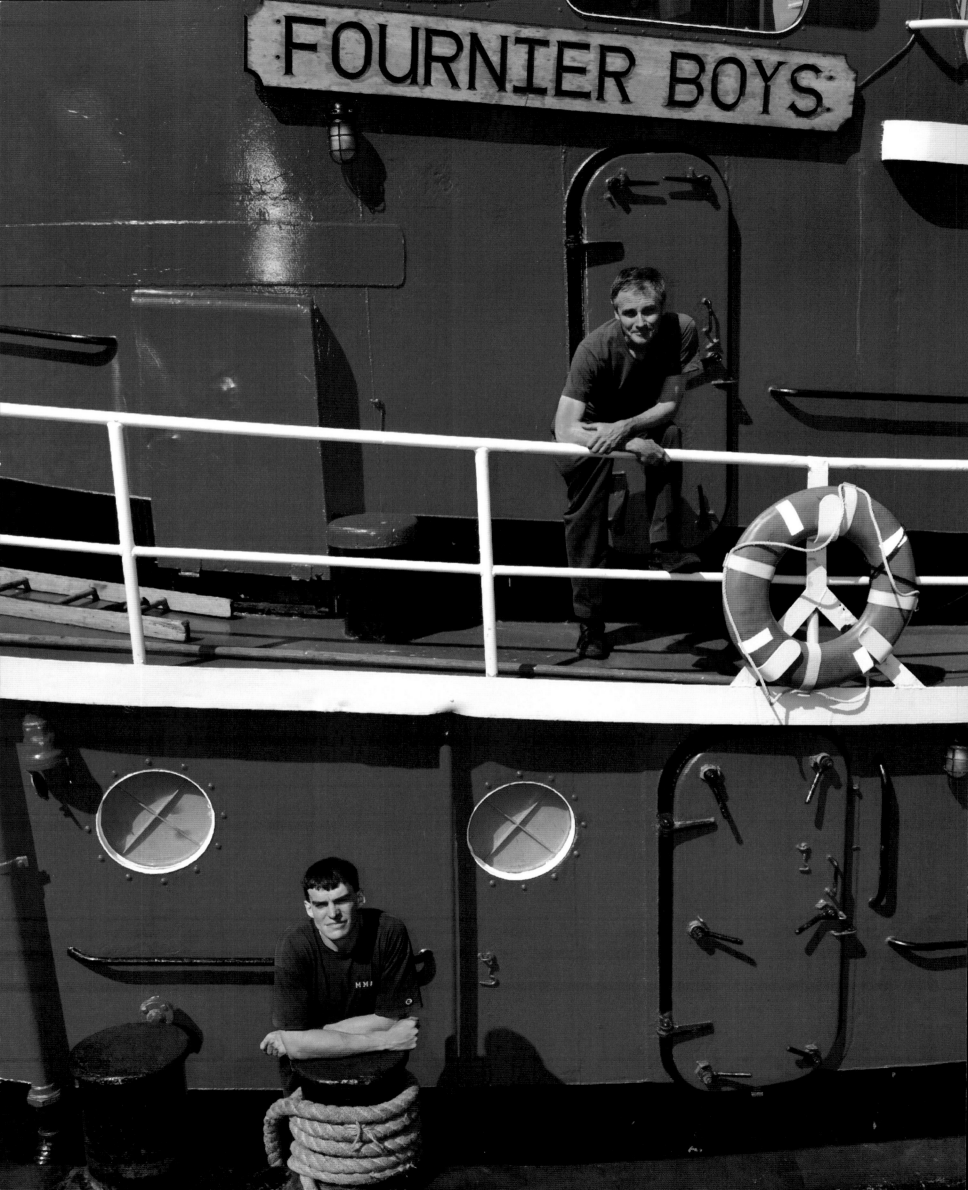

PORTLAND HARBOR

Captain Bob Rand (top) and engineer Ed Holland of the Portland Tugboat Company just docked their tug *Fournier Boys*. The 100-foot, 4,200-horsepower workhorse spends most days escorting three oil tankers in and out of Casco Bay. Portland Harbor's six oil terminals handle refined products as well as crude oil.

Photos by Jeffrey Stevensen

PORTLAND HARBOR

When an oil tanker like the *Torm Gertrud* enters Portland Harbor, the tug *Fournier Boys* delivers a docking master to the ship who then pilots the behemoth safely to its dock. The *Fournier Boys* works in tandem with its sister tugboat *Fournier Girls* to maneuver the tanker in shallow water.

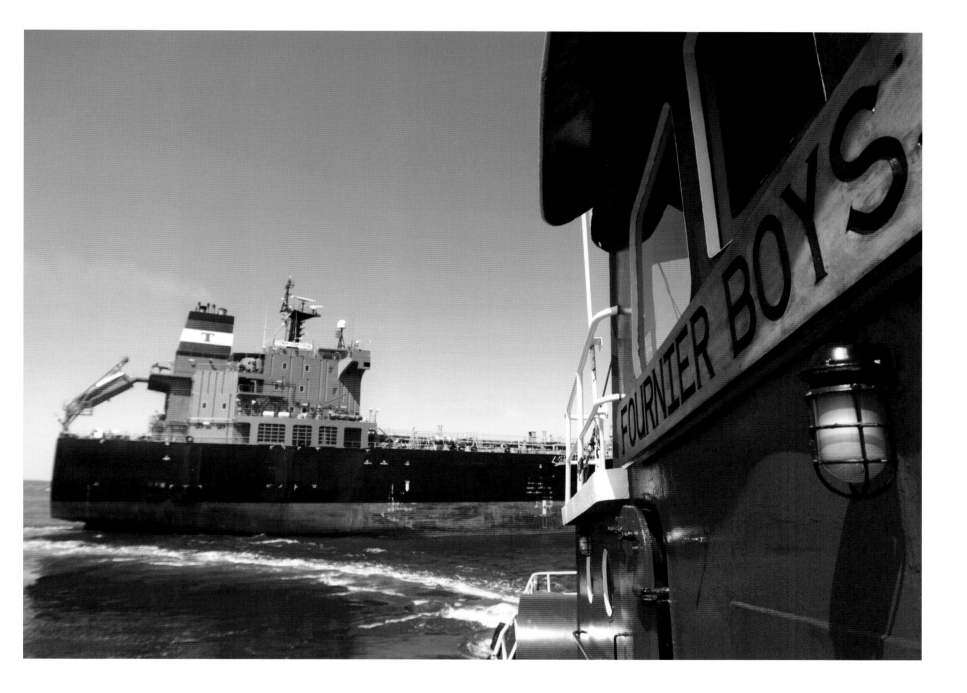

FALMOUTH

Housed in a turn-of-the-century building, the family-run Town Landing Market has been featured in national television commercials and L.L. Bean catalogs. At closing time, Kristina Gramlich brings in the lobsters from the front porch.

Photo by Jim Daniels

BAILEY ISLAND

Lifelong Bailey Island resident Robert Bernat, 37, knew since he was a child that he wanted to be a fisherman. He spends summers catching mackerel and herring with nylon net traps he sews himself. During winter he snorkels for sea urchins and oysters that he scrapes free with a rake and collects in a dive bag attached to his waist.

Photo by James Marshall, Corbis

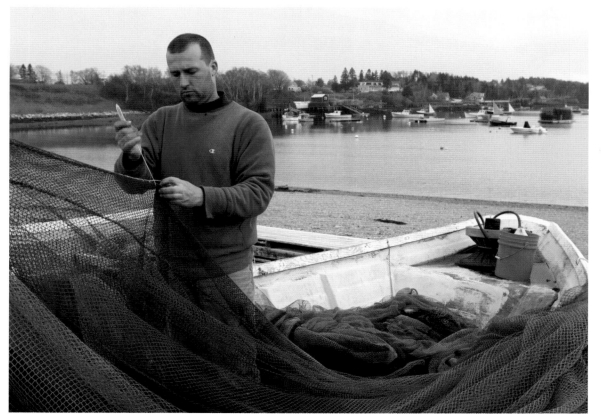

DOVER-FOXCROFT
Three years ago, retired public works technician Albert Sands was hired by the town manager to record the name of everyone buried in 11 local cemeteries. The 29,000 names Sands has collected so far (several belonging to childhood friends) will eventually be entered into a computer program to aid the living with genealogical research.
Photo by Stephen M. Katz

OGUNQUIT
A game of solitaire occupies Matt Ouellette, while Ryan Lavertu offers advice. The two, along with apron-wearing Lincoln Marston, are part of the off-season crew at Barnacle Billy's on Perkins Cove.
Photo by Thatcher Hullerman Cook,
Thatcher Cook Photography

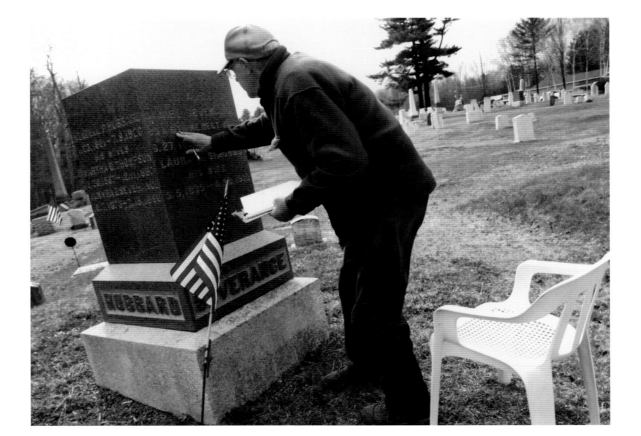

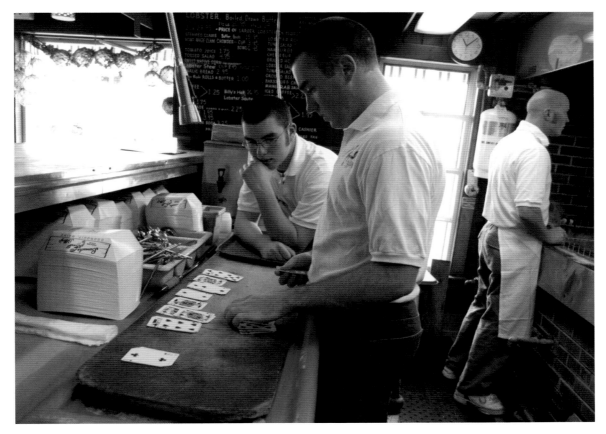

CARIBOU
Two out, bottom of the ninth, bases loaded.
Fourteen-year-olds Justin Bouchard (swinging for the fences) and Jordan Haines
(throwing the heat) play in their own field
of dreams.
Photo by Kevin Bennett, Bangor Daily News

PORTLAND

When the Double-A Portland Sea Dogs became a Boston Red Sox affiliate in 2002, the team decided to pay homage to that team's Fenway Park. Hadlock Field's "Green Monster"—complete with a Citgo sign—is just as high (37 feet) but not as long as the original.

Photo by Suzy Preston

PORTLAND

In addition to his duties as assistant general manager and director of business operations, Jim Heffley of the Portland Sea Dogs is chief lightbulb changer. He also helps devise between-innings activities for fans, such as a rubber lobster toss and a duct tape fashion show.

Photo by Robert F. Bukaty

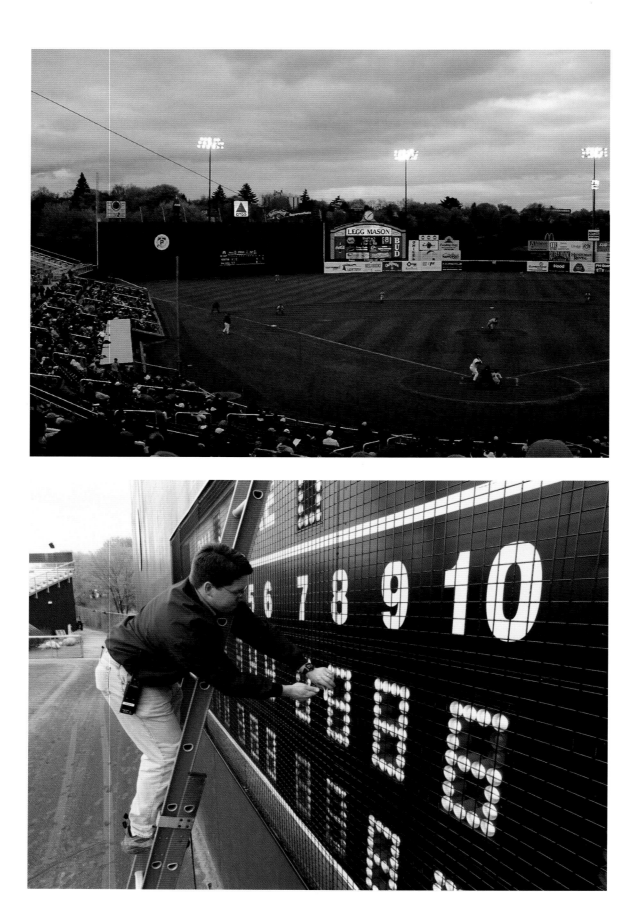

PORTLAND

Die-hard Sea Dogs fans Sam and Anna Boothby weather the rain and 30-something-degree temperature at Hadlock Field. Anna, a lifelong baseball fan, turned Sam on to the game. Originally, the retired high school math teacher kept score to stay interested. "Now he's a fanatic," she says. "He even keeps score at high school games."

Photo by Robert F. Bukaty

PORTLAND

Baseball is a game, like cards, but it's also a business. Outfielder Justin Headley and infielder Raul Nieves know that if they make the "bigs," their salaries will increase substantially. Major leaguers earn a minimum of $300,000 a year while Sea Dogs players make between $6,000 and $8,000.

Photo by Robert F. Bukaty

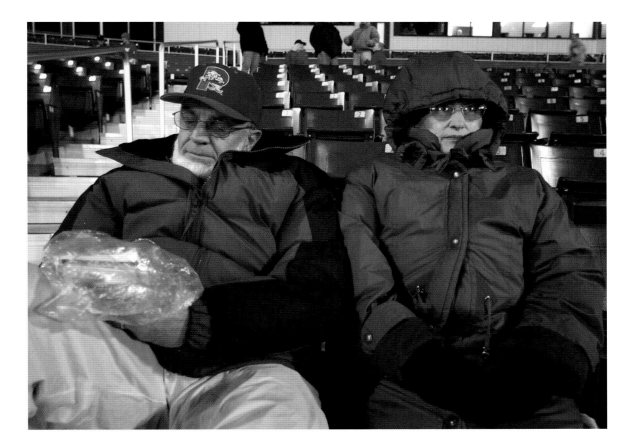

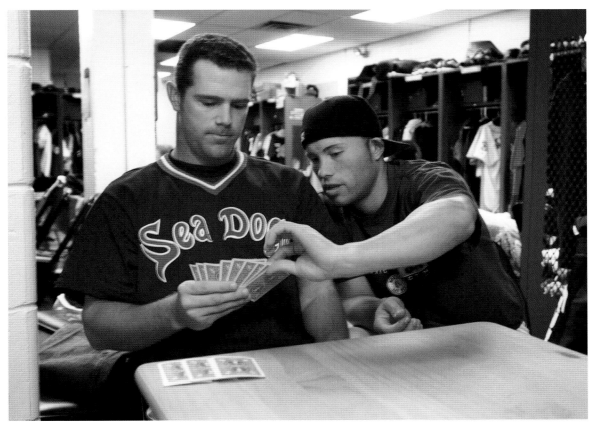

SEQUIN ISLAND
Looking west from Sequin Island the view includes Muscungus Bay and kayakers exploring the island's precipitous shore. With its blue water, granite-rimmed bays and headlands, and hundreds of small coastal islands, Maine is a kayaker's dream—as long as the weather holds.
Photo by David McLain, Aurora

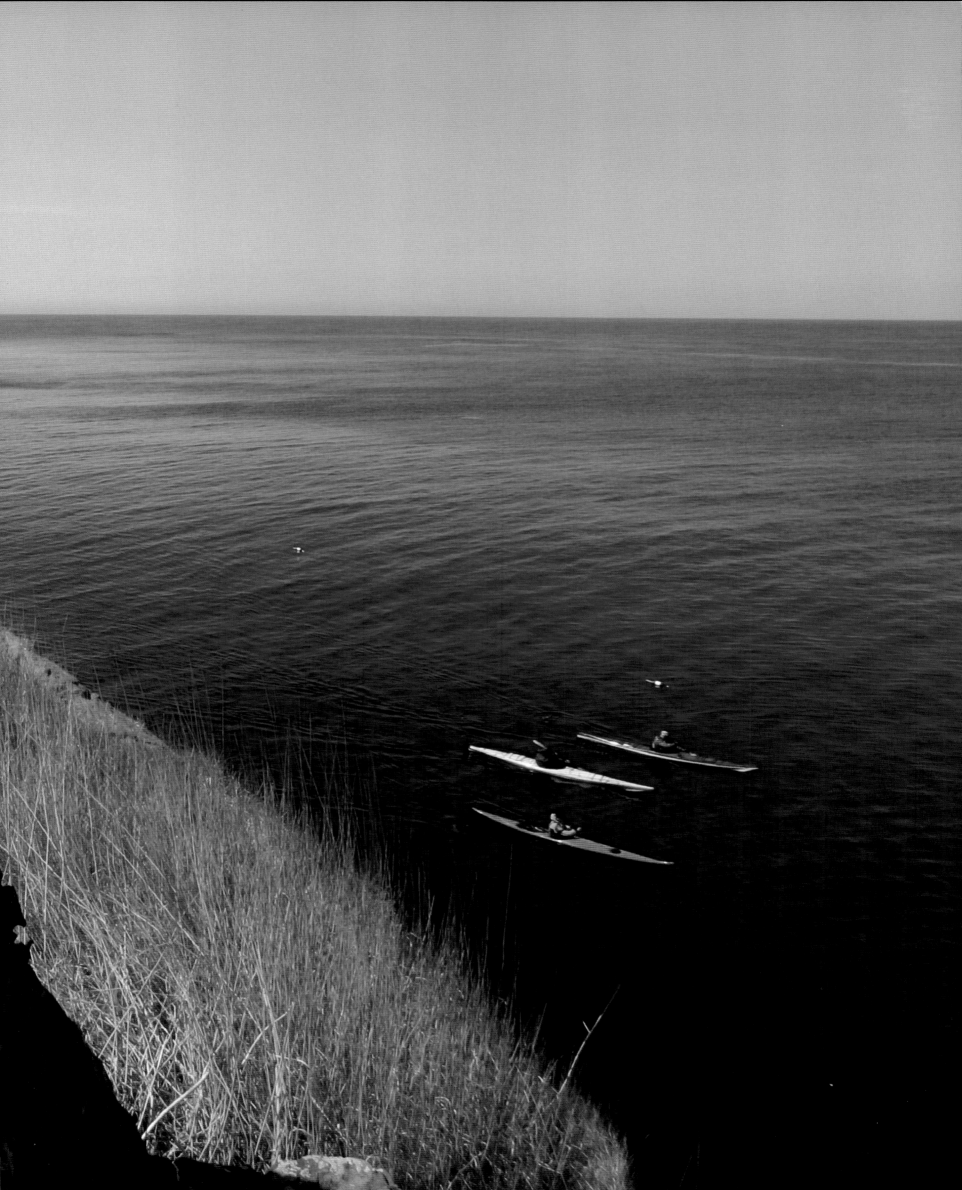

KENNEBEC RIVER
In 1976, only one outfit offered whitewater river rafting in Maine. Today, fifteen businesses float 90,000 customers a year. The most popular river is the Kennebec. Its most daunting spot is the hole called Magic Falls, ranked Class V, the highest level of difficulty on a commercially run river.
Photo by José Azel, Aurora

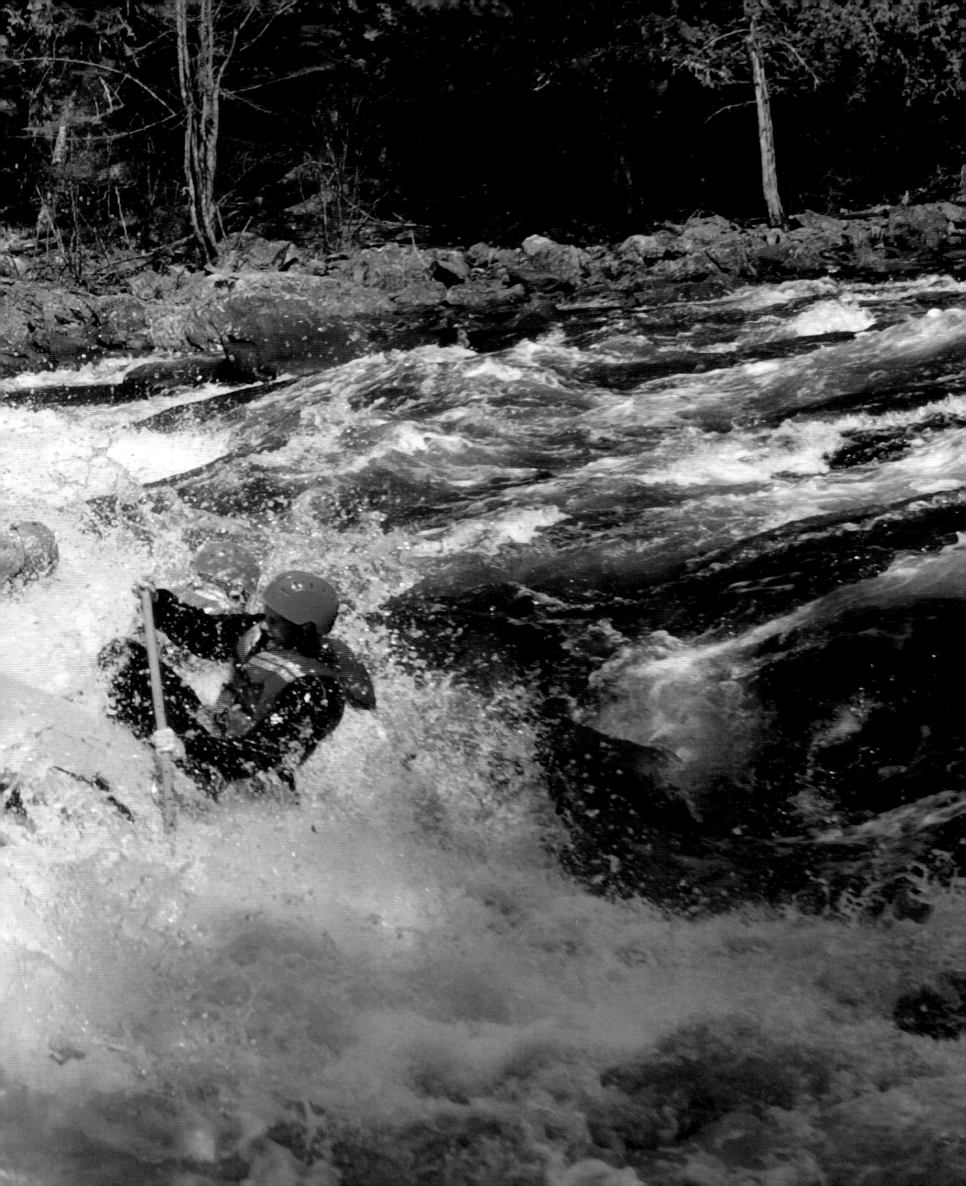

BRUNSWICK

Members of the Mid-Coast Hospital's Running Start fitness program work out at the Bowdoin College pool three times a week. In addition to hip circles, bicep curls, and tricep extensions, the participants, ages 68 to 94, socialize, which program director Keith Guiou says is an important part of any health regimen.

Photo by James Marshall, Corbis

BREWER

Twenty years ago, Sumner Rogers, now 80, retired from his job as a hardware salesman and began teaching square and line dancing full-time. At Brewer Auditorium, he announces the annual Sweetheart Dance, held for 250 men and women from local nursing homes.

Photo by Michele Stapleton

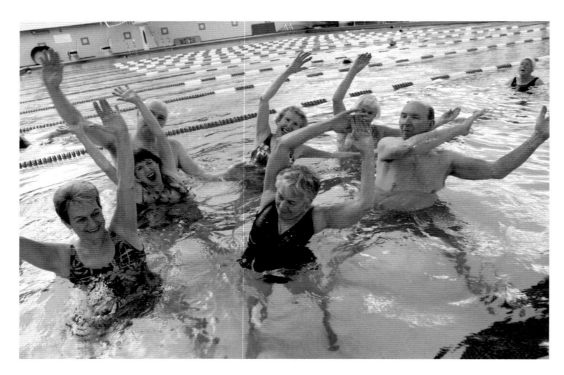

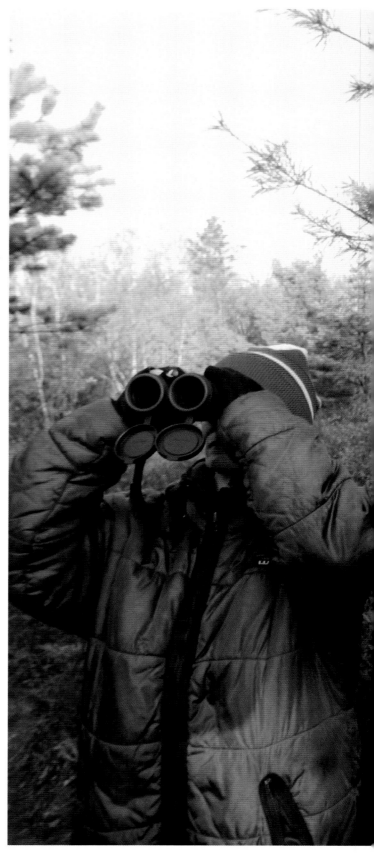

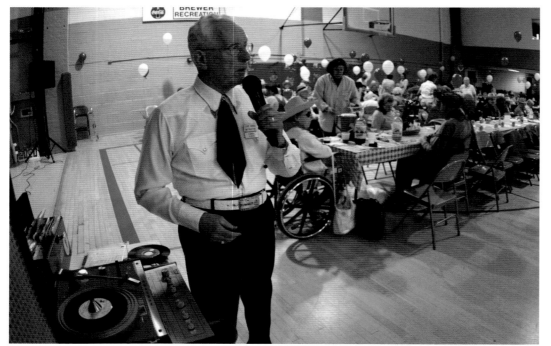

KENNEBUNK
Pat Moynahan (right), head of the York
County Audubon Society's 24-hour bird
count, leads Anne and Bob Watson through the
blueberry barrens of Kennebunk. Whippoorwills,
chickadees, blue birds, robins, and nighthawks
were among the 147 species spotted by the
birders this day.
Photo by Gregory Rec

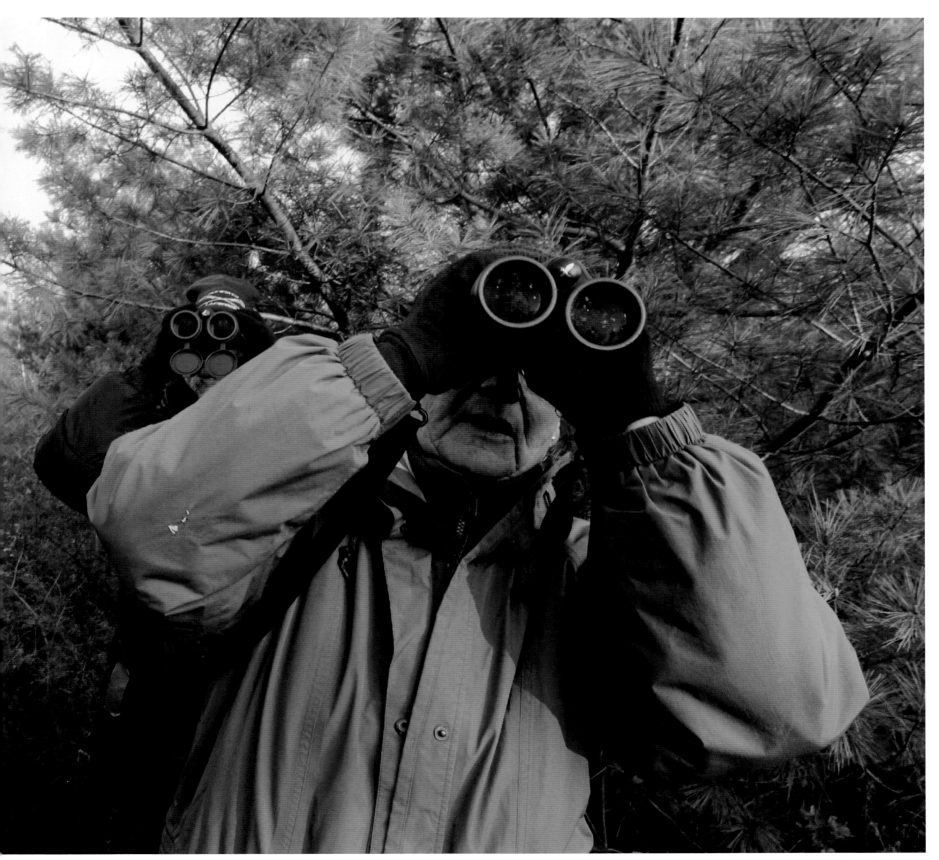

CAMDEN

In all relationships, trust is a key ingredient.
Lindsay Stewart puts hers in photographer
Chris Pinchbeck. While she scales Barrett's Cove
Cliff, he's anchored by a belay device through
which he can bring in the slack on her rope.
Chris is also Lindsay's fiancé, a word that means
"to trust" in French.
Photos by Chris Pinchbeck,
Pinchbeck Photography

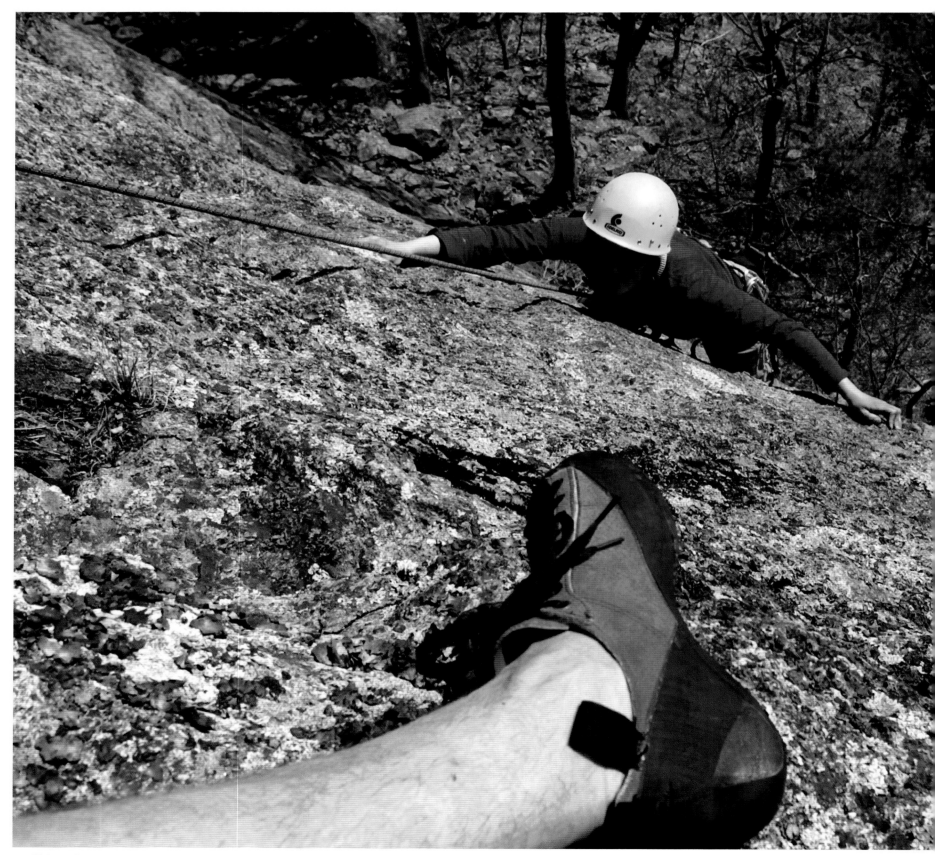

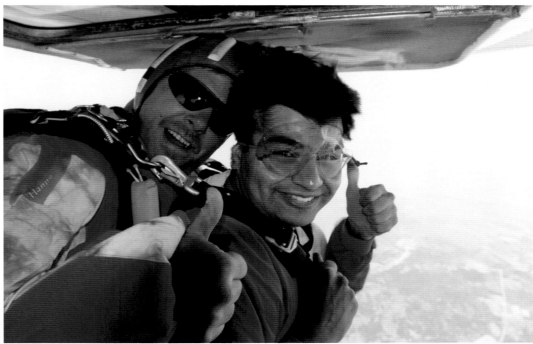

PITTSFIELD
University of Maine senior Kiril Naoumov (right) jumps in tandem with Dan Dyer of Central Maine Skydiving. Doubling up with a professional is common for first-time skydivers like Naoumov. He swears he isn't scared— "It's more a question of, 'Am I insane?'"

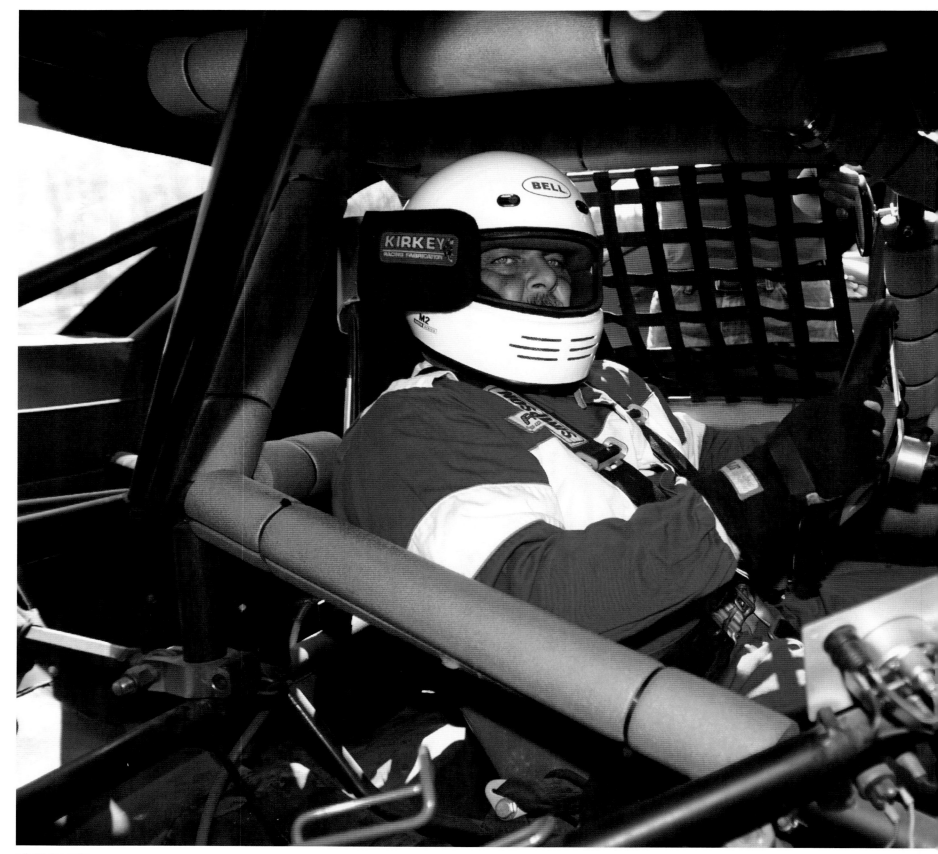

SCARBOROUGH

Bobby Ricci rides in the competitive Short Series division at Beech Ridge Motor Speedway, a NASCAR-affiliated short track. Each week, in stock cars whose engines are permitted only slight enhancements, up to 60 semipros seek the thrill of victory.

Photos by Jeffrey Stevensen

SCARBOROUGH

The checkered flag signals a winner in the Beech Ridge Wildcat Series final. Drivers in this primarily amateur division pilot street-style cars, which gives them the chance to hone their skills before they start spending more money on the sport.

SCARBOROUGH

Grandstanding for grandpa: A fan cheers on his racing relative at Beech Ridge Motor Speedway, which draws more than 100,000 spectators annually.

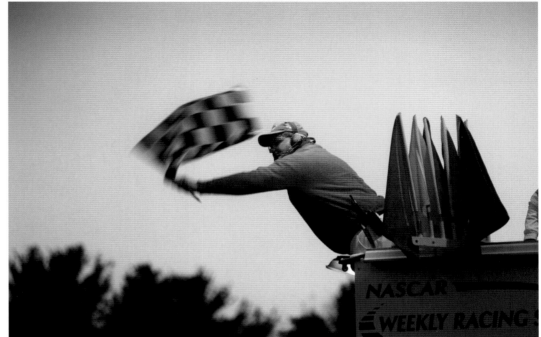

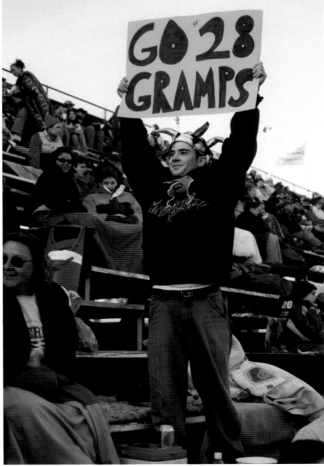

PISCATAQUIS COUNTY

Charles Stevens of Wilton uses a "wooly bugger" imitation worm fly to hook brook trout on West Branch Pond. Stevens, who's been fly-fishing for the past 20 years, likes the challenge of selecting the perfect fly for each place he fishes. "It's like an art," he says.

Photo by Stephen M. Katz

RICHARDSONTOWN

A fisherman from Massachusetts casts off the dam between Richardson and Mooselookmeguntic Lakes. Despite restrictions—fly fishing only and a catch limit of just one fish per day—people show up for the landlocked salmon and brook trout. Various fly streamers are used; the most popular, including the gray ghost, were designed by local legend Carrie Stevens (1882–1970).

Photo by José Azel, Aurora

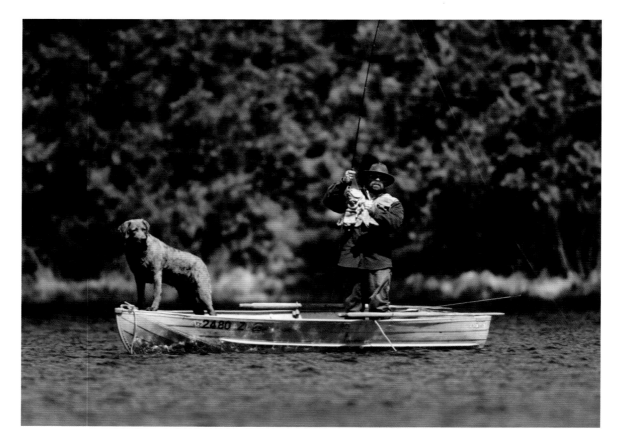

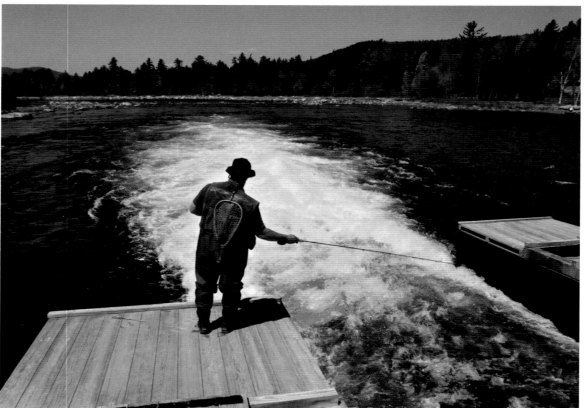

HOLLIS

When photographer Shawn Ouellette approached Doug Reil for a photo, the fish were not biting on this section of the Saco River. But all that changed. "I'll never forget it," Reil says. "As soon as the photographer said, 'Catch a big one for me,' I got a strike, and then another and another. That guy has great fishing karma."

Photo by Shawn Patrick Ouellette

HOLLIS

Angler Doug Reil is about to put this 16-inch, 2-pound brown trout he caught back into the Saco River. "I've always fished for sport, not for food," Reil says.

Photo by Shawn Patrick Ouellette

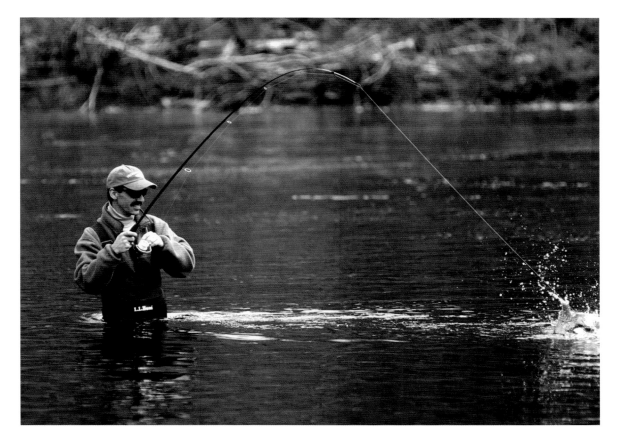

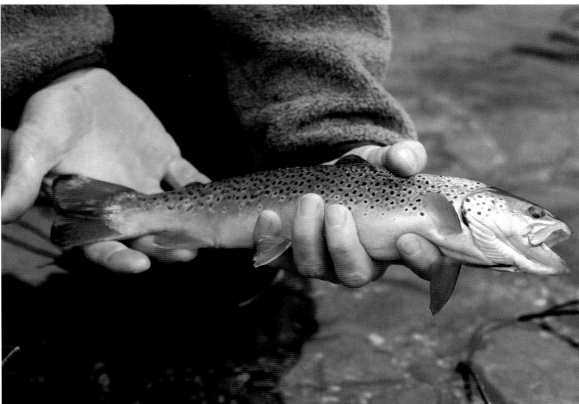

PORTLAND
Sharron "Indy" Desrochers, a safety with
the Maine Freeze, hoped to play in the game
against New York State's Rochester Raptors,
but her trainer sidelined her due to a persis-
tent knee injury. The National Women's
Football Association, formed in 2000 by
sports-entertainment entrepreneur
Catherine Masters, fielded 29 teams in 2003.
Photo by Robert F. Bukaty

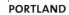

PORTLAND

For the love of the game: The sentiment couldn't be more fitting for the National Women's Football Association. Players like tailback Rebecca Mason receive no salary and have to pay for their own uniforms and insurance.

Photos by Robert F. Bukaty

PORTLAND

After losing all eight games in 2002 and the first four in 2003, the two-year-old Maine Freeze finally (Do It) with a win against the Rochester Raptors.

PORTLAND

Defensive end Theresa Amell braids the hair of linebacker Tyanita Ferrel. Why braids? Helmets won't fit over pony-tails. Don't be fooled by the pregame niceties: "After a good game," Arnell says, "I'm black and blue all over."

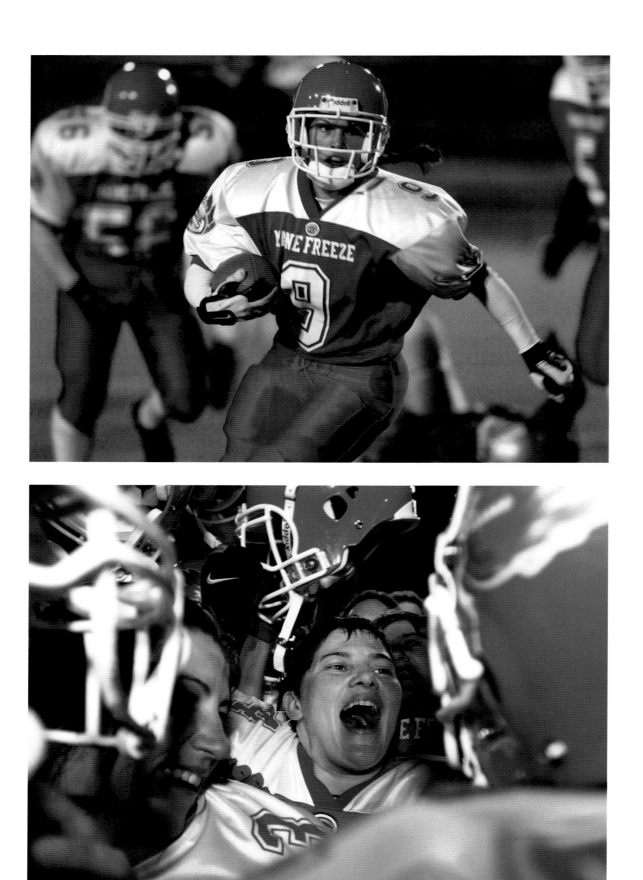

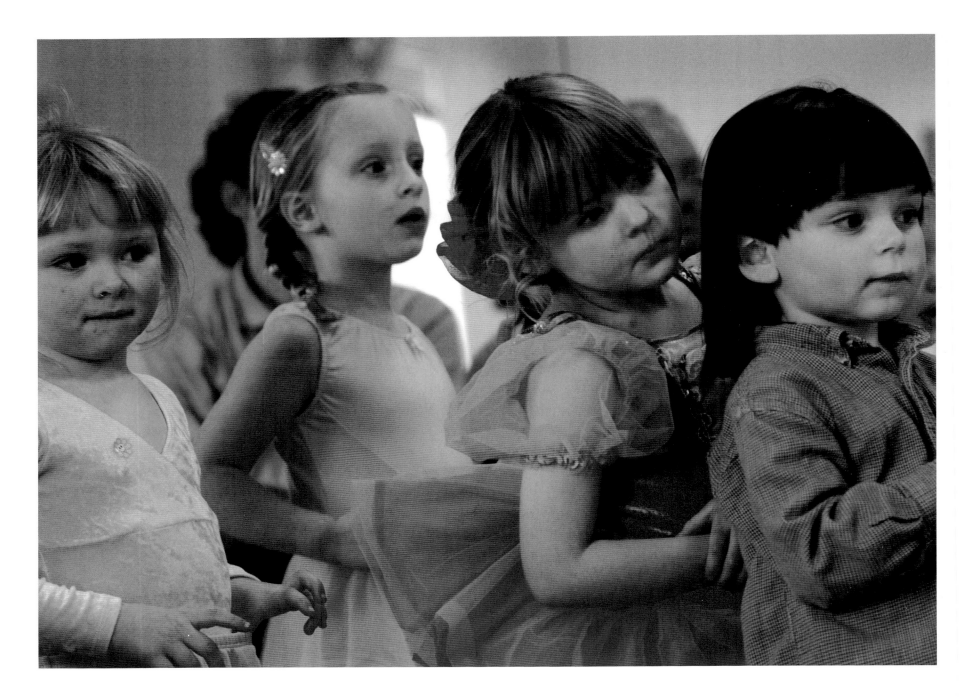

BANGOR
Dane Kelly (far right) lines up with YMCA ballet classmates Delanie Shepard, Hailey Betts, and Katrina Bowden. While the 3- and 4-year-old girls plan to continue dancing, Dane says he loves to dance but is ready to try basketball and soccer.
Photo by Michele Stapleton

PRESQUE ISLE

During her 41 years as manager of the Presque Isle Motel Dress Shop, Jessie Nelson (right), aunt of well-known dress designer Jessica McClintock, has seen the styles go from ball gowns and neo-Victorian lace to today's short, strapless black prom dresses. Nelson, a dressmaker in her youth, was her niece's mentor and now carries only McClintock dresses at her boutique.
Photo by Stephen M. Katz

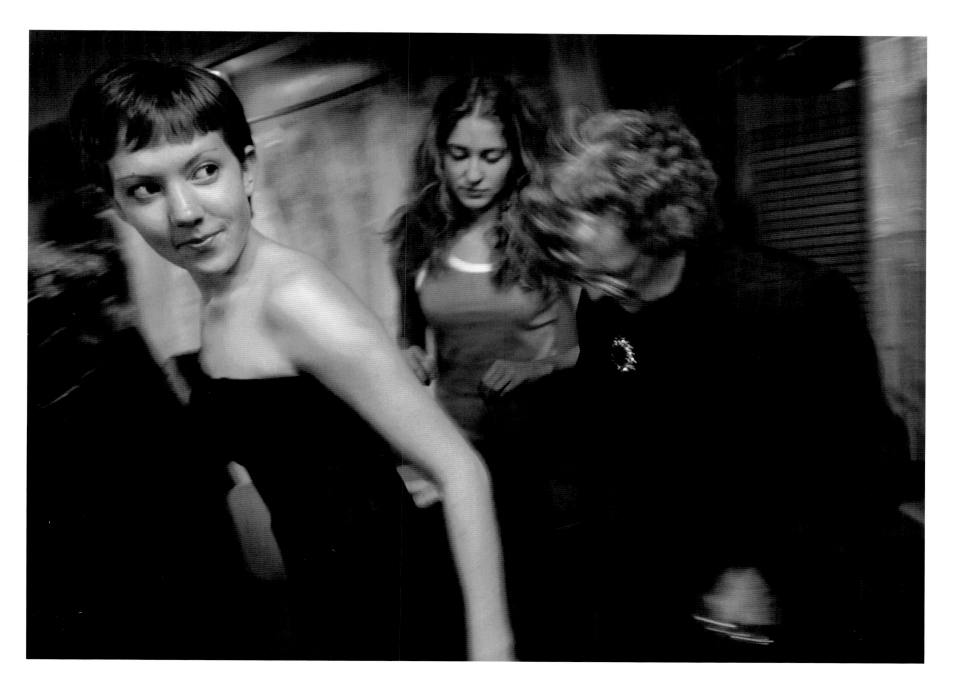

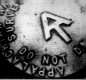

LOVELL

Pondering which two cards to throw into the "crib," players match wits in the weekly cribbage game at the Charlotte Hobbs Memorial Library. The dozen or so old-timers have been playing together since 1998. Instead of collecting bets, they contribute $1 each time they play. The money is donated to the library.
Photo by José Azel, Aurora

BRUNSWICK

Happy as a quahog: Jim MacLeod digs for hard shell clams when the tide is right. While others stand in boats and use long rakes, MacLeod dons a wet suit and plucks them off the shallow mud bottom with his hands. It's easier on the back. Plus, he says, "That's the way mother dug them."
Photo by Robert F. Bukaty

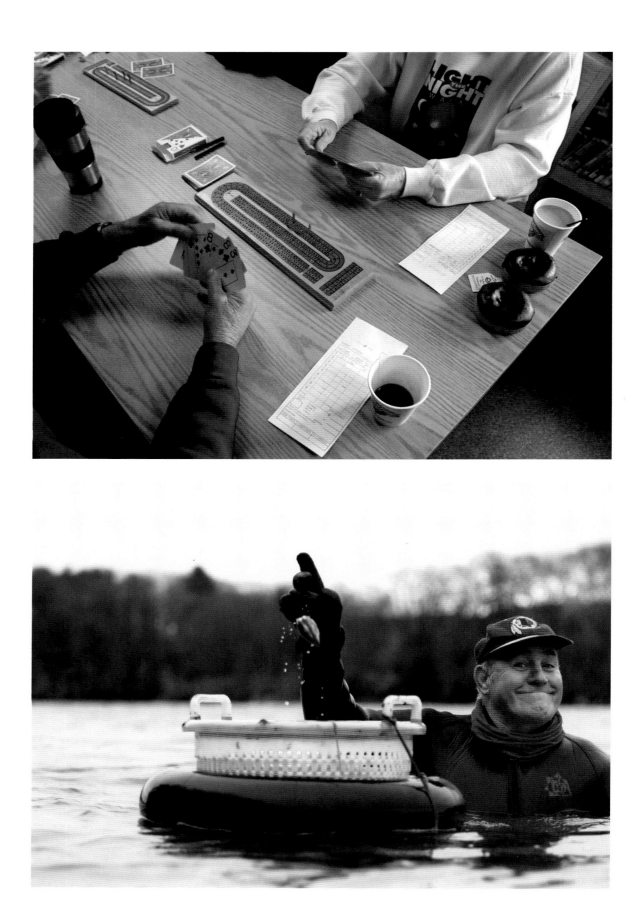

YARMOUTH

Leslie Gillert and son Everett, 10, hang bags under the Cousin Island dock to snag sea creatures for their saltwater fish tank, but pickings are slim. Not one lumpfish, their favorite. However, all was not lost: Mother and son had a squirt gun fight with a few clams.

Photo by Jim Daniels

GRAFTON TOWNSHIP

As one of 650 volunteer members of the Maine Appalachian Trail Club, Peter Roderick maintains a 3.5-mile section of trail on West Baldpate Mountain, building water bars to prevent erosion and clearing away fallen trees. An avid hiker, Roderick has walked all 267 miles of Maine's portion of the Appalachian Trail.

Photo by Alexandra C. Daley-Clark

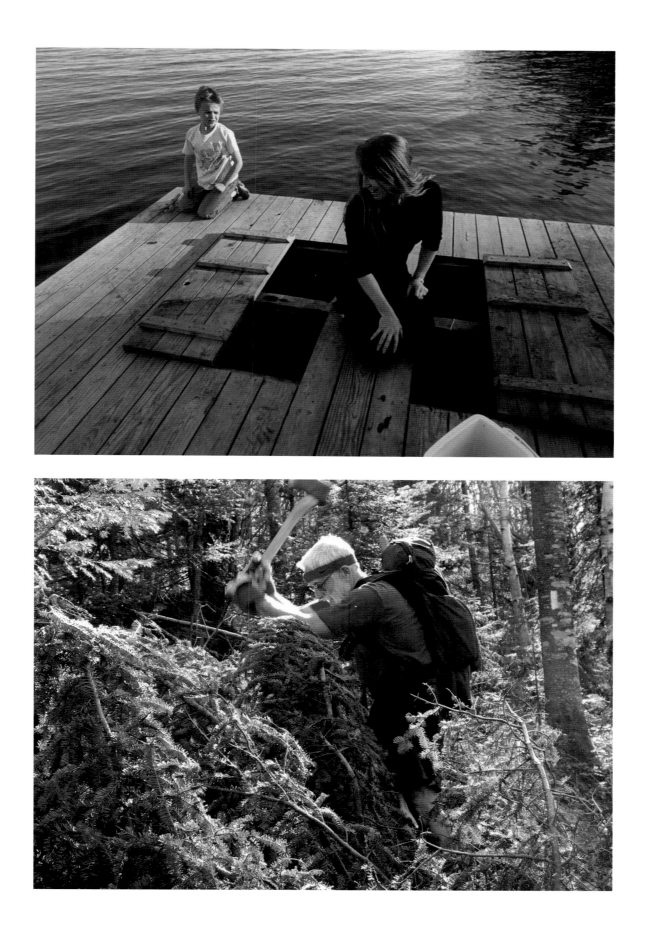

BRUNSWICK

Hyde School senior Michael Deissig
lost his mother to cancer and, with
Tess Guckenheimer, holds vigil beside
the candle they lit in her memory. The
candle was one of hundreds lined up during
the luminaria ceremony, which followed the
Brunswick Relay for Life, an American
Cancer Society fundraiser.
Photo by James Marshall, Corbis

Reason To Believe

Dedicated To

mom,
You are my angel, and
my guardian to protect me
from the pain & sadness and to
make me smile...

BANGOR

Anna Hettermann and Ellen Hendricks are now full-fledged members of Bangor's Catholic community. Their second-grade class at St. John's Catholic Church celebrated confirmation and first communion in May.
Photos by Michele Stapleton

BANGOR

Musician Steven Burgess travels the globe in search of pipe organs. The Montana native fell in love with the pipe organ at St. John's Catholic Church. Crafted in 1860 by Hook Brothers of Boston, the 1,800-pipe, three-keyboard organ is the star at the church's summer recital series, when Burgess and others put it through its paces.

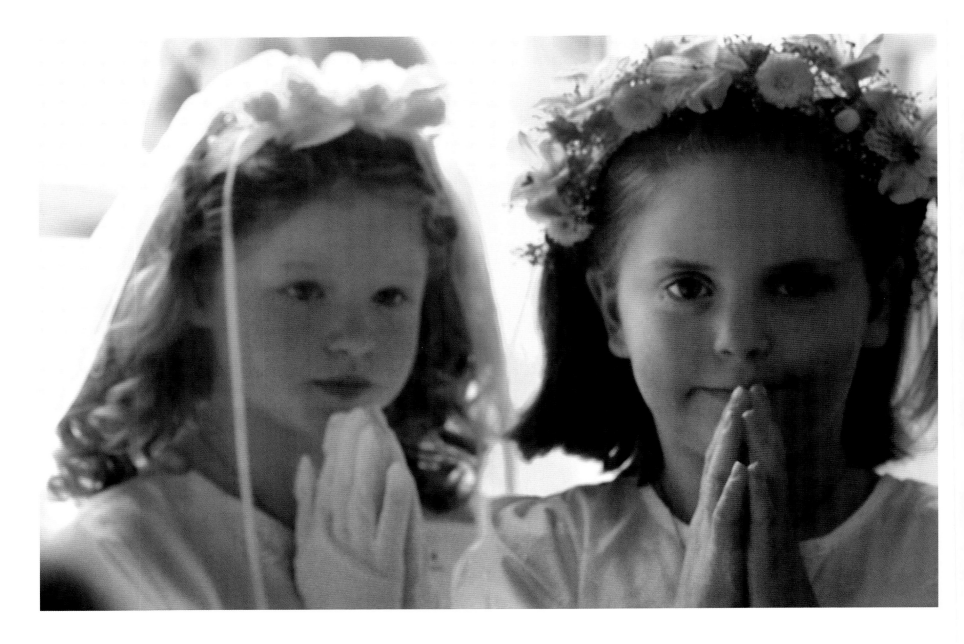

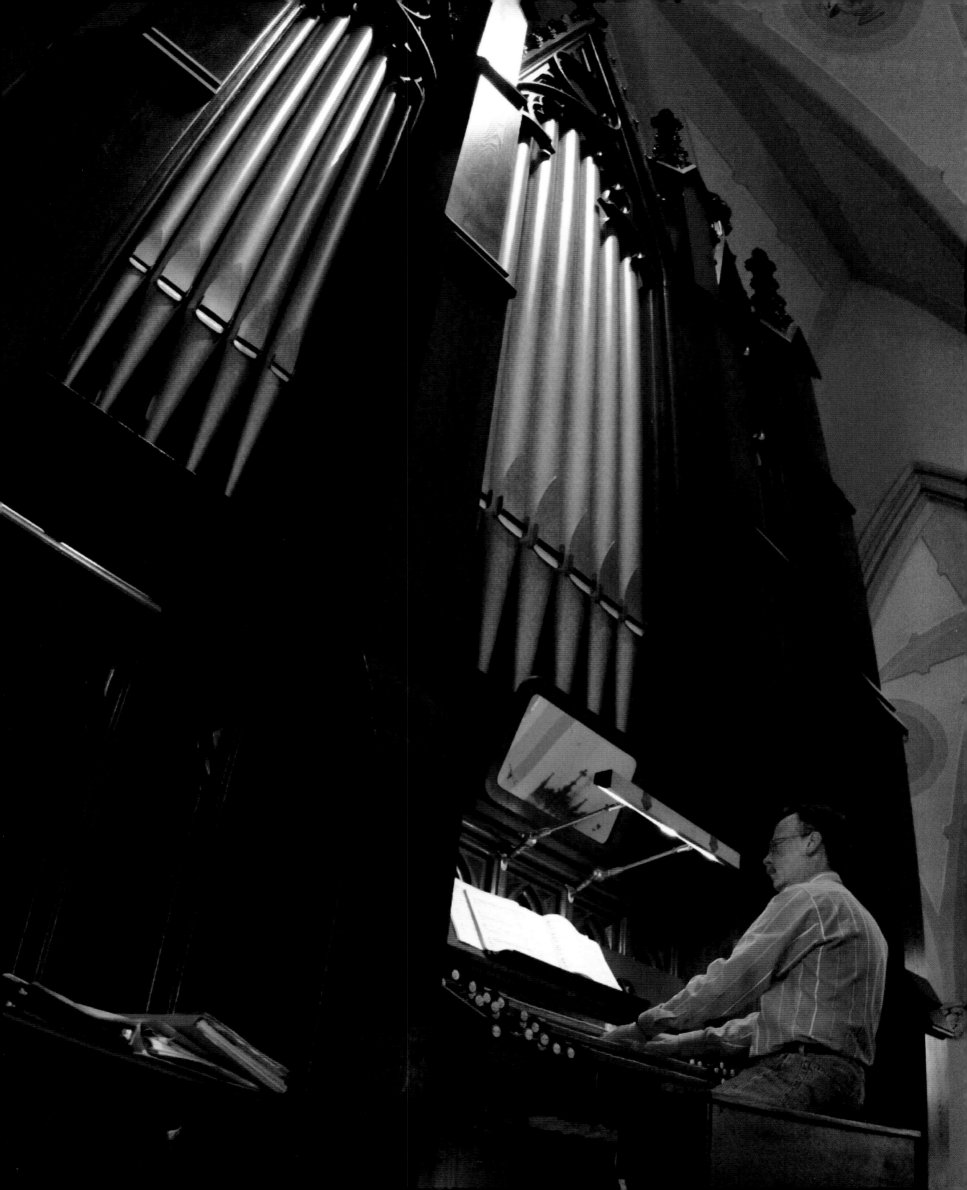

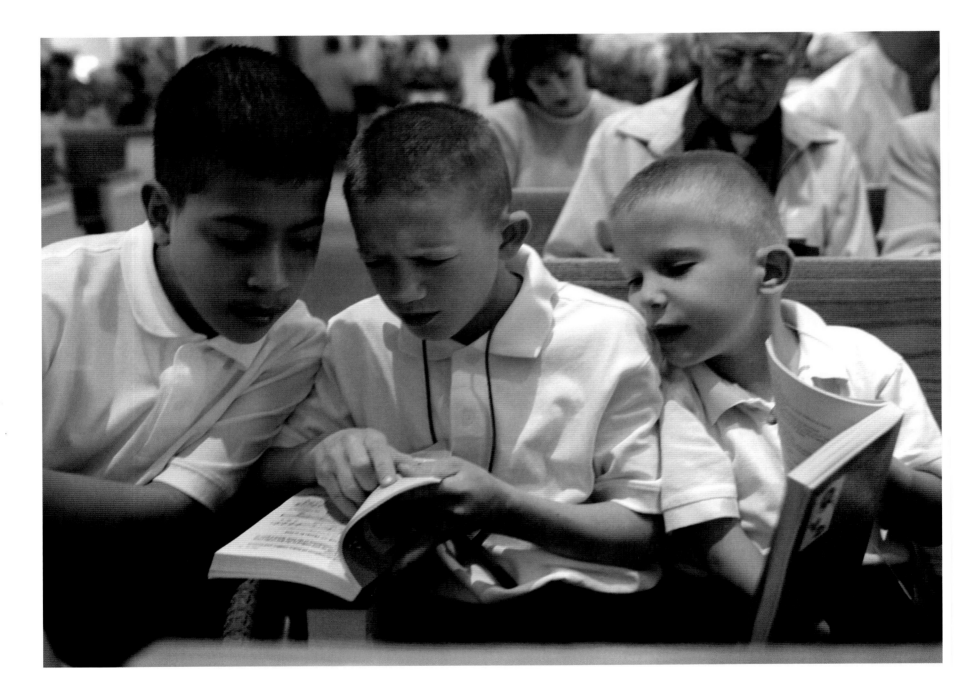

WELLS
John Christopher, Vanya, and Nikolai are three of John and Christine Tomaszewski's 10 adopted children. John Christopher was born in Paraguay, and Vanya and Nikolai came from Russia. When people asked the couple when they were going to stop adopting, they responded, "When we take up a whole pew."
Photo by Gregory Rec

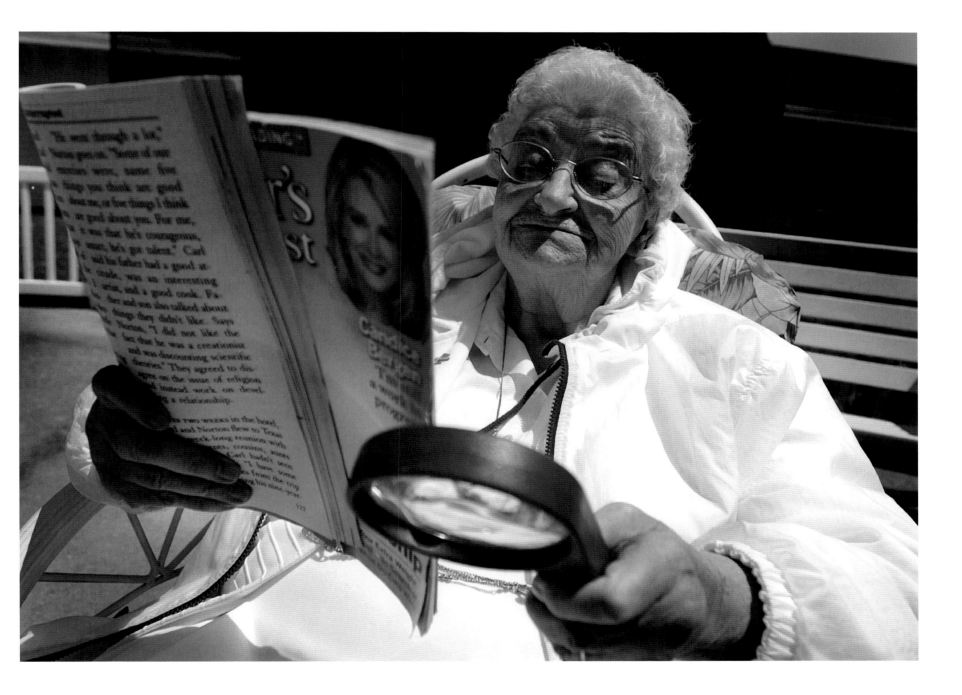

BIDDEFORD

Although legally blind, retired high school teacher Sister Evelyn Jean, 93, is still an avid reader, devouring everything from philosophy and fiction to a large-print copy of *Reader's Digest*. "Reading has helped me stay flexible in my outlook on life...and also stay out of trouble," she says.

Photo by Shawn Patrick Ouellette

PRESQUE ISLE
Maine's Aroostook band of Micmac live in government housing, but construct teepees for powwows and story circles. They build them with canvas instead of the traditional birch bark and skin, making this conical style sturdy enough to use year-round.
Photo by Amy Toensing

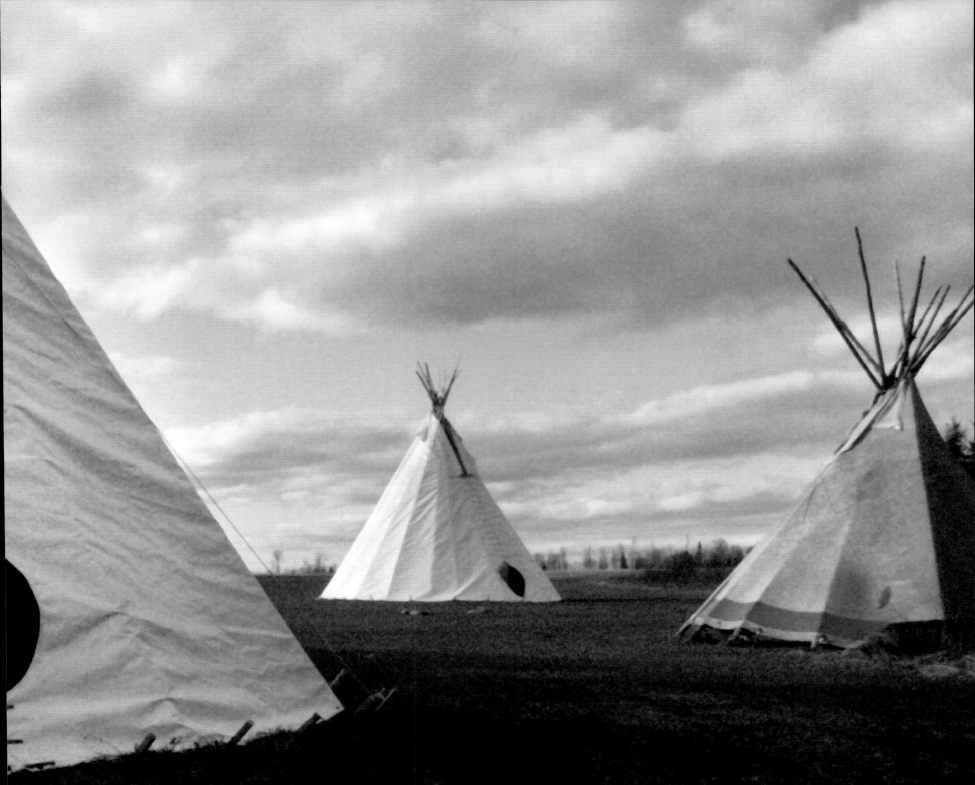

PRESQUE ISLE
Teacher's aide Ramona Jerome holds hands with two girls during nap time at Little Feathers Head Start. The center, which opened in 1995, teaches a basic preschool curriculum as well as Native American songs, stories, arts, and crafts. Seventeen of the 20 children are Micmac; the others are Maliseet from a nearby reservation in Canada.
Photo by Amy Toensing

PRESQUE ISLE

Max Romero weaves baskets with his grand-
mother Mary Sanipass, who taught him the craft.
The 23-year-old made his first basket when he
was 7. After a year of college, he returned to the
craft and now sells the family's baskets in Old
Town and throughout New England.
Photos by Amy Toensing

PRESQUE ISLE

Micmac artist Mary Sanipass weaves traditional
black ash baskets. She uses ash for its strength,
flexibility, and ease (the tree's growth rings
actually strip off into splints when pounded).
Sanipass's baskets have won numerous artistic
awards. The national First People's Fund named
Sanipass one of five Community Spirit recipients
to recognize her commitment to traditional
basket making.

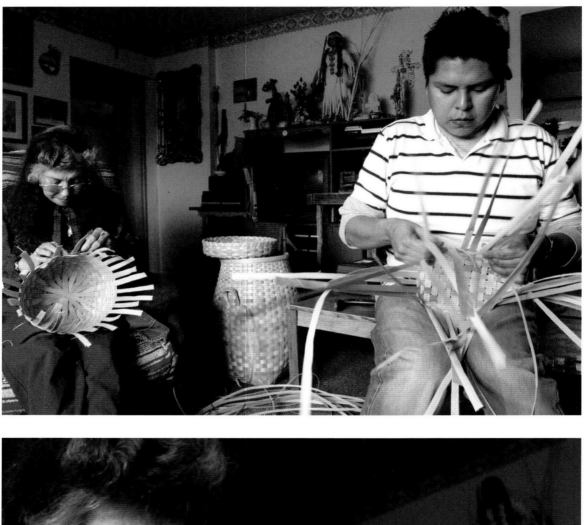

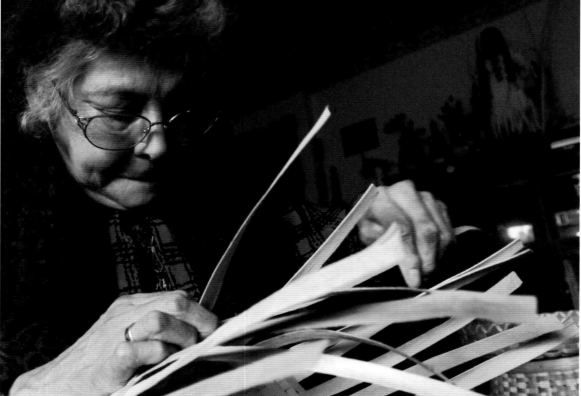

PRESQUE ISLE

Marline Sanipass Morey and her daughter Tania Morey practice a traditional Micmac song for their women's group. Tania made the drum out of moose hide, painted the feather motifs and stuffed the head of the drumstick with cotton to create the proper sound.

PRESQUE ISLE

Born in New Brunswik, Micmac Indian Donald Sanipass moved to Maine 50 years ago looking for work. He found it in the potato fields, then as a lumberjack, and finally as an electric utility poleman. "I quit that one fast," he says. "It was too dangerous." These days, Sanipass helps with his wife's basket weaving and picks out country-western tunes on his guitar.

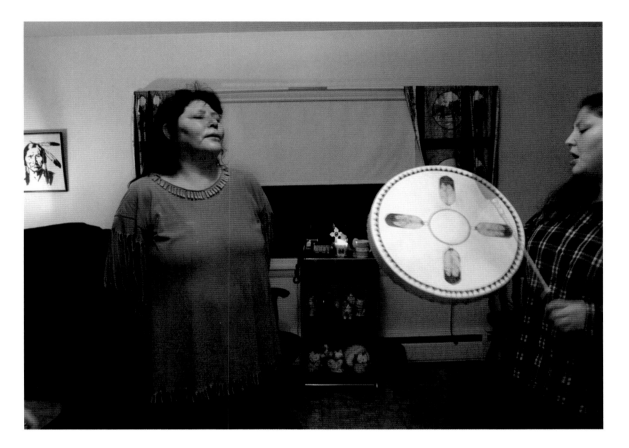

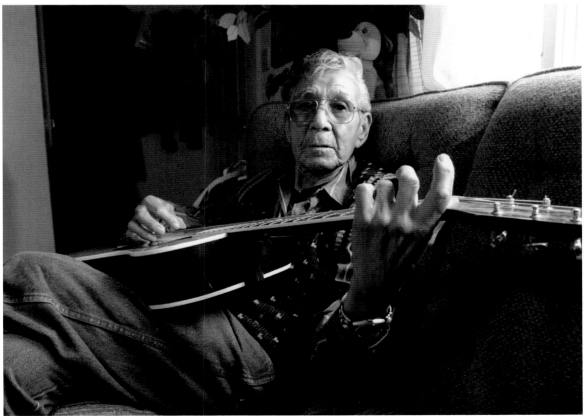

WELLS
Wells Beach attracts thousands of visitors during the summer, but sometimes you can have it all to yourself in the off-season. The lookout sits on a seawall that extends the length of the beach to protect homes during winter storms.
Photo by Thatcher Hullerman Cook,
Thatcher Cook Photography

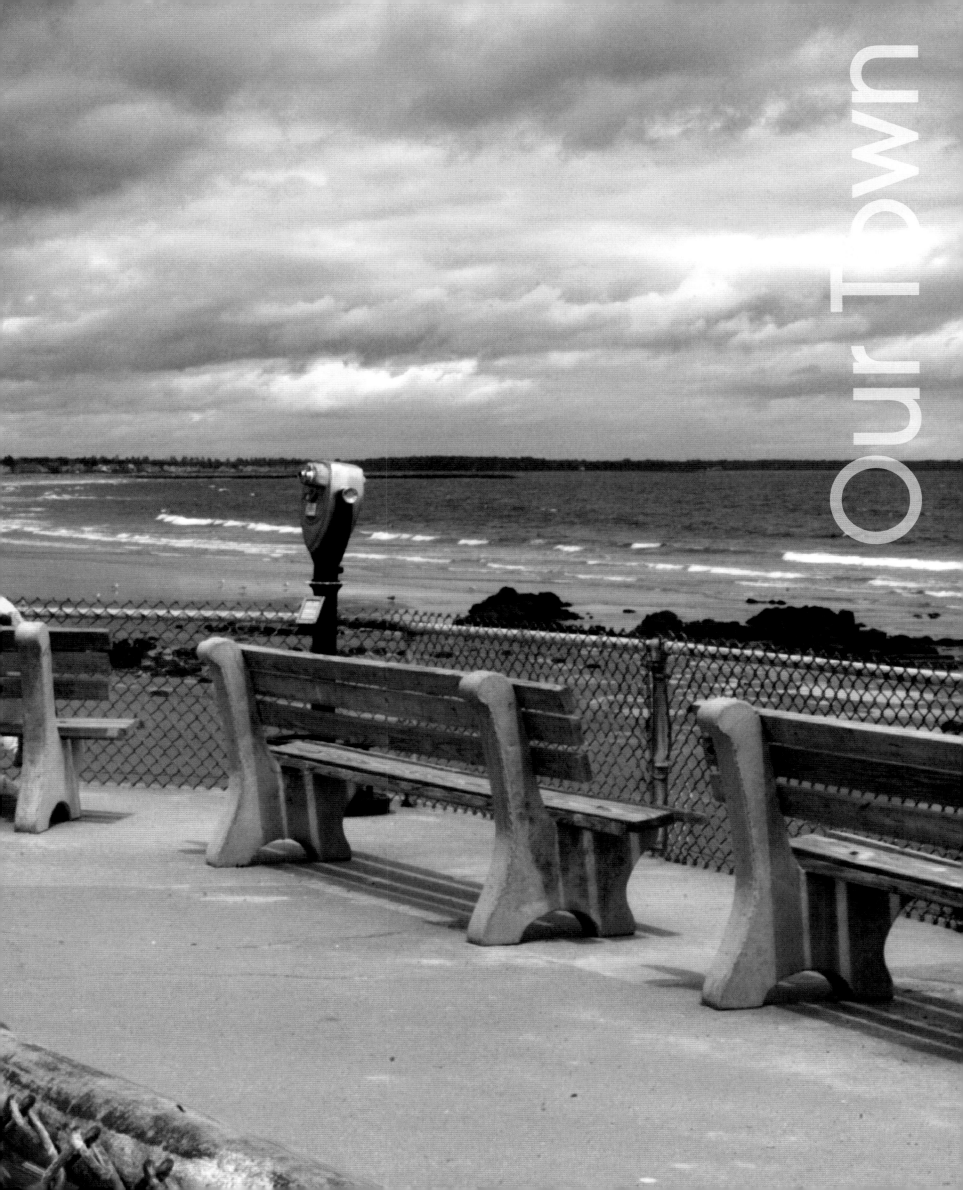

RUMFORD POINT
Curtiss Hallock brings Calvin and Hobbs back from the woods on Orchard Hill Farm after hauling firewood. Hallock's family homesteaded the 165-acre farm in 1799, when Maine was part of Massachusetts. A former mechanical engineer, Hallock took over in 1997 to raise organic chickens, eggs, and pigs. Business is good—sales have increased 70 percent since 2001.
Photo by David McLain, Aurora

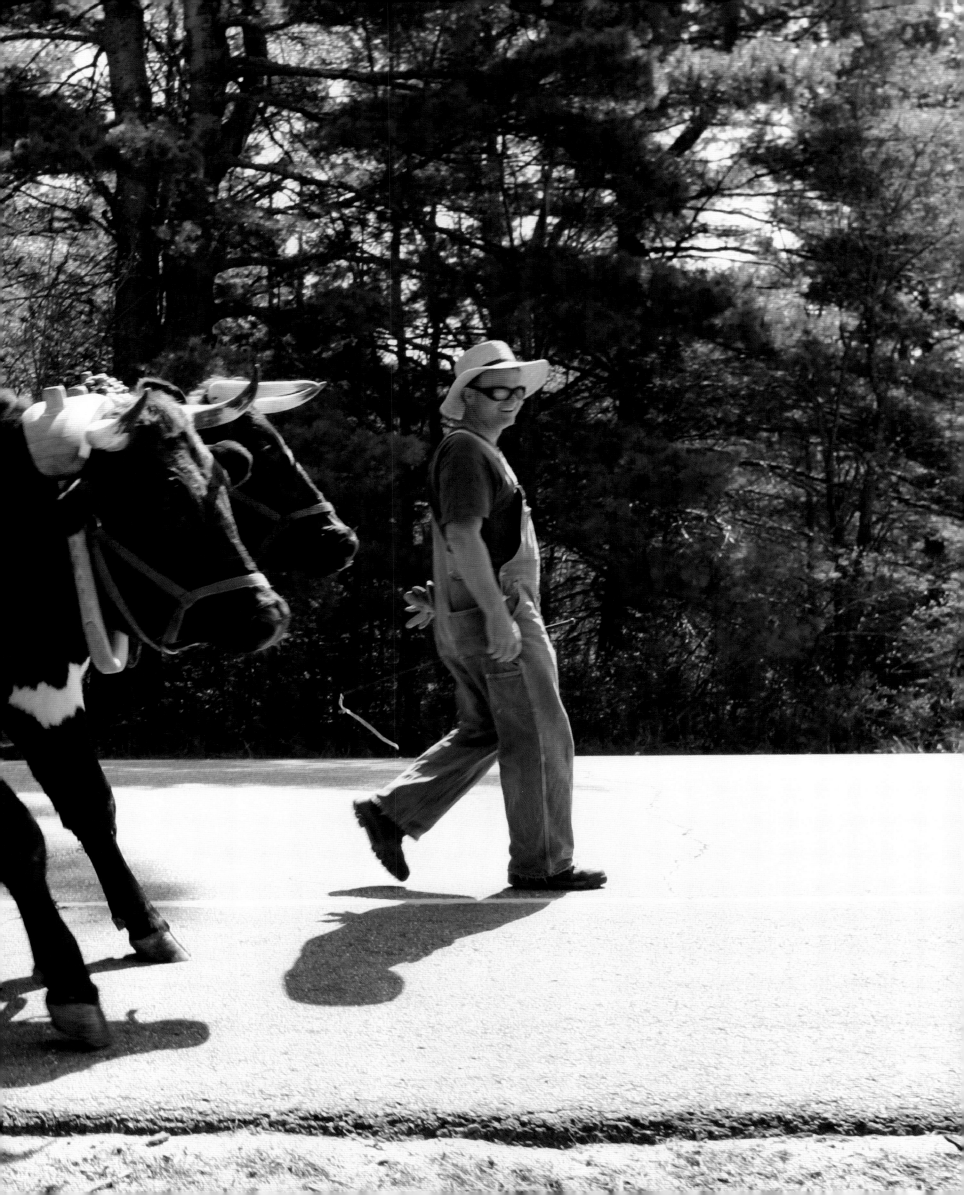

FREEPORT

Time waits for no man, but Joseph Gats of Livermore Falls must wait for his wife Denise to finish shopping at L.L. Bean. The two are among the 3.5 million annual visitors to the Main Street store—making it Maine's second most popular tourist attraction after Acadia National Park.
Photo by Robert F. Bukaty

BOWDOINHAM
Jazz jam: Hope Hoffman and Craig Hensley play an impromptu jazz string duet by Merrymeeting Bay.
Photo by James Marshall, Corbis

CUNDY'S HARBOR
The 300-square-foot Cundy's Harbor Library serves the town as both a social center and reading room. Among the 3,500 books are works by Maine writers Stephen King, E.B. White, and Rachel Carson. Director Dallas Van Koll says her ambition is to modernize the library yet maintain its small-town character.
Photo by James Marshall, Corbis

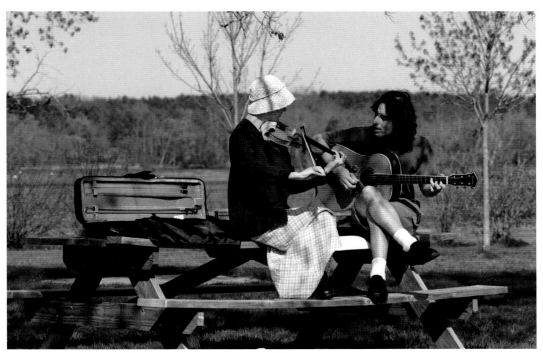

RANGELEY LAKE STATE PARK
Looking a bit like fall, deciduous trees
rush to bud in Maine's abbreviated spring.
In addition to oak, maple, ash, cedar, and
birch, evergreens fir and spruce flourish in
the 869-acre park.
Photo by José Azel, Aurora

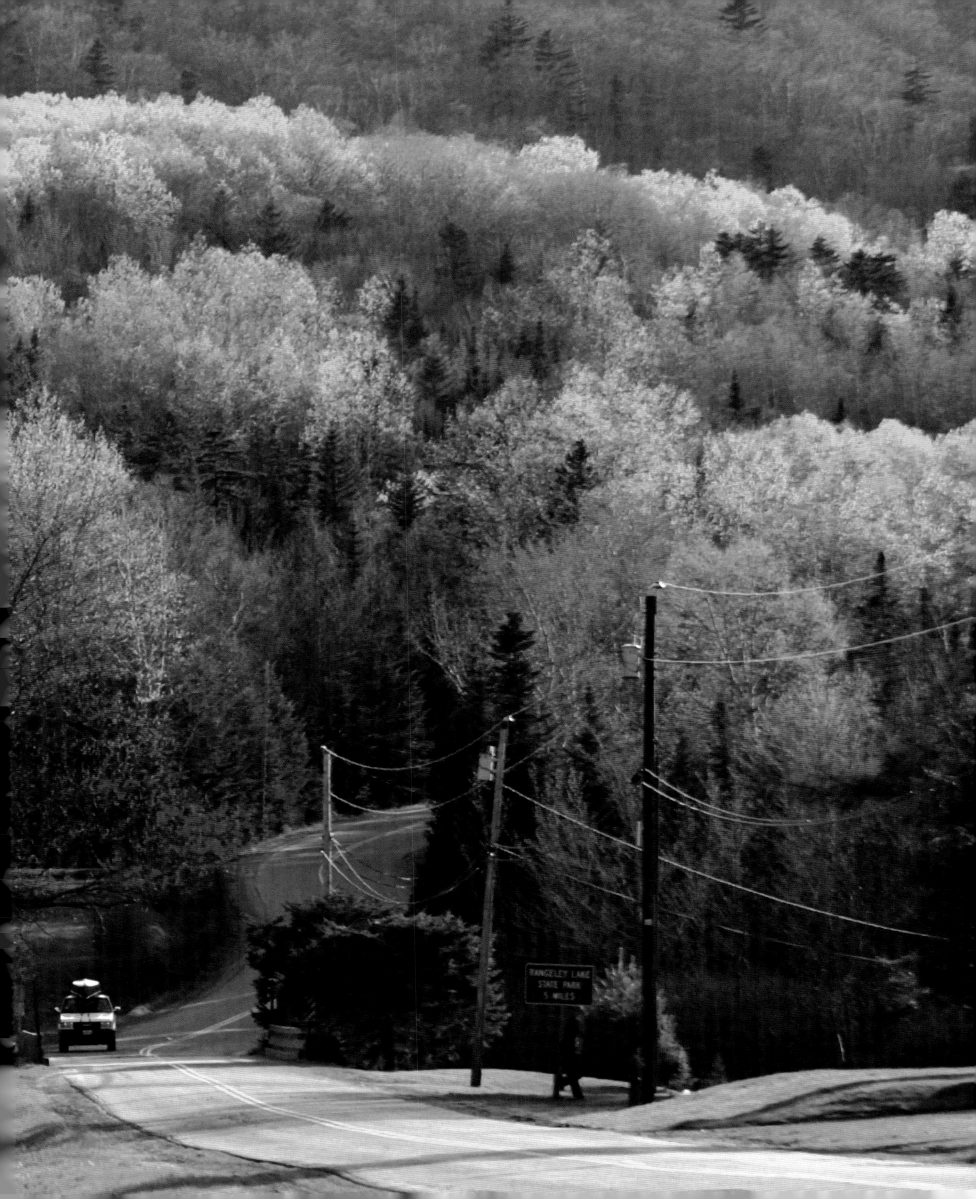

RANGELEY LAKE STATE PARK

This 100-year-old Northern white cedar rises 50 to 60 feet above Rangeley Lake. Over the years, the shoreline has eroded, revealing the cedar's root system, used by heron and osprey as a convenient perch for hunting.
Photo by José Azel, Aurora

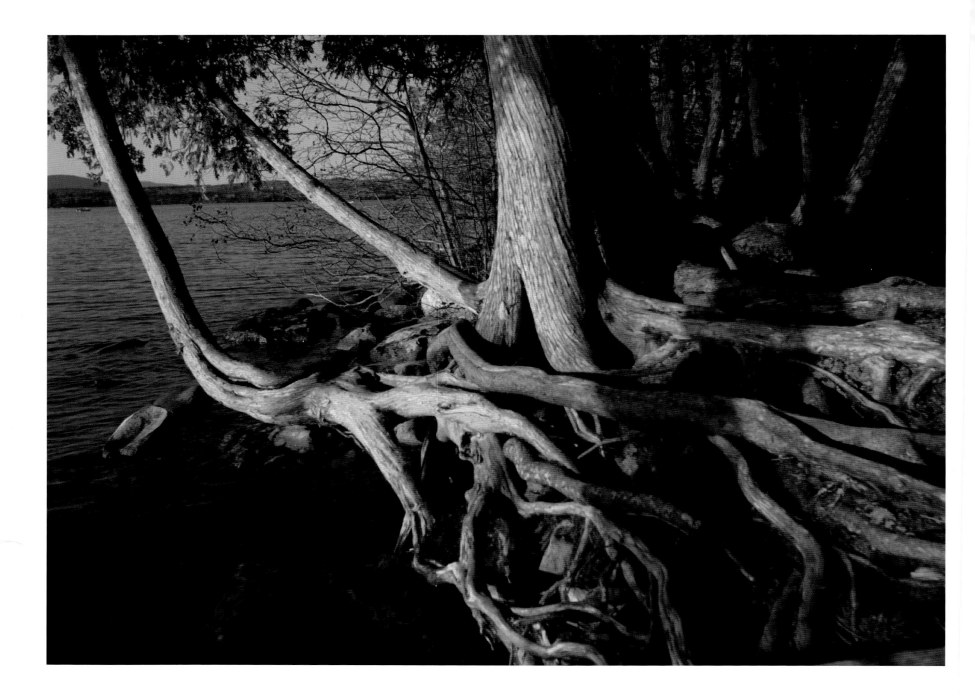

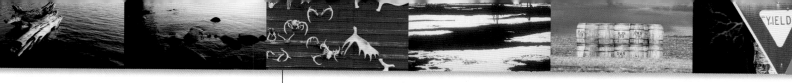

ASHLAND

North woods collage: Moose and deer antlers decorate the side of an abandoned hunter's cabin on Route 163 in Aroostook County.
Photo by Kevin Bennett, Bangor Daily News

LONG COVE

At Long Cove Quarry on the Saint George River Peninsula between Thomaston and Tenants Harbor, a large pine tree casts its shadow on a lichen-covered granite wall.

Photos by John Paul Caponigro

HEWITT'S ISLAND

Blocks of cut granite, left over from the island's days as a granite quarry, are piled up on its small harbor. Located just off Spruce Head Harbor, Hewitt's Island is now home to a dozen rustic, off-the-grid vacation cottages.

CLARK ISLAND

Clark Island granite was used to construct several New York City historic sites, including the Central Park bridges and Brooklyn-Battery Tunnel. Employing Irish and Finnish workers along with English and Swedish stonecutters, quarrying began in 1830 and peaked around 1880. The last quarry to operate on Clark Island closed in the early 1960s.

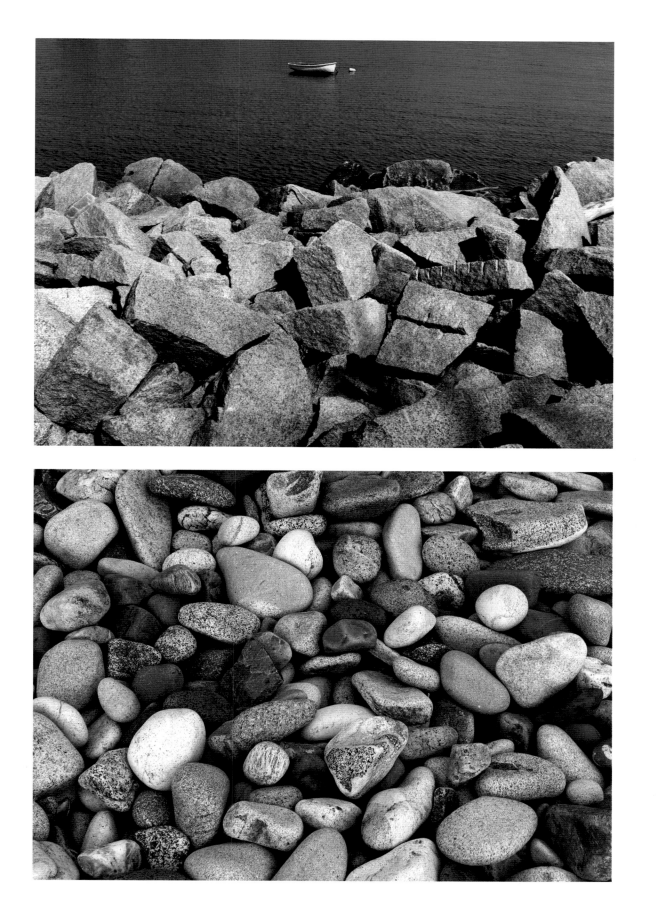

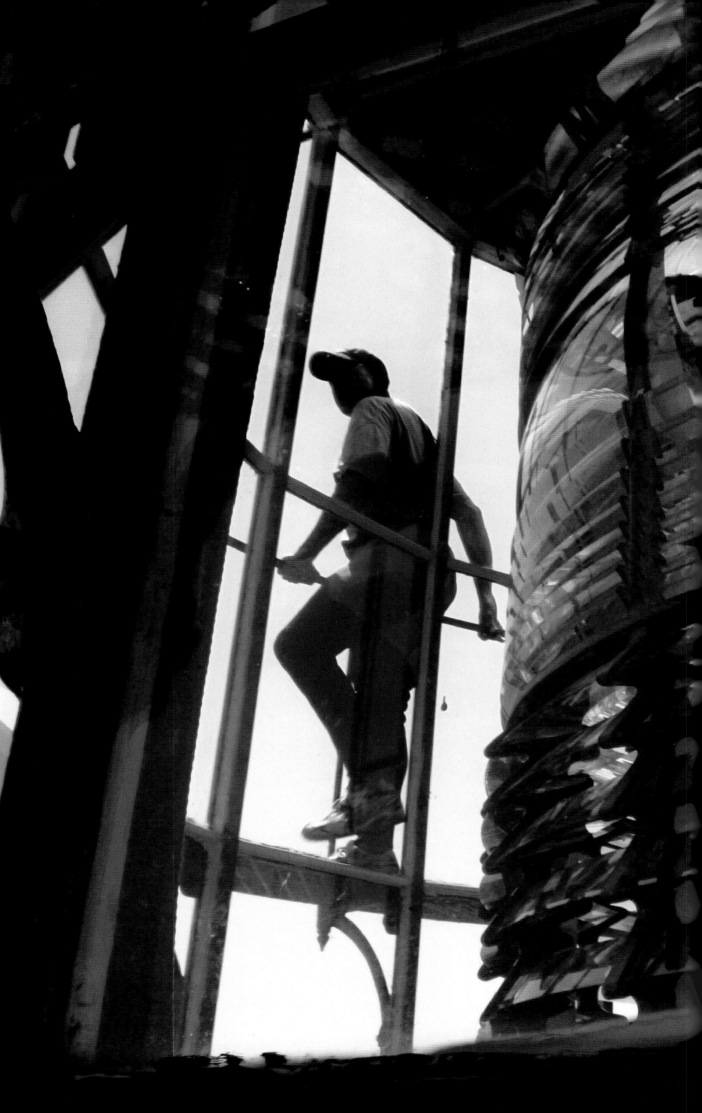

SEQUIN ISLAND
In 1857, a First Order Fresnel Lens was
installed in the Sequin Island lighthouse.
The 12-foot lens, invented by French
physicist Jean Fresnel in 1822, uses
282 prisms to amplify and focus the
light source into a concentrated beam.
Photo by David McLain, Aurora

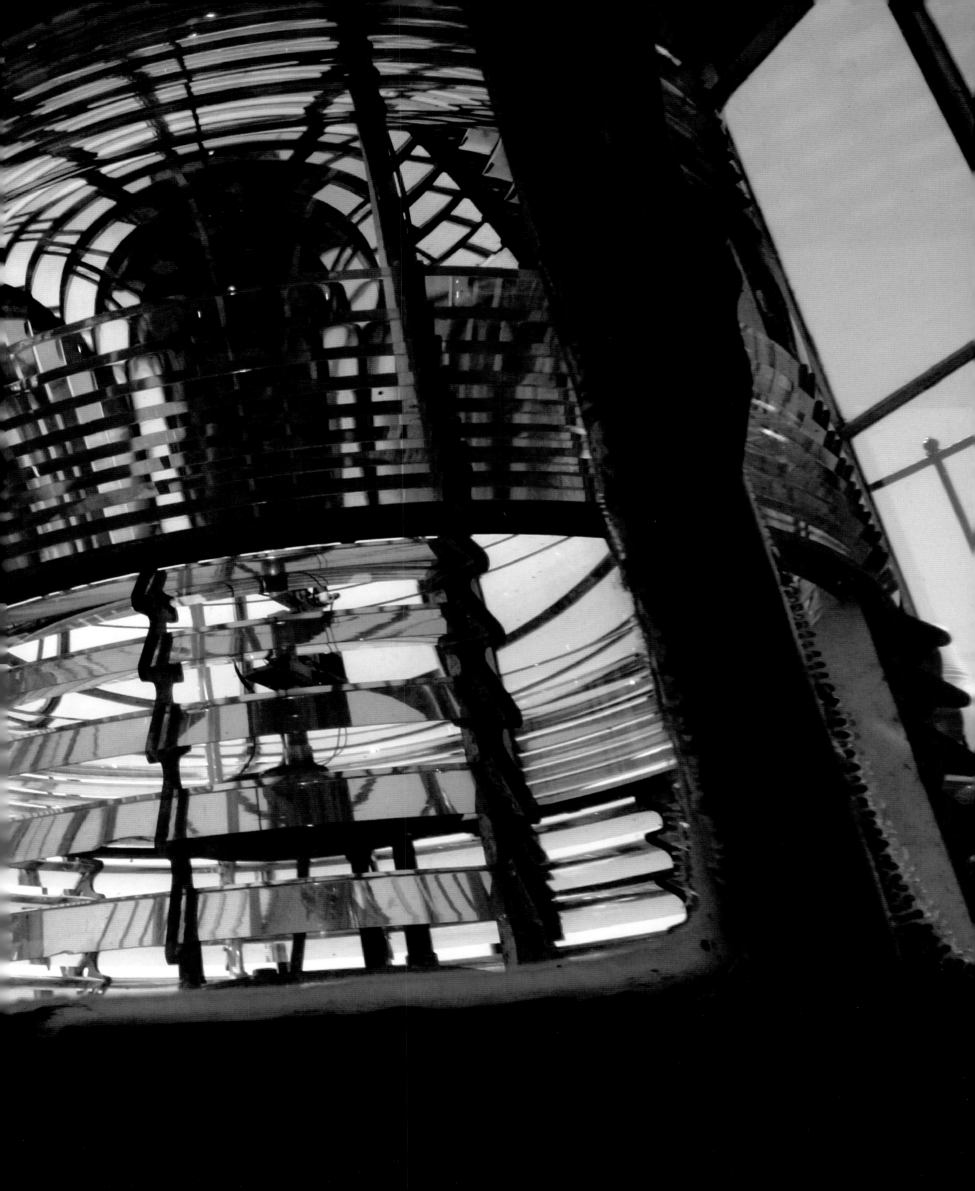

GREENVILLE

Jamieson's Market opened in 1947. In 1980, Henry Gilbert bought it and added a pizza parlor and sandwich shop. Located across the road from the 35-mile-long Moosehead Lake, the mini-complex is a popular stop for Greenville's 1,600 residents. Gilbert, who opens the shop every day at 5 a.m., says the place hasn't been closed one day since he acquired it.
Photo by José Azel, Aurora

TOPSHAM

Paul Raymond supplies and steams lobsters for 200 at a $20-per-plate fundraiser, helping raise $4,000 toward the $1 million necessary to build Topsham's first permanent library.
Photo by James Marshall, Corbis

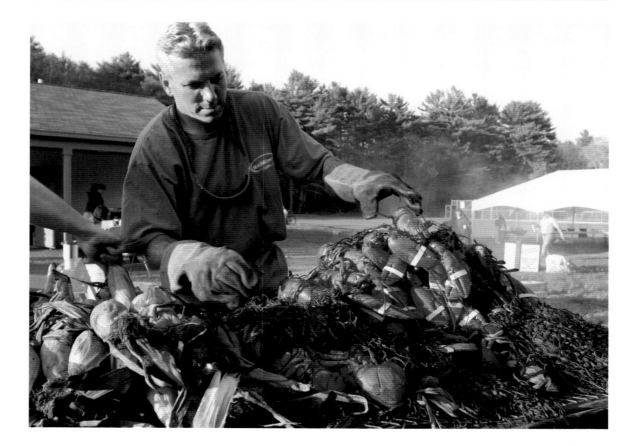

BAR HARBOR

Regulars arrive as early as 5 a.m. for breakfasts of eggs and sausage at Tapley's Variety and Grill in the resort town of Bar Harbor. In winter, when 2 feet of snow cover the ground and the tourists have gone home, locals linger at the counter, hovering over hot chocolate and weaving yarns about remembered days.

Photo by Alexandra C. Daley-Clark

WISCASSET

Right on Highway 1, Red's Eats is a Wiscasset landmark, attracting customers on their way Down East. Although the food comes fast at Red's, the summertime queue for a lobster roll (a whole lobster on a buttered bun for $13) can run up to an hour.

Photo by James Marshall, Corbis

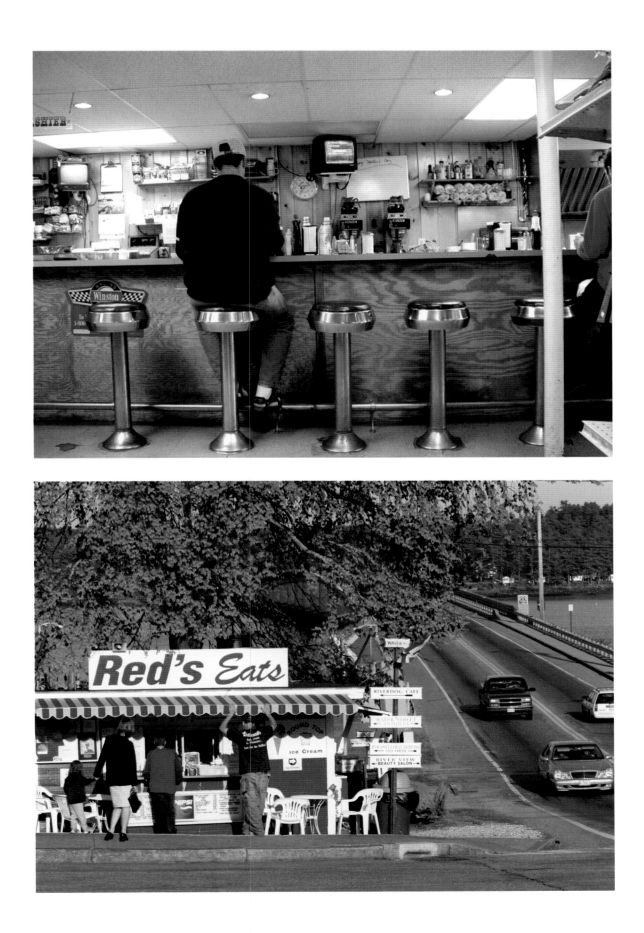

BRUNSWICK

Members of the Merrymeeting Kennels Young Retrievers Training Class are entranced by a quail flapping off camera. During the four-month class, labs, pointers, and spaniels are trained to flush and retrieve birds. Some of these dogs will go on to compete in hunting events, earning prizes for their ability to return "markings" and run in a straight line following a hand direction.

Photo by James Marshall, Corbis

GRAY

"To be good, it has to be red"—that, says hot dog seller Lonnie Humphrey, is how most Mainers feel about their hot dogs. The beef and pork dogs are made by the Jordan Meat Co. Red dye gives them color; natural casings give them snap. Humphrey has been selling them in the same supermarket parking lot for 25 years. Regular toppings set you back $1.50; chili and cheese, $1.75.

Photo by Thatcher Hullerman Cook,
Thatcher Cook Photography

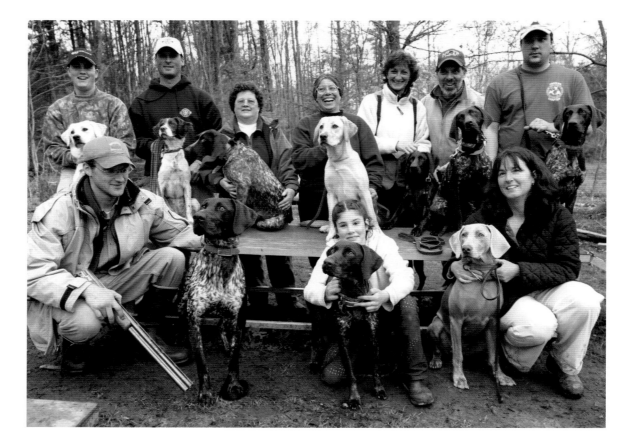

PORTLAND

A Company of Girls is an afterschool program for 7- to 15-year-old aspiring actresses, mostly from low-income families. This production of *Lord of the Flies* features Crystal Cron, Chelsea DiPietro, Eve Barker-Miller, Jolene Bouffier, Nhi Nguyen, and Monique Harrison (far right), who plays the bossy and controlling Jane. "I didn't have to act too much," admits the 13-year-old.

Photo by Jeffrey Stevensen

TOPSHAM

Express yourself: Mike Olson, 16, sports the only Mohawk at Mt. Ararat High School. While his parents were shocked when he came home with the teal blue hairdo, Olson's classmates swarmed around him to ask if they could touch it. Olson, who maintains his Mohawk with wood glue and hairspray, says he plans to keep it for awhile.

Photo by James Marshall, Corbis

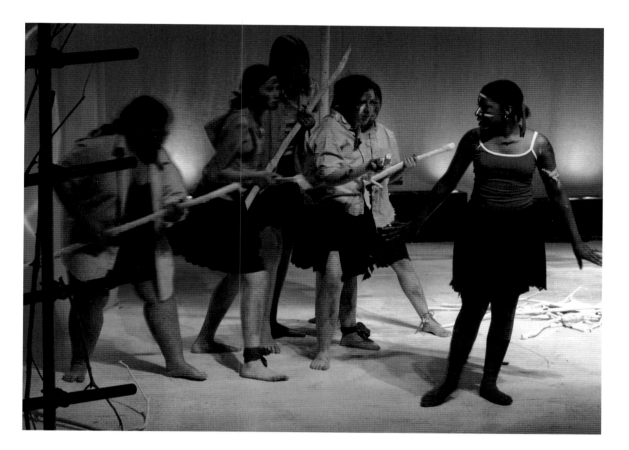

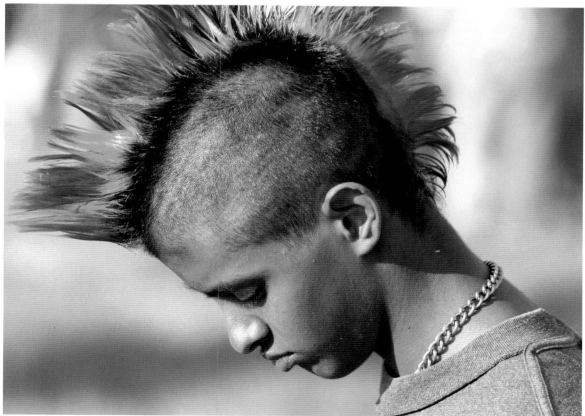

For the final exam of their American Foreign Policy class at Bowdoin College, senior Julie Dawson and classmates write an essay positioning themselves as Henry Kissinger analyzing a debate between Colin Powell and Donald Rumsfeld. Founded in 1794, Bowdoin is a liberal arts college of 1,550 students whose noted alumni include Nathaniel Hawthorne and Henry Wadsworth Longfellow
Photo by James Marshall, Corbis

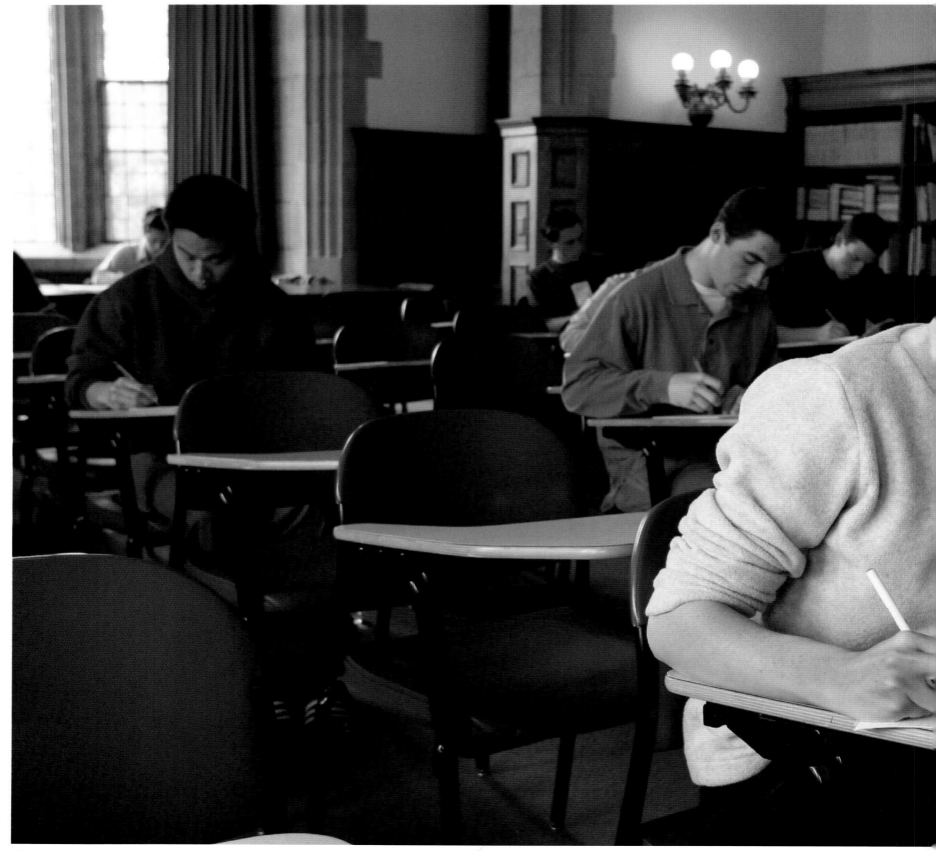

ORONO

With one ecstatic exception, the Class of 2003 files calmly into Alfond Stadium for the University of Maine's 201st commencement. The top academic rankings for the 1,961 seniors turned into quite a battle, with a three-way tie for valedictorian and a four-way tie for salutatorian.
Photo by Michele Stapleton

ORONO

Bottle caps and gown: Krisjand Rothweiler wore part of his bottle cap collection to University of Maine's graduation. An ROTC cadet all four years, Rothweiler will serve as a 2nd lieutenant in Army Intelligence at Ft. Huachuca in Arizona, where he's headed for training immediately after graduation.
Photo by Michele Stapleton

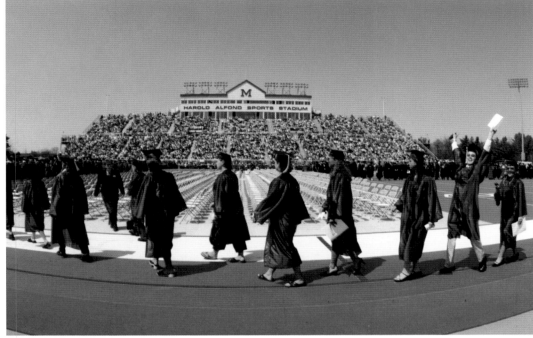

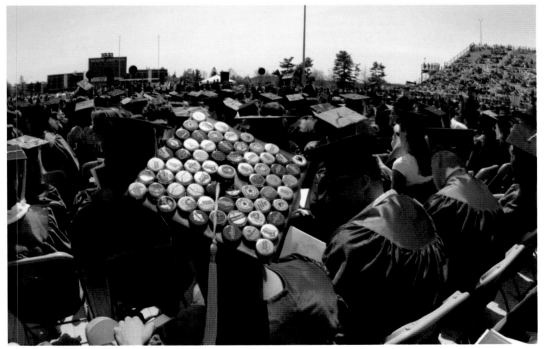

JEFFERSON

Shovels, wash basins, metal sculptures, collectibles, and antiques—name it and he's probably got it. For more than two decades, Dale Weaver has been selling anything and everything on the front lawn of his home in Jefferson, 25 miles east of Augusta. Hagglers welcome.
Photo by Chris Pinchbeck,
Pinchbeck Photography

PORTLAND

Old Port, Portland's derelict brick and cobblestone warehouse district, saw its fortunes turn with the arrival of artists in the 70s, and retail stores in the 90s.
Photo by Jennifer Smith-Mayo

THOMASTON

The window of a waterfront convenience store on the St. Georges River reflects the complexities of America's dependence on foreign oil.
Photo by John Paul Caponigro

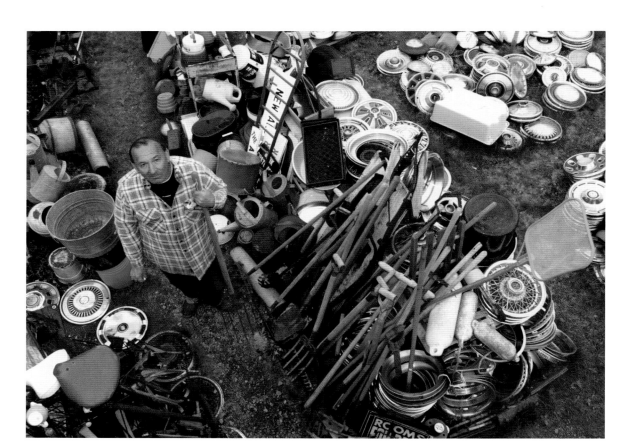

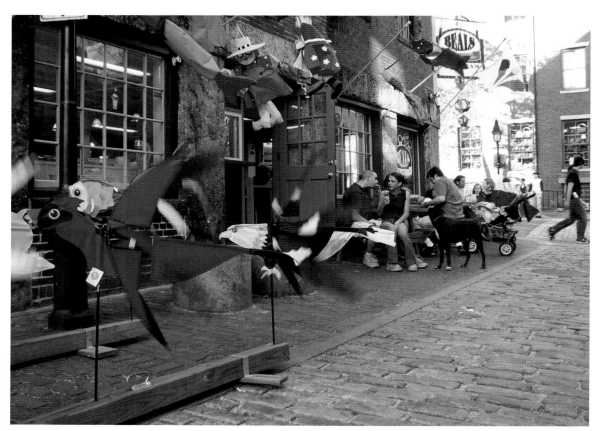

LILY BAY

A cow moose and her bull calf graze in a clearing near Moosehead Lake, a prime moose-watching spot in northern Maine. Moose offspring begin foraging with their mothers at 3 weeks of age. By 5 months, they stop nursing, and after a year, when the bull's antlers have appeared, they head out into the wilderness on their own.

Photo by Stephen M. Katz

CUSHING

Fifteen minutes of fame: This rooster is the star of a small, temporary petting zoo, set up for Mother's Day. The supporting cast includes a lamb, and a turkey.

Photo by John Paul Caponigro

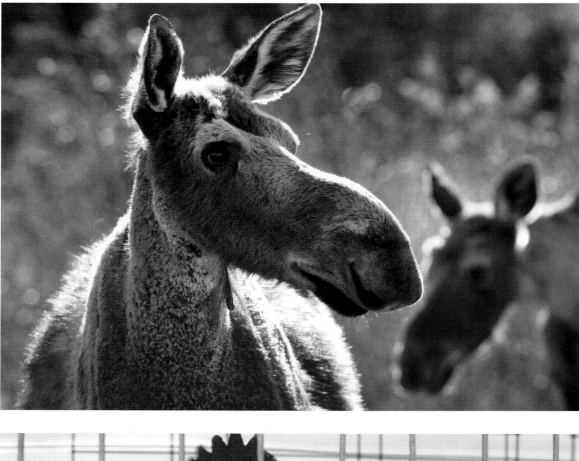

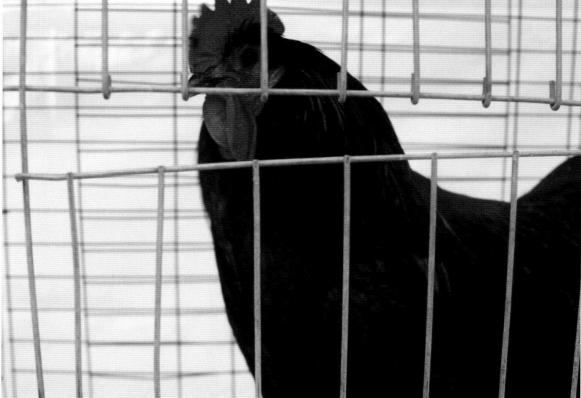

CAPE ELIZABETH

Air apparent: Clodagh, a 3-year-old Irish wolfhound, cools off after a romp in Fort William Park. According to owner Tom Daly, Clodagh likes breezy, cold days and is crazy for snow. "She eats it, rolls in it, and does her business in it," he says.
Photo by Robert F. Bukaty

PISCATAQUIS COUNTY

At West Branch Pond, a cow moose skims the shallows for food. As herbivores who favor aquatic plants like horsetails and pondweed, moose spend much of their time in the water and can swim at speeds of up to 6 miles per hour.
Photo by Stephen M. Katz

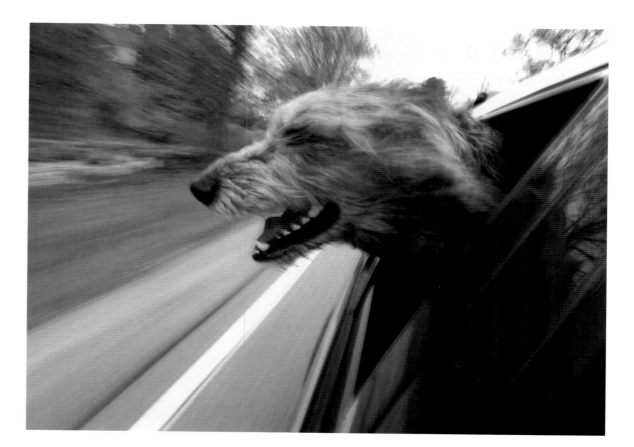

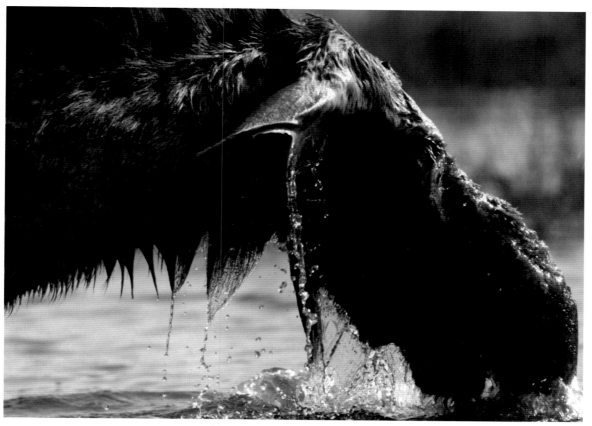

MATINICUS ISLAND

Fishermen use these 14-foot aluminum skiffs to shuttle between their boats, moored offshore, and the wharf on Matinicus Island. The skiffs are hauled out by a system of booms and hydraulic winches.

Photo by Alison Langley

CAPE PORPOISE

The town of Cape Porpoise, founded in 1653 at the mouth of the Kennebunk River in southern Maine, lights up in the morning sun.

Photo by Gregory Rec

MATINICUS ISLAND

Paul Murray's front yard showcases a few staples of Matinicus scenery. The daffodils planted by Murray's wife are ripe for a vase, but the Block Island dragger, once floated for pleasure trips and lobstering, is no longer seaworthy.

Photo by Alison Langley

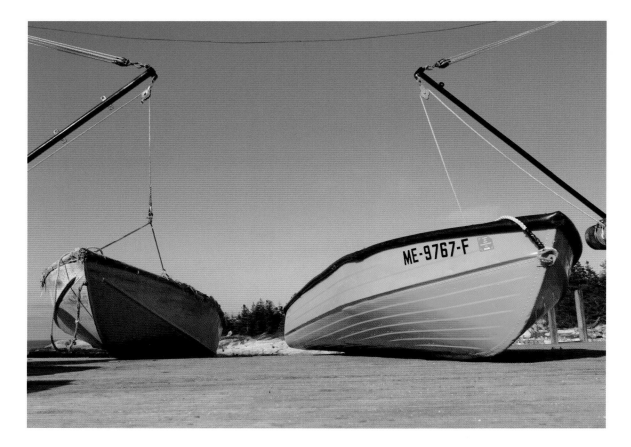

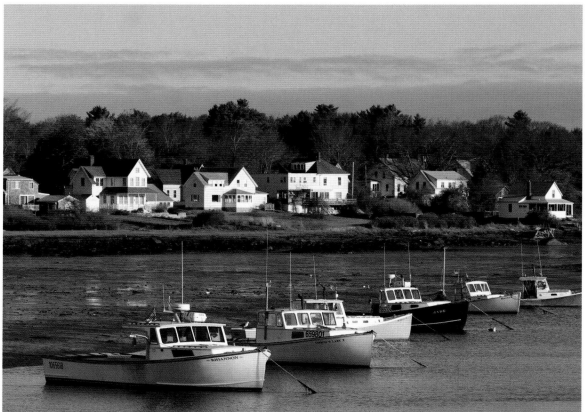

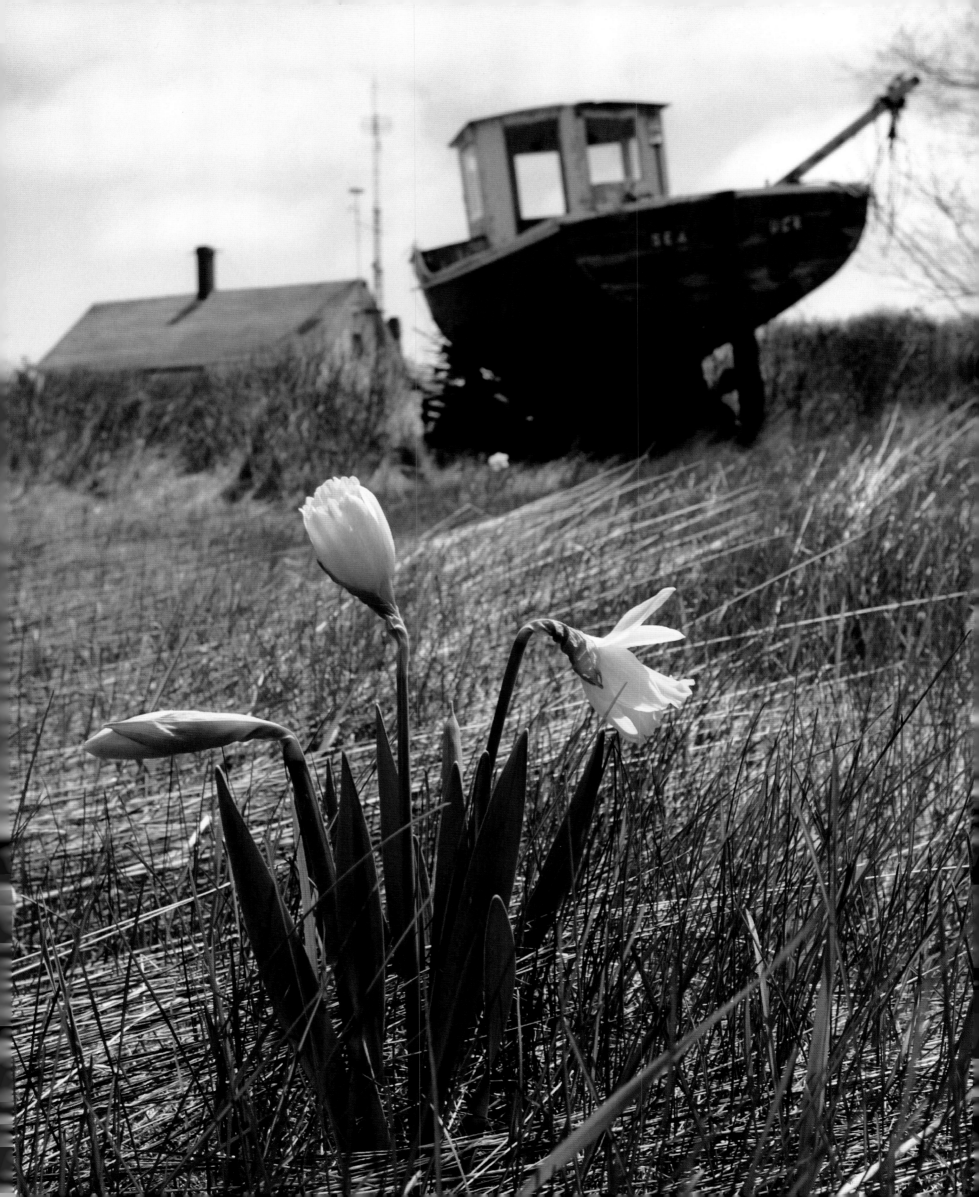

RANGELEY LAKE STATE PARK
At home in the north woods. Significant development has occurred around Rangeley Lake in the past ten years, but most of the new homes (called camps) are used only in the summer.
Photo by José Azel, Aurora

OLD ORCHARD BEACH

Rose Kennedy met her husband Joe in this sleepy resort town, which wakes up with a jolt every summer. That's when 100,000 visitors storm its 7-mile-long sandy beach, the longest in Maine. Many are Canadians; it's their closest beach. Of Maine's 3,478 miles of shoreline, only 35 are lined with sand.
Photo by Suzy Preston

RANGELEY LAKE STATE PARK
Rangeley Lake, at 10 square miles, is
the centerpiece of 112 lakes and ponds in
western Maine. Fishing for the lake's native
brook trout and landlocked salmon begins
from ice out in May and ends in October. The
surrounding park is a haven for kayakers,
mountain bikers, hikers, hunters, cross-
country skiers, and snowmobilers.
Photo by José Azel, Aurora

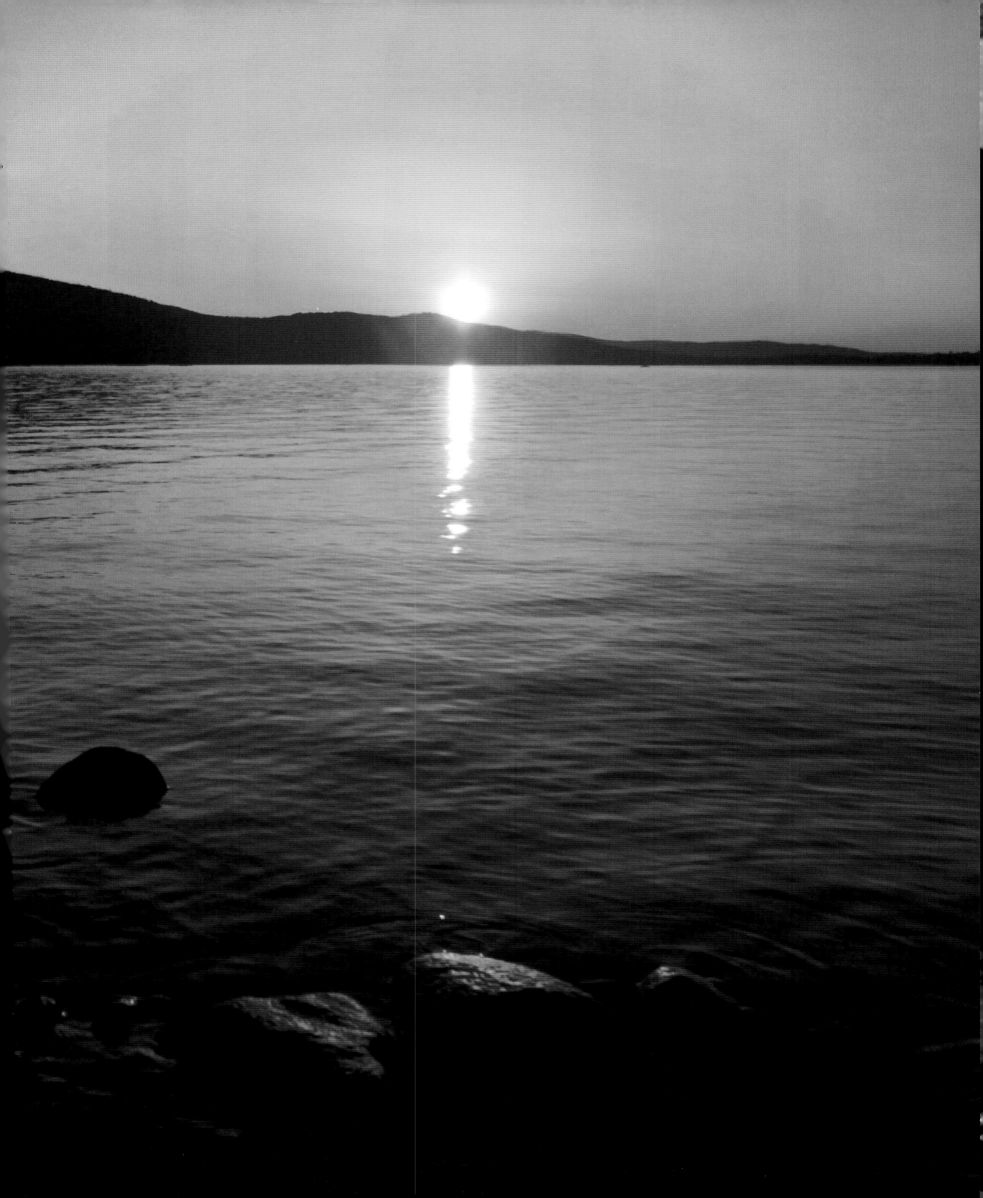

PORTLAND
A crane and oil rig tower over Portland's waterfront and Back Cove. Two rigs are being constructed at the old Bath Iron Works repair facility. When completed, the 324-foot-high, 12,000-ton rigs will be put to work in the Gulf of Mexico or the Atlantic Ocean.
Photo by Robert F. Bukaty

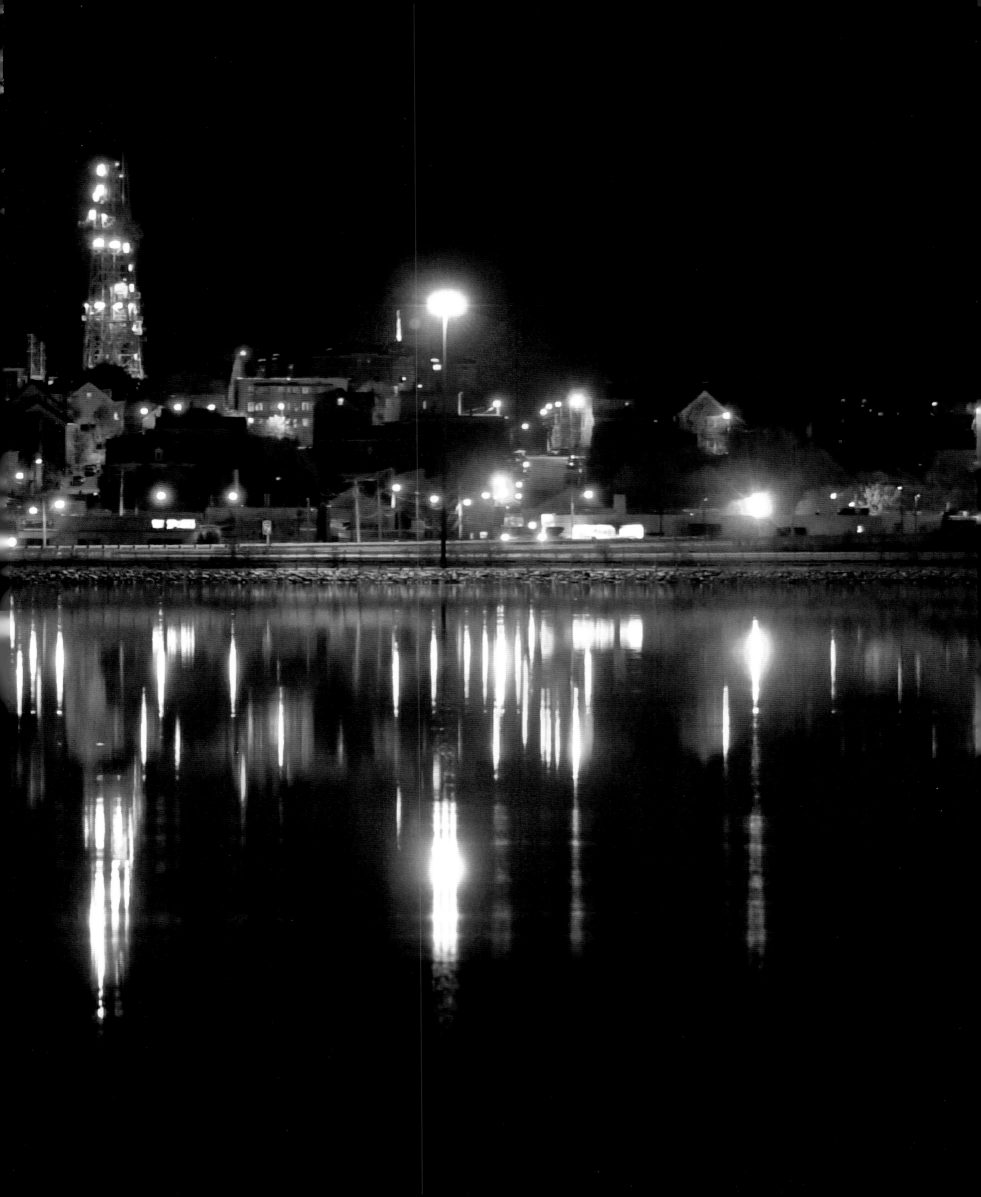

How It Worked

The week of May 12-18, 2003, more than 25,000 professional and amateur photographers spread out across the nation to shoot over a million digital photographs with the goal of capturing the essence of daily life in America.

The professional photographers were equipped with Adobe Photoshop and Adobe Album software, Olympus C-5050 digital cameras, and Lexar Media's high-speed compact flash cards.

The 1,000 professional contract photographers plus another 5,000 stringers and students sent their images via FTP (file transfer protocol) directly to the *America 24/7* website. Meanwhile, thousands of amateur photographers uploaded their images to Snapfish's servers.

At *America 24/7*'s Mission Control headquarters, located at CNET in San Francisco, dozens of picture editors from the nation's most prestigious publications culled the images down to 25,000 of the very best, using Photo Mechanic by Camera Bits. These photos were transferred into Webware's ActiveMedia Digital Asset Management (DAM) system, which served as a central image library and enabled the designers to track, search, distribute, and reformat the images for the creation of the 51 books, foreign language editions, web and magazine syndication, posters, and exhibitions.

Once in the DAM, images were optimized (and in some cases resampled to increase image resolution) using Adobe Photoshop. Adobe InDesign and Adobe InCopy were used to design and produce the 51 books, which were edited and reviewed in multiple locations around the world in the form of Adobe Acrobat PDFs. Epson Stylus printers were used for photo proofing and to produce large-format images for exhibitions. The companies providing support for the *America 24/7* project offer many of the essential components for anyone building a digital darkroom. We encourage you to read more on the following pages about their respective roles in making *America 24/7* possible.

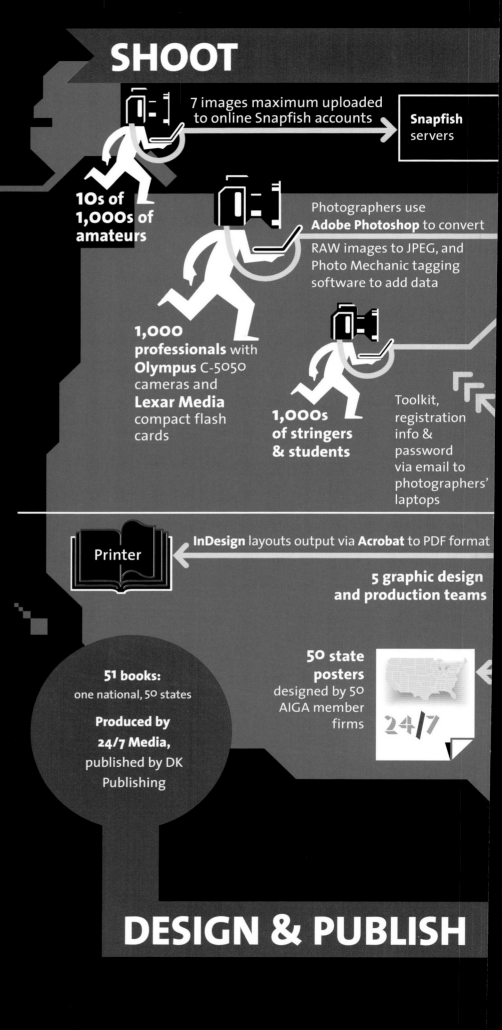

SHOOT

7 images maximum uploaded to online Snapfish accounts

Snapfish servers

10s of 1,000s of amateurs

Photographers use **Adobe Photoshop** to convert RAW images to JPEG, and Photo Mechanic tagging software to add data

1,000 professionals with **Olympus** C-5050 cameras and **Lexar Media** compact flash cards

1,000s of stringers & students

Toolkit, registration info & password via email to photographers' laptops

Printer

InDesign layouts output via **Acrobat** to PDF format

5 graphic design and production teams

51 books: one national, 50 states

Produced by 24/7 Media, published by DK Publishing

50 state posters designed by 50 AIGA member firms

24/7

DESIGN & PUBLISH

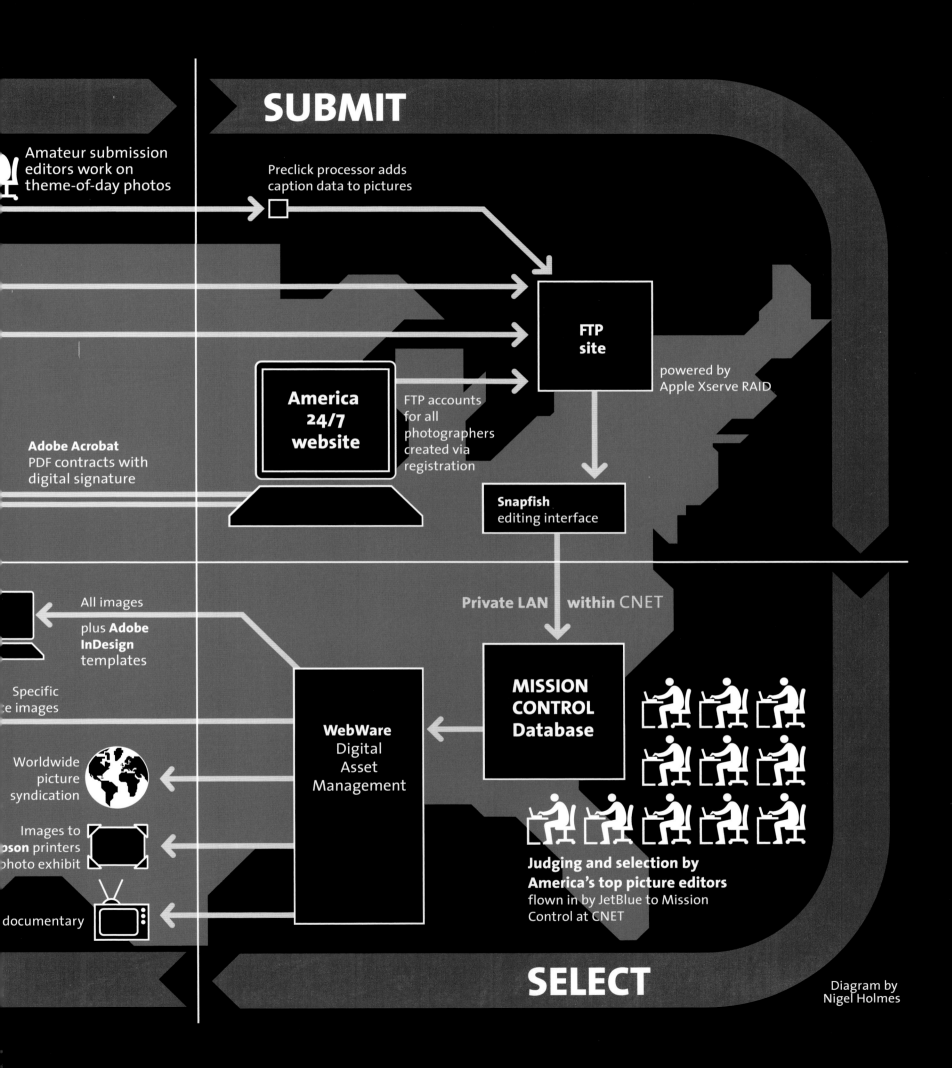

SUBMIT

Amateur submission
editors work on
theme-of-day photos

Preclick processor adds
caption data to pictures

**FTP
site**

powered by
Apple Xserve RAID

**America
24/7
website**

FTP accounts
for all
photographers
created via
registration

Adobe Acrobat
PDF contracts with
digital signature

Snapfish
editing interface

All images

plus **Adobe
InDesign**
templates

Private LAN **within** CNET

Specific
e images

**MISSION
CONTROL
Database**

WebWare
Digital
Asset
Management

Worldwide
picture
syndication

Images to
son printers
hoto exhibit

**Judging and selection by
America's top picture editors**
flown in by JetBlue to Mission
Control at CNET

documentary

SELECT

Diagram by
Nigel Holmes

About Our Sponsors

America 24/7 gave digital photographers of all levels the opportunity to share their visions of what it means to live in the United States. This project was made possible by a digital photography revolution that is dramatically changing and improving picture-taking for professionals and amateurs alike. And an Adobe product, Photoshop®, has been at the center of this sea change.

Adobe's products reflect our customers' passion for the creative process, be it the photographer, graphic designer, layout artist, or printer. Adobe is the Publishing and Imaging Software Partner for *America 24/7* and products such as Adobe InDesign®, Photoshop, Acrobat®, and Illustrator® were used to produce this stunning book in a matter of weeks. We hope that our software has helped do justice to the mythic images, contributed by well-known photographers and the inspired hobbyist.

Adobe is proud to be a lead sponsor of *America 24/7*, a project that celebrates the vibrancy of the American spirit: the same spirit that helped found Adobe and inspires our employees and customers to deliver the very best.

Bruce Chizen
President and CEO
Adobe Systems Incorporated

Olympus, a global technology leader in designing precision healthcare solutions and innovative consumer electronics, is proud to be the official digital camera sponsor of *America 24/7*. The opportunity to introduce Americans from coast to coast to the thrill, excitement, and possibility of digital photography makes the vision behind this book a perfect fit for Olympus, a leader in digital cameras since 1996.

For most people, the essence of digital photography is best grasped through firsthand experience with the technology, which is precisely what *America 24/7* is about. We understand that direct experience is the pathway to inspiration, and welcome opportunities like this sponsorship to bring the power of the digital experience into the lives of people everywhere. To Olympus, *America 24/7* offers a platform to help realize a core mission: to deliver and make accessible the power of the digital experience to millions of American photographers, amateurs, and professionals alike.

The 1,000 professional photographers contracted to shoot on the America 24/7 project were all equipped with Olympus C-5050 digital cameras. Like all Olympus products, the C-5050 is offered by a company well known for designing, manufacturing, and servicing products used by professionals to perform their work, every day. Olympus is a customer-centric company committed to working one-to-one with a diverse group of professionals. From biomedical researchers who use our clinical microscopes, to doctors who perform life-saving procedures with our endoscopes, to professional photographers who use cameras in their daily work, Olympus is a trusted brand.

The digital imaging technology involved with *America 24/7* has enabled the soul of America to be visually conveyed, not just by professional observers, but by the American public who participated in this project—the very people who collectively breath life into this country's existence each day.

We are proud to be enabling so many photographers to capture the pictures on these pages that tell the story of who we are as a nation. From sea to shining sea, digital imagery allows us to connect to one another in ways we never dreamed possible.

At Olympus, our ideas have proliferated as rapidly as technology has evolved. We have channeled these visions into breakthrough products and solutions to meet the demands of our changing world- products like microscopes, endoscopes, and digital voice recorders, supported by the highly regarded training, educational, and consulting services we offer our customers.

Today, 83 years after we introduced our first microscope, we remain as young, as curious, and as committed as ever.

Lexar Media has grown from the digital photography revolution, which is why we are proud to have supplied the digital memory cards used in the America 24/7 project. Lexar Media's high-performance memory cards utilize our unique and patented controller coupled with high-speed flash memory from Samsung, the world's largest flash memory supplier. This powerful combination brings out the ultimate performance of any digital camera.

Photographers who demand the most from their equipment choose our products for their advanced features like write speeds up to 40X, Write Acceleration technology for enabled cameras, and Image Rescue, which recovers previously deleted or lost images. Leading camera manufacturers bundle Lexar Media digital memory cards with their cameras because they value its performance and reliability.

Lexar Media is at the forefront of digital photography as it transforms picture-taking worldwide, and we will continue to be a leader with new and innovative solutions for professionals and amateurs alike.

Snapfish, which developed the technology behind the *America 24/7* amateur photo event, is a leading online photo service, with more than 5 million members and 100 million photos posted online. Snapfish enables both film and digital camera owners to share, print, and store their most important photo memories, at prices that cannot be equaled. Digital camera users upload photos into a password-protected online album for free. Users can also order film-quality prints on professional photographic paper for as low as 25¢. Film camera users get a full set of prints, plus online sharing and storage, for just $2.99 per roll.

Founded in 1995, eBay created a powerful platform for the sale of goods and services by a passionate community of individuals and businesses. On any given day, there are millions of items across thousands of categories for sale on eBay. eBay enables trade on a local, national and international basis with customized sites in markets around the world.

Through an array of services, such as its payment solution provider PayPal, eBay is enabling global e-commerce for an ever-growing online community.

JetBlue Airways is proud to be *America 24/7's* preferred carrier, flying photographers, photo editors, and organizers across the United States.

Winner of Condé Nast Traveler's Readers' Choice Awards for Best Domestic Airline 2002, JetBlue provides friendly service and low fares for travelers in 22 cities in nine states across America.

On behalf of JetBlue's 5,000 crew members, we're excited to be involved in this remarkable project, and for the opportunity to serve American travelers each and every day, coast to coast, 24/7.

Digital Pond has been a leading creator of large graphic displays for museums, corporations, trade shows, retail environments and fine art since 1992.

We were proud to bring together our creative, print and display capabilities to produce signage and displays for mission control, critical retouching for numerous key images for the book, and art galleries for the New York Public Library and Bryant Park.

The Pond's team and SplashPic® Online service enabled us to nimbly design, produce and install over 200 large graphic panels in two NYC locations within the truly "24/7" production schedule of less than ten days.

WebWare Corporation is pleased to be a major sponsor of the America 24/7 project. We take pride in being part of a groundbreaking adventure that is stretching the boundaries—and the imagination—in digital photography, digital asset management, publishing, news, and global events.

Our ActiveMedia Enterprise™ digital asset management software is the "nerve center" of *America 24/7*, the central repository for managing, sharing, and collaborating on the project's photographs. From photo editors and book publishers to 24/7's media relations and marketing personnel, ActiveMedia provides the application support that links all facets of the project team to the content worldwide.

WebWare helps Global 2000 firms securely manage, reuse, and distribute media assets locally or globally. Its suite of ActiveMedia software products provide powerful media services platforms for integrating rich media into content management systems marketing and communication portals; web publishing systems; and e-commerce portals.

Google's mission is to organize the world's information and make it universally accessible and useful.

With our focus on plucking just the right answer from an ocean of data, we were naturally drawn to the America 24/7 project. The book you hold is a compendium of images of American life distilled from thousands of photographs and infinite possibilities. Are you looking for emotion? Narrative? Shadows? Light? It's all here, thanks to a multitude of photographers and writers creating links between you, the reader, and a sea of wonderful stories. We celebrate the connections that constitute the human experience and are pleased to help engender them. And we're pleased to have been a small part of this project, which captures the results of that interaction so vividly, so dynamically, and so dramatically.

Special thanks to additional contributors: FileMaker, Apple, Camera Bits, LaCie, Now Software, Preclick, Outpost Digital, Xerox, Microsoft, WoodWing Software, net-linx Publishing Solutions, and Radical Media. The Savoy Hotel, San Francisco; The Pan Pacific, San Francisco; Four Seasons Hotel, San Francisco; and The Queen Anne Hotel. Photography editing facilities were generously hosted by CNET Networks, Inc.

Participating Photographers

Coordinator: José Azel, Aurora

José Azel, Aurora
Kevin Bennett, *Bangor Daily News*
Rob Bernstein
Bridget Besaw Gorman, Aurora
Robert F. Bukaty*
John Paul Caponigro
Denis Clark
Thatcher Hullerman Cook, Thatcher
Cook Photography
Cy Jariz Cyr
Alexandra C. Daley-Clark
Jim Daniels
Judith Harris
Nancy Jervey
Stephen M. Katz
Blake Lagasse
Alison Langley

Serge J-F. Levy
James Marshall, Corbis
David McLain, Aurora
Shawn Patrick Ouellette
Chris Pinchbeck, Pinchbeck Photography
Suzy Preston
Gregory Rec
Jennifer Smith-Mayo
Michele Stapleton
Jeffrey Stevensen
Amy Toensing
Dianna Townsend
Nycole Tremblay
Nance S. Trueworthy
Carl D. Walsh, Aurora
Shoshannah White, Aurora

*Pulitzer Prize winner

Thumbnail Picture Credits

Credits for thumbnail photographs are listed by the page number and are in order from left to right.

20 Nance S. Trueworthy
Suzy Preston
David McLain, Aurora
Suzy Preston
Nance S. Trueworthy
David McLain, Aurora
Michele Stapleton

21 Robert F. Bukaty
David McLain, Aurora
Nance S. Trueworthy
Suzy Preston
Michele Stapleton
Shoshannah White, Aurora
David McLain, Aurora

22 Amy Toensing
David McLain, Aurora
Bridget Besaw Gorman, Aurora
James Marshall, Corbis
Michele Stapleton
Stephen M. Katz
James Marshall, Corbis

23 David McLain, Aurora
Bridget Besaw Gorman, Aurora
David McLain, Aurora
Stephen M. Katz
Alexandra C. Daley-Clark
Thatcher Hullerman Cook,
Thatcher Cook Photography
Bridget Besaw Gorman, Aurora

24 Shawn Patrick Ouellette
Shawn Patrick Ouellette
Shawn Patrick Ouellette
Shawn Patrick Ouellette
Shawn Patrick Ouellette
Shawn Patrick Ouellette
Shawn Patrick Ouellette

25 Shawn Patrick Ouellette
Shawn Patrick Ouellette
Shawn Patrick Ouellette
Shawn Patrick Ouellette
Shawn Patrick Ouellette
Shawn Patrick Ouellette
Shawn Patrick Ouellette
Shawn Patrick Ouellette

27 Shawn Patrick Ouellette
Shawn Patrick Ouellette
Shawn Patrick Ouellette
Shawn Patrick Ouellette
Shawn Patrick Ouellette
Shawn Patrick Ouellette
Shawn Patrick Ouellette

28 Jeffrey Stevensen
Alexandra C. Daley-Clark
Gregory Rec
Alexandra C. Daley-Clark
Amy Toensing
Carl D. Walsh, Aurora
Gregory Rec

29 Carl D. Walsh, Aurora
Serge J-F. Levy
James Marshall, Corbis
José Azel, Aurora
Nance S. Trueworthy
Stephen M. Katz
Nance S. Trueworthy

33 Amy Toensing
Michele Stapleton
Michele Stapleton
Michele Stapleton
Amy Toensing
Michele Stapleton
Michele Stapleton

34 Amy Toensing
Thatcher Hullerman Cook,
Thatcher Cook Photography
Gregory Rec
Gregory Rec
John Paul Caponigro
James Marshall, Corbis
Michele Stapleton

35 Suzy Preston
Gregory Rec
Thatcher Hullerman Cook,
Thatcher Cook Photography
Alison Langley
Gregory Rec
Thatcher Hullerman Cook,
Thatcher Cook Photography
Thatcher Hullerman Cook,
Thatcher Cook Photography

36 Shawn Patrick Ouellette
Alexandra C. Daley-Clark
Alison Langley
Shawn Patrick Ouellette
Carl D. Walsh, Aurora
Carl D. Walsh, Aurora
John Paul Caponigro

37 Jennifer Smith-Mayo
John Paul Caponigro
Carl D. Walsh, Aurora

Thatcher Hullerman Cook,
Thatcher Cook Photography
Thatcher Hullerman Cook,
Thatcher Cook Photography
Thatcher Hullerman Cook,
Thatcher Cook Photography
Carl D. Walsh, Aurora

38 Carl D. Walsh, Aurora
Thatcher Hullerman Cook,
Thatcher Cook Photography
Shawn Patrick Ouellette
Shawn Patrick Ouellette
Shawn Patrick Ouellette
Shawn Patrick Ouellette
James Marshall, Corbis

39 Shawn Patrick Ouellette
Carl D. Walsh, Aurora
Shawn Patrick Ouellette
Shawn Patrick Ouellette
Thatcher Hullerman Cook,
Thatcher Cook Photography
Thatcher Hullerman Cook,
Thatcher Cook Photography
Shawn Patrick Ouellette

48 Alison Langley
Alison Langley
Stephen M. Katz
Alexandra C. Daley-Clark
Stephen M. Katz
Stephen M. Katz
Stephen M. Katz

49 Alison Langley
Cy Jariz Cyr
Alison Langley
Stephen M. Katz
Stephen M. Katz
Stephen M. Katz
Alexandra C. Daley-Clark

50 Bridget Besaw Gorman, Aurora
Alison Langley
Bridget Besaw Gorman, Aurora
Alison Langley
Alexandra C. Daley-Clark
Alexandra C. Daley-Clark
Bridget Besaw Gorman, Aurora

51 Carl D. Walsh, Aurora
Bridget Besaw Gorman, Aurora
Bridget Besaw Gorman, Aurora
Stephen M. Katz
Deb Cram, *Portsmouth Herald*
Jim Daniels
Bridget Besaw Gorman, Aurora

53 Jeffrey Stevensen
Jeffrey Stevensen
Jeffrey Stevensen
Jeffrey Stevensen
Jeffrey Stevensen
Jeffrey Stevensen

54 Alison Langley
Alison Langley
Alison Langley
Tim Byrne
Alison Langley
Jim Daniels
Alison Langley

55 Alison Langley
Alison Langley
Alison Langley
Jim Daniels
José Azel, Aurora
Jim Daniels
Alison Langley

56 Bridget Besaw Gorman, Aurora
Jim Daniels
Jim Daniels
Jim Daniels
Jim Daniels
Michele Stapleton
Jim Daniels

57 Jim Daniels
Jim Daniels
Jim Daniels

Nance S. Trueworthy
Jim Daniels
Stephen M. Katz
Alexandra C. Daley-Clark

60 Robert F. Bukaty
Alison Langley
Robert F. Bukaty
James Marshall, Corbis
Robert F. Bukaty
Jim Daniels
Nance S. Trueworthy

61 Jim Daniels
Robert F. Bukaty
Stephen M. Katz
Robert F. Bukaty
Tim Byrne
Robert F. Bukaty
Stephen M. Katz

63 Shawn Patrick Ouellette
Shawn Patrick Ouellette
Jim Daniels
Shawn Patrick Ouellette
Jim Daniels
Jim Daniels
Jim Daniels

64 Alexandra C. Daley-Clark
Kevin Bennett, *Bangor Daily News*
Kevin Bennett, *Bangor Daily News*
Kevin Bennett, *Bangor Daily News*
José Azel, Aurora
Kevin Bennett, *Bangor Daily News*
Alexandra C. Daley-Clark

65 Kevin Bennett, *Bangor Daily News*
Jennifer Smith-Mayo
Kevin Bennett, *Bangor Daily News*
David McLain, Aurora
Kevin Bennett, *Bangor Daily News*
Kevin Bennett, *Bangor Daily News*
Alexandra C. Daley-Clark

67 Robert F. Bukaty
Robert F. Bukaty
Jim Daniels
Robert F. Bukaty
Jeffrey Stevensen
Alexandra C. Daley-Clark
Robert F. Bukaty

68 Nance S. Trueworthy
Bridget Besaw Gorman, Aurora
Jeffrey Stevensen
Jim Daniels
Jeffrey Stevensen
David McLain, Aurora
Jeffrey Stevensen

69 Jeffrey Stevensen
Jeffrey Stevensen
Bridget Besaw Gorman, Aurora
Carl D. Walsh, Aurora
Jeffrey Stevensen
Jim Daniels
Jim Daniels

70 David McLain, Aurora
Alexandra C. Daley-Clark
Gregory Rec
Gregory Rec
Gregory Rec
Gregory Rec
Gregory Rec

71 Jeffrey Stevensen
Jeffrey Stevensen
Gregory Rec
James Marshall, Corbis
Suzy Preston
Stephen M. Katz
Thatcher Hullerman Cook,
 Thatcher Cook Photography

72 Amy Toensing
Alexandra C. Daley-Clark
Carl D. Walsh, Aurora
James Marshall, Corbis
Cy Jariz Cyr
James Marshall, Corbis
Shoshannah White, Aurora

73 Michele Stapleton
Alexandra C. Daley-Clark
Michele Stapleton
Michele Stapleton
Cy Jariz Cyr
Michele Stapleton
Nance S. Trueworthy

74 Chris Pinchbeck, Pinchbeck Photography
Chris Pinchbeck, Pinchbeck Photography
Chris Pinchbeck, Pinchbeck Photography
Chris Pinchbeck, Pinchbeck Photography
Chris Pinchbeck, Pinchbeck Photography
Chris Pinchbeck, Pinchbeck Photography
Chris Pinchbeck, Pinchbeck Photography

75 Chris Pinchbeck, Pinchbeck Photography
Chris Pinchbeck, Pinchbeck Photography
Chris Pinchbeck, Pinchbeck Photography
Chris Pinchbeck, Pinchbeck Photography
Chris Pinchbeck, Pinchbeck Photography
Alexandra C. Daley-Clark

78 Michele Stapleton
Michele Stapleton
Michele Stapleton
Michele Stapleton
Stephen M. Katz
Michele Stapleton
Michele Stapleton

79 Michele Stapleton
Michele Stapleton
Michele Stapleton
Stephen M. Katz
Michele Stapleton
Michele Stapleton
Michele Stapleton

81 Jeffrey Stevensen
Jeffrey Stevensen
Jeffrey Stevensen
Jeffrey Stevensen
Jeffrey Stevensen
Jeffrey Stevensen
Jeffrey Stevensen

82 Thatcher Hullerman Cook,
Thatcher Cook Photography
Jim Daniels
Jim Daniels
James Marshall, Corbis
Jim Daniels
Jim Daniels
Thatcher Hullerman Cook,
Thatcher Cook Photography

83 Stephen M. Katz
Thatcher Hullerman Cook,
Thatcher Cook Photography
Stephen M. Katz
Stephen M. Katz
Thatcher Hullerman Cook,
Thatcher Cook Photography
Jim Daniels
Jim Daniels

86 Robert F. Bukaty
Suzy Preston
Alexandra C. Daley-Clark
Robert F. Bukaty
Robert F. Bukaty
Robert F. Bukaty
Suzy Preston

87 James Marshall, Corbis
Robert F. Bukaty
Robert F. Bukaty
Robert F. Bukaty
Robert F. Bukaty
Shawn Patrick Ouellette
Alexandra C. Daley-Clark

92 Amy Toensing
Gregory Rec
James Marshall, Corbis
Gregory Rec
Michele Stapleton
Gregory Rec
James Marshall, Corbis

93 Michele Stapleton
James Marshall, Corbis
Gregory Rec
Michele Stapleton
Michele Stapleton
James Marshall, Corbis
Michele Stapleton

94 Chris Pinchbeck, Pinchbeck Photography
Chris Pinchbeck, Pinchbeck Photography
Chris Pinchbeck, Pinchbeck Photography
Chris Pinchbeck, Pinchbeck Photography
Carl D. Walsh, Aurora
Chris Pinchbeck, Pinchbeck Photography
Chris Pinchbeck, Pinchbeck Photography

95 Chris Pinchbeck, Pinchbeck Photography
Chris Pinchbeck, Pinchbeck Photography
Chris Pinchbeck, Pinchbeck Photography
Chris Pinchbeck, Pinchbeck Photography
Carl D. Walsh, Aurora
Chris Pinchbeck, Pinchbeck Photography

96 Jeffrey Stevensen
Jeffrey Stevensen
Jeffrey Stevensen
Jeffrey Stevensen
Jeffrey Stevensen
Jeffrey Stevensen

97 Jeffrey Stevensen
Jeffrey Stevensen
Jeffrey Stevensen
Jeffrey Stevensen
Jeffrey Stevensen
Jeffrey Stevensen

98 Bridget Besaw Gorman, Aurora
Stephen M. Katz
José Azel, Aurora
Stephen M. Katz
José Azel, Aurora
José Azel, Aurora
José Azel, Aurora

99 José Azel, Aurora
Shawn Patrick Ouellette
José Azel, Aurora
Stephen M. Katz
Shawn Patrick Ouellette
Shawn Patrick Ouellette
Suzy Preston

102 Robert F. Bukaty
Robert F. Bukaty
Robert F. Bukaty
Robert F. Bukaty
Robert F. Bukaty
Robert F. Bukaty
Robert F. Bukaty

104 Amy Toensing
Carl D. Walsh, Aurora
José Azel, Aurora
Michele Stapleton
Carl D. Walsh, Aurora
Carl D. Walsh, Aurora
Nance S. Trueworthy

105 Stephen M. Katz
Nance S. Trueworthy
Michele Stapleton
Stephen M. Katz
José Azel, Aurora
Stephen M. Katz
Michele Stapleton

106 Alexandra C. Daley-Clark
José Azel, Aurora
Alexandra C. Daley-Clark
Alexandra C. Daley-Clark
Robert F. Bukaty
Alexandra C. Daley-Clark
Alexandra C. Daley-Clark

107 Alexandra C. Daley-Clark
Jim Daniels
Alexandra C. Daley-Clark
José Azel, Aurora
Alexandra C. Daley-Clark
Jim Daniels
Robert F. Bukaty

110 Michele Stapleton
Michele Stapleton
Michele Stapleton
Michele Stapleton
Michele Stapleton
Michele Stapleton

112 James Marshall, Corbis
Gregory Rec
Nance S. Trueworthy
Shawn Patrick Ouellette
Carl D. Walsh, Aurora
Shawn Patrick Ouellette
Carl D. Walsh, Aurora

113 Serge J-F. Levy
Shawn Patrick Ouellette
Gregory Rec
Shawn Patrick Ouellette
Shawn Patrick Ouellette
Carl D. Walsh, Aurora
Shawn Patrick Ouellette

118 Amy Toensing
Amy Toensing
Amy Toensing
Amy Toensing
Amy Toensing
Amy Toensing
Amy Toensing

119 Amy Toensing
Amy Toensing
Amy Toensing
Amy Toensing
Amy Toensing
Amy Toensing
Amy Toensing

124 Alexandra C. Daley-Clark
Robert F. Bukaty
Jim Daniels
Jeffrey Stevensen
James Marshall, Corbis
Robert F. Bukaty
Kevin Bennett, *Bangor Daily News*

125 Robert F. Bukaty
Nance S. Trueworthy
Robert F. Bukaty
James Marshall, Corbis
Robert F. Bukaty
James Marshall, Corbis
Nance S. Trueworthy

128 José Azel, Aurora
José Azel, Aurora
José Azel, Aurora
José Azel, Aurora
John Paul Caponigro
José Azel, Aurora
José Azel, Aurora

129 John Paul Caponigro
José Azel, Aurora
José Azel, Aurora
Kevin Bennett, *Bangor Daily News*
Jim Daniels
Kevin Bennett, *Bangor Daily News*
Kevin Bennett, *Bangor Daily News*

131 John Paul Caponigro
John Paul Caponigro
José Azel, Aurora
John Paul Caponigro
John Paul Caponigro
John Paul Caponigro
John Paul Caponigro

134 Alison Langley
José Azel, Aurora
Alexandra C. Daley-Clark
Carl D. Walsh, Aurora
James Marshall, Corbis
Alexandra C. Daley-Clark
Alexandra C. Daley-Clark

135 John Paul Caponigro
Alexandra C. Daley-Clark
James Marshall, Corbis
Cy Jariz Cyr
James Marshall, Corbis
Jennifer Smith-Mayo
James Marshall, Corbis

136 James Marshall, Corbis
James Marshall, Corbis
Carl D. Walsh, Aurora
Jeffrey Stevensen
Thatcher Hullerman Cook,
Thatcher Cook Photography
James Marshall, Corbis
Jeffrey Stevensen

137 James Marshall, Corbis
Jeffrey Stevensen
Suzy Preston
Suzy Preston
James Marshall, Corbis
Thatcher Hullerman Cook,
Thatcher Cook Photography
James Marshall, Corbis

138 Carl D. Walsh, Aurora
Michele Stapleton
Michele Stapleton
James Marshall, Corbis
Thatcher Hullerman Cook,
Thatcher Cook Photography
Michele Stapleton
James Marshall, Corbis

139 James Marshall, Corbis
Thatcher Hullerman Cook,
Thatcher Cook Photography
Michele Stapleton
Thatcher Hullerman Cook,
Thatcher Cook Photography
Michele Stapleton
Thatcher Hullerman Cook,
Thatcher Cook Photography
Thatcher Hullerman Cook,
Thatcher Cook Photography

140 Jennifer Smith-Mayo
Chris Pinchbeck, Pinchbeck Photography
Jennifer Smith-Mayo
Jennifer Smith-Mayo
Jennifer Smith-Mayo
John Paul Caponigro
Jennifer Smith-Mayo

142 Nance S. Trueworthy
Stephen M. Katz
Nance S. Trueworthy
Alexandra C. Daley-Clark
John Paul Caponigro
Carl D. Walsh, Aurora
Kevin Bennett, *Bangor Daily News*

143 Stephen M. Katz
Robert F. Bukaty
Stephen M. Katz
John Paul Caponigro
Stephen M. Katz
Nance S. Trueworthy
Stephen M. Katz

144 Alison Langley
Alison Langley
Alison Langley
Gregory Rec
Jennifer Smith-Mayo
Alison Langley
Alexandra C. Daley-Clark

Staff

The *America 24/7* series was imagined years ago by our friend Oscar Dystel, a publishing legend whose vision and enthusiasm have been a source of great inspiration.

We also wish to express our gratitude to our truly visionary publisher, DK.

Rick Smolan, Project Director
David Elliot Cohen, Project Director

Administrative
Katya Able, Operations Director
Gina Privitere, Communications Director
Chuck Gathard, Technology Director
Kim Shannon, Photographer Relations Director
Erin O'Connor, Photographer Relations Intern
Leslie Hunter, Partnership Director
Annie Polk, Publicity Manager
John McAlester, Website Manager
Alex Notides, Office Manager
C. Thomas Hardin, State Photography Coordinator

Design
Brad Zucroff, Creative Director
Karen Mullarkey, Photography Director
Judy Zimola, Production Manager
David Simoni, Production Designer
Mary Dias, Production Designer
Heidi Madison, Associate Picture Editor
Don McCartney, Production Designer
Diane Dempsey Murray, Production Designer
Jan Rogers, Associate Picture Editor
Bill Shore, Production Designer and Image Artist
Larry Nighswander, Senior Picture Editor
Bill Marr, Sarah Leen, Senior Picture Editors
Peter Truskier, Workflow Consultant
Jim Birkenseer, Workflow Consultant

Editorial
Maggie Canon, Managing Editor
Curt Sanburn, Senior Editor
Teresa L. Trego, Production Editor
Lea Aschkenas, Writer
Olivia Boler, Writer
Korey Capozza, Writer
Beverly Hanly, Writer
Bridgett Novak, Writer
Alison Owings, Writer
Fred Raker, Writer
Joe Wolff, Writer
Elise O'Keefe, Copy Chief
Daisy Hernández, Copy Editor
Jennifer Wolfe, Copy Editor

Infographic Design
Nigel Holmes

Literary Agent
Carol Mann, The Carol Mann Agency

Legal Counsel
Barry Reder, Coblentz, Patch, Duffy & Bass, LLP
Phil Feldman, Coblentz, Patch, Duffy & Bass, LLP
Gabe Perle, Ohlandt, Greeley, Ruggiero & Perle, LLP
Jon Hart, Dow, Lohnes & Albertson, PLLC
Mike Hays, Dow, Lohnes & Albertson, PLLC
Stephen Pollen, Warshaw Burstein, Cohen, Schlesinger & Kuh, LLP
Rick Pappas

Accounting and Finance
Rita Dulebohn, Accountant
Robert Powers, Calegari, Morris & Co. Accountants
Eugene Blumberg, Blumberg & Associates
Arthur Langhaus, KLS Professional Advisors Group, Inc.

Picture Editors
J. David Ake, Associated Press
Caren Alpert, formerly *Health* magazine
Simon Barnett, *Newsweek*
Caroline Couig, *San Jose Mercury News*
Mike Davis, formerly *National Geographic*
Michel duCille, *Washington Post*
Deborah Dragon, *Rolling Stone*
Victor Fisher, formerly Associated Press
Frank Folwell, *USA Today*
MaryAnne Golon, *Time*
Liz Grady, formerly *National Geographic*
Randall Greenwell, *San Francisco Chronicle*
C. Thomas Hardin, formerly *Louisville Courier-Journal*
Kathleen Hennessy, *San Francisco Chronicle*
Scot Jahn, *U.S. News & World Report*
Steve Jessmore, *Flint Journal*
John Kaplan, University of Florida
Kim Komenich, *San Francisco Chronicle*
Eliane Laffont, *Hachette Filipacchi Media*
Jean-Pierre Laffont, *Hachette Filipacchi Media*
Andrew Locke, MSNBC
Jose Lopez, *The New York Times*
Maria Mann, formerly AFP
Bill Marr, formerly *National Geographic*
Michele McNally, *Fortune*
James Merithew, *San Francisco Chronicle*
Eric Meskauskas, *New York Daily News*
Maddy Miller, *People* magazine
Michelle Molloy, *Newsweek*
Dolores Morrison, *New York Daily News*
Karen Mullarkey, formerly *Newsweek, Rolling Stone, Sports Illustrated*
Larry Nighswander, Ohio University School of Visual Communication
Jim Preston, *Baltimore Sun*
Sarah Rozen, formerly *Entertainment Weekly*
Mike Smith, *The New York Times*
Neal Ulevich, formerly Associated Press

Website and Digital Systems
Jeff Burchell, Applications Engineer

Television Documentary
Sandy Smolan, Producer/Director
Rick King, Producer/Director
Bill Medsker, Producer

Video News Release
Mike Cerre, Producer/Director

Digital Pond
Peter Hogg
Kris Knight
Roger Graham
Philip Bond
Frank De Pace
Lisa Li

Senior Advisors
Jennifer Erwitt, Strategic Advisor
Tom Walker, Creative Advisor
Megan Smith, Technology Advisor
Jon Kamen, Media and Partnership Advisor
Mark Greenberg, Partnership Advisor
Patti Richards, Publicity Advisor
Cotton Coulson, Mission Control Advisor

Executive Advisors
Sonia Land
George Craig
Carole Bidnick

Advisors
Chris Anderson
Samir Arora
Russell Brown
Craig Cline
Gayle Cline
Harlan Felt
George Fisher
Phillip Moffitt
Clement Mok
Laureen Seeger
Richard Saul Wurman

DK Publishing
Bill Barry
Joanna Bull
Therese Burke
Sarah Coltman
Christopher Davis
Todd Fries
Dick Heffernan
Jay Henry
Stuart Jackman
Stephanie Jackson
Chuck Lang
Sharon Lucas
Cathy Melnicki
Nicola Munro
Eunice Paterson
Andrew Welham

Colourscan
Jimmy Tsao
Eddie Chia
Richard Law
Josephine Yam
Paul Koh
Chee Cheng Yeong
Dan Kang

Chief Morale Officer
Goose, the dog